Live Nude Girl

Live Nude Girl

My Life as an Object

Kathleen Rooney

The University of Arkansas Press
Fayetteville • 2008

Copyright © 2008 by The University of Arkansas Press

ISBN-10: 1-55728-891-7
ISBN-13: 978-1-55728-891-2

12 11 10 09 08 5 4 3 2 1

Text design by Ellen Beeler
 •

⊗ The paper used in this publication meets the minimum requirements of the
American National Standard for Permanence of Paper for Printed Library
Materials Z39.48-1984.

Library of Congress Cataloging-in-Publication Data

Rooney, Kathleen, 1980–
 Live nude girl : my life as an object / Kathleen Rooney.
 p. cm.
 Includes bibliographical references and index.
 ISBN 978-1-55728-891-2 (cloth : alk. paper)
 1. Rooney, Kathleen, 1980– 2. Artists' models—United States—Biography.
 I. Title.
 N7574.4.R66 2009
 709.2—dc22
 [B]
 2008036620

for Martin

The nude is for the artist what love is for the poet.

—Paul Valéry

Most people can tolerate being looked at only when they are wearing a mask.

—Darian Leader

Contents

Acknowledgments

Grateful acknowledgment is made to the editors of the publications in which parts of this manuscript first appeared, usually in slightly different form: "His Coy Mistress," *Apostrophe*; "Notes of Another Nude Model," *Provincetown Arts;* "Naked Truths," *The Telegraph (UK);* "You Only Live Twice," *turnrow;* "Live Nude Girl," *Twentysomething Essays by Twentysomething Writers;* "Why I Do It, " *Western Humanities Review.*

Thanks are also due to: Abigail Beckel, Christopher Busa, Sally Drumm, Christen Enos, Andrea Mason, and the Fine Arts Work Center in Provincetown, Massachusetts, as well as all the artists with whom I have worked.

Out of respect for privacy, the names of some individuals mentioned in this book have been changed.

Introduction

Look at Me

Bishop Berkeley worried that if he wasn't looking at the world, it might disappear. I worry that if the world isn't looking at me, I might. Or at least I used to.

I have worked as an artist's model for the past six years. It's a weird way to earn money, but it is not how I make a living. It's more of a hobby. OK, more of a habit. OK, a compulsion.

When people find out that I model for artists, the first thing they ask is, "Like, naked?" Yes. Naked.

Everyone wants to know what the job is like. But it was many years before I could tell my own mother what I do—I fibbed that I was working as a classroom aide. (Another thing people want to know is, "What does your family think?" My parents find it embarrassing, best left untalked about, particularly to my devout Roman Catholic grandmothers, aunts, uncles, and cousins. My sisters and husband think it's cool—they support the arts, and besides, it's my life.)

So this is what it is like to work as a nude art model, or, rather, this is what it has been like for me. During different years, I am either a poetry graduate student working lots of part-time jobs to make rent and tuition, or I am a new college professor with lots of free time, relatively speaking, looking to pay off my staggering loans. I travel via public transportation or on foot to the place where I am scheduled to pose. I arrive at a university classroom, a professional studio, or a private home with my boyfriend's, my fiancé's, or my husband's blue flannel bathrobe (increasingly ratty over the years of our relationship) in my enormous handbag. Also in

1

tow? Books to read, papers to grade, and my hot pink Nalgene water bottle. I have probably come straight from class, either one I've been attending or one I've been teaching.

Maybe I will walk through the door and the room will be full of Intro to Drawing students, battered easels ranged around an elevated model stand, a balding and harried assistant professor at the center of the ring, doing his best to see that all eighteen to twenty-five undergraduates will have a decent view once I climb up and there's something to see. Or maybe there will be a trio of middle-aged ladies in tapered blue jeans and Keds renting space in a converted warehouse, Norah Jones on the stereo, and low-fat snacks in the mini-fridge, a bedsheet spread on the floor to serve as a stage and various chairs, sofas, and ottomans arrayed at the perimeter as props and backdrops. Or maybe this will be the home or apartment of a lone artist who'll peer through the peephole and pull back the chainlock to let me enter the living room, where the furniture has all been pushed to one end, save perhaps a single piece, lit up like a movie set with lights the artist has bought, rented, stolen, or borrowed from the school where he or she either takes or teaches classes when not practicing alone.

Wherever it is, there will almost always be a screen or a wall to change behind, often one whose sole purpose is to shield the model during his or her transition from street clothes to bathrobe. I never use the screen. I will excuse myself to the "restroom" if it is an institution, or the "bathroom" if it is a residence. There, I will make myself ready for the coming disrobing. I prefer the bathroom because I can use it if I need to; nobody likes a model who can't stop fidgeting because she needs to pee. And bathrooms have mirrors that give the model the chance to give herself a quick once-over, especially if she needs to make any adjustments to features of her person that might be distracting or distasteful to a professor, a student, or an amateur artist: Does she have lipstick on her teeth? Has she tucked her tampon string all the way up inside to avoid unsightly dangling?

Then I will return to the room clad in the bathrobe, always on time for class to start, because no one likes a model who runs late or makes excuses. One near-constant is that the modeling session will last three hours. Beyond that, anything could happen: it could be a sculpture class, a painting workshop, a drawing group session, or maybe even a photo shoot, depending what I've signed on for. Oh, and of course the other near-constant: I will position myself at the focal point of the room, untie the blue flannel bathrobe, and stand, sit, or lie completely naked before one or

more relative strangers. (Another question: "What's it like to be in front of a bunch of people where you're the only one with no clothes on?" A spine-tingling combination of power and vulnerability, submission and dominance. But we'll get to that.)

I will receive instructions from the instructor, the group, or the artist on how I am to position my body and how often I am entitled to pause for breaks. At the universities, the standard is twenty minutes on, five off, with a long break in the middle, perhaps with a lecture or demonstration here or there. I can hold still for much longer than that if necessary. Maybe the teacher or artist will hand me a clicking kitchen timer with a jangly bell to keep track of the minutes, or maybe I'll be expected to do that in my head, with the assistance of my wristwatch if I've remembered to wear one and remembered to leave it on.

And then it will come, the moment we've all been waiting for: the ribbon-cutting, the dramatic unveiling. I'll slip off the loose knot of the belt at my waist and set my robe in a heap at side of the stand, out of the composition, but within easy reach. If the day is cold, my skin might erupt into goose bumps, the fine brown hairs on my arms standing tinily on end. If it is hot, I might begin to sweat under the added heat of the lights.

The first thirty seconds of nudity are always the most jarring, charged for me and for those who are looking at me, at least if it is a class or artist who has never seen me naked, never worked with me in the past. The disrobing is a gentle shock, a surprise, a kind of eyewash, and the instant is electrified, more vivid than those that preceded it and those that will come after. My nudity might seem unreal, as if it can't really be happening, as if this strange other person can't possibly be presenting herself without a stitch and letting her body be drawn. So too might my nudity feel hyper-real, as if this person is the most three-dimensional object in space, vulnerable in her nakedness, but powerful in her command of the entire room's studious and uninterrupted attention. But after these first few seconds, the flamboyance and the frisson seem to settle a bit, and the artists get down to the task at hand, which is not merely to gawk or to watch or to gaze, but to transmit from their eyes to the model, to their hands, to the page or the canvas or the clay the image they hope to render over the course of those three short hours.

If the artist or class or group is familiar, even the first thirty seconds might feel more routine, more like business, stripping down for a purpose, like, say, going to the doctor. I might seem as clad in my nudity as white-

collar workers seem clad in their suits, as blue-collar workers seem clad in their uniforms. I will settle into the mechanics of the work: pose and break, pose and break; nude then robed, nude then robed. There is a meditative rhythm to a modeling session, one punctuated with trips to the bathroom, calls on my cell phone, the jotting of notes in my notebook, the adjustments of space heaters or fans according to the season. I might chat with the students or compare teaching notes with the professor. I might get out my calendar and set up further private appointments with the group or the artist. I might get hit on, or then again I might not. Maybe it's a class I'm friends with and I'll get invited to a birthday party, a basketball game, or a kegger. Maybe the teacher and I have worked together a lot, have hit it off, and we'll make plans to have lunch. Maybe the drawing group ladies will find out I'm giving a poetry reading somewhere and plot a field trip to hear me. I am continually surprised by how three hours can fly by, and then it's back to the bathroom to suit back up and get ready to rejoin the more uniform world of the fully clothed. Once dressed, I'll swing back by the classroom, living room, or studio space to collect my cash. These jobs are sometimes contract-employee, sometimes under-the-table, and while I prefer the latter, it's good money either way.

Depending on how interested the person asking me about my job as an art model really is (beyond the nudity, the job is not all that riveting to most people, but rather seems too repetitive, too quiet), I might try to describe it as if they needed to learn how to do it themselves.

Many times, when I was just starting out, I wanted so badly to please the classes and the instructors that I would throw an especially hard pose and then not move at all until the end of the allotted time. My feet and legs, executing some daring twist, would fall asleep, and I would rise and step off the platform only to collapse embarrassingly on the deadened limbs, a marionette with the strings cut. I'd try to play it off, and often the professor wouldn't notice—or at least would pretend not to, maybe to be polite. But once, Doug, a sculpture professor at Boston University, took me aside to say, "You know, you can move if you need to—you are allowed to take an unscheduled break if something's hurting you." He gave me some advice he learned in the Army: when you're standing at attention for a long period of time, don't lock your knees. Micro-bend them; otherwise, you stop the flow of blood to your head and you'll lose sensation, maybe even pass out. Doug and I went on to become good friends.

Other times, the hazard isn't metaphorical pins and needles, but rather real ones—pushpins, easel clips, nails, glass. I learned quickly to wear shoes at all times when not on the platform, and even so I still come home with the bottoms of my feet burnt-looking from the charcoal that coats a drawing classroom's every surface like ash from a Dickensian factory, like soot on a company town. If I've been in a sculpture class, my hands and feet are chalky, gray, like I've just fled Pompeii.

More experienced models have warned me that taking too many difficult poses will ruin your body, or can if you let it. Above all, you should never try to keep your hands higher than your heart for longer than, say, a five-minute gesture without a brace or your arms will go numb and it will become hard to breathe.

By now I've learned how not to get hurt, how to shake it out, how to assert myself if I need to if a pose really kills, but I rarely need to, because I can use pillows, poles, and stools to brace myself, to create gestures that look beautiful and excruciating without actually being the latter. People seem to respond most passionately to the poses that look agonizing, stretched out and mannerist, to the extent that I have become convinced, like Edmund Burke, that "we have a degree of delight, and that no small one, in the real misfortunes and pains of others." People like the more torturous poses because they find them sublime—pretty and scary—and they delight in looking at them, but are glad they don't contain them. Sympathy and pathos.

It took me a while to learn all this, for I had no one to ask; I just jumped in. Which brings me to another question people like to raise, "How on earth did you get into this line of work in the first place?"

It was kind of an accident, actually, a decision born of what seemed at first like a sad mistake or a silly waste, but that later proved felicitous—like the discovery of microwaves, or maybe champagne.

Originally, I had no desire to appear in art, but rather simply to be around it. I had always loved museums and art books as a kid, and since moving to Washington, D. C. for college I had availed myself of the many free museums on the Mall and the free days and nights at the city's private galleries and collections. My junior year abroad at Oxford, I dragged friends and loved ones to museums all over the United Kingdom during terms—the Bodleian, the National Portrait Gallery, the Tate!—and the continent during breaks—the Louvre, the Museu do Chiado, the Neue

Pinakothek!—driving everyone crazy by taking forever to get through the exhibits, reading every placard, taking every audio tour, glomming on to every docent-led circuit, learning everything I could about the provenance of the paintings, the personal lives of the artists, and the backstories of the scenes depicted and the long-dead people in them. It never crossed my mind that I could appear in paintings or sculptures myself; I was not that classic, that eternal, that worthy of depiction.

Returning to D. C. my senior year, I needed a job, preferably one that would be close to—and would help pay for—my diminutive apartment in Dupont Circle. When, late one muggy August afternoon, I found a want ad announcing part-time positions in the gift shop of a prestigious art museum just up the street, I called immediately. The man on the other end of the line asked if I could come in for an interview before they closed at five, and since I was only a few blocks away, I said yes, sure, I'd be right there. I showed up in jeans, sweaty and disheveled from my dash through the sunny humidity, but my interviewer and future boss—let's call him Fred—seemed unfazed by my failure to dress for success and hired me on the spot.

In *The Beauty Myth*—a book that I read for a class during my breaks at the museum gift shop—Naomi Wolf told me that typically "a girl learns that stories happen to 'beautiful' women, whether they are interesting or not," and that "interesting or not, stories do not happen to women who are not 'beautiful.'" I supposed this was true, both in literature and on television. By the winter of 2001, a story was happening to me.

When I began working for him the preceding fall, Fred told me I was pretty. I didn't take it personally; he said that to everybody. He prided himself on hiring girls—always calling them girls, never, ever women—who he thought were attractive. As to whether they were interesting, that part didn't seem to concern him particularly.

Tall and wiry, Fred was in a band. He had limpid brown eyes and floppy dark hair and pierced ears that appeared unused to hearing the word "no." His apparent inability to hire any male junior staff was a long-standing workplace joke. On my first day, I was quipped at by multiple new colleagues, "So you're the latest addition to Fred's harem. Welcome!" He and his two male supervisors were in their mid-thirties, and all the new help happened to be females in their early twenties.

The next hire after me was Patricia, a shy art history grad student from small-town Indiana, thin as a pin and quiet as a church mouse, at least

until you took the time to get to know her. She and I became close friends for a number of reasons—not the least of which was that both of us felt maddened by the unsubtle attentions of our bosses. They asked us out despite our refusals, insinuated themselves into the cramped quarters behind the registers with us to give us instructions, questioned us about our sex lives, and bought us unasked-for lunches from the museum café. Their conduct subsided slightly when two of them began dating two new salespeople—Laura and Stephie—but the harassment persisted in a low-grade way. Still, the job was easy and convenient and our complaints were hard to document, so Trish and I stayed.

We did not want to sleep with Fred or Alex or Hugh; we wanted low-key jobs a few blocks from where we lived. We had the minimum possible amount of responsibility, and that was OK with us, but not with everybody.

"No thanks, Fred," I said to him that winter when he cornered me in the stockroom and asked me out again as I was rolling up posters of the museum's most popular holdings: Renoir's *The Boating Party,* Picasso's *The Blue Room,* Bonnard's *The Open Window.* "And honestly, you know what? I wish you'd please just stop asking."

"Look, if you don't want to do what's expected of you here, I think you'd better start seeking other options," he said.

"What are you talking about?"

"This position was supposed to be seasonal. Temporary. And I think maybe the season's over. It's January. There's no more Christmas rush—your time is up."

"That's not what the ad said," I said. "That's not what you said when you hired me."

"Whatever," said Fred. "I'm sure you'll think of something."

Trish got the same news later that morning. Although they were hired months after we were, Laura and Stephie would be kept on because they were "performing essential duties."

Trish and I went to my fifth floor walkup that day for cheap, home-made lunch—clearly there would be no more free ones—and we lamented our impending unemployment while eating peanut butter sandwiches and scanning the classifieds. "Be a part of art!" one of them beckoned. I read the blurb aloud to Trish—a call for nude models for the Corcoran College of Art and Design—and I suggested she apply.

She turned red at the thought.

"Yeah, right. Why don't *you* apply?"

"OK," I said. "I will. Right now," and picked up my cell phone.

Shivaun, the model coordinator, answered on the first ring, and explained to me the basics of the job: sit naked, very still, with lots of breaks, for three hours at a time. Being looked at and not touched or harassed sounded fine.

And that's how I found myself sitting in the back room of the gallery at the end of one of my final lunch breaks, burning through the remaining days of my two weeks' notice, filling out the forms Shivaun had faxed over, trying to concentrate over the jovial Irish reels piping from the NPR program on the boombox in the frosty window.

"Ooh, the Corcoran," said Phil, my bearded, bespectacled coworker who worked in shipping. He was an Irish folk music aficionado. He was wearing a Cosby sweater and leaning over my shoulder as I plugged in my information: last name first, daytime phone number, address, and so on. "Just can't get enough of the museum gift shops of Washington, D.C., eh?"

"It's not for the gift shop," I said. "It's for the school."

"You're going to be a teacher? But you don't have a degree yet. And you're an English major."

"I know, Phil. I know. I'm going to be a model. I hope."

"A model? Like, naked? Oh, god. Oh wow. Aren't you afraid?" asked Phil.

"I did that when I was in college," said Fred, who had come in to fill a shipping order and was checking his e-mail, long fingers with silver rings clacking across noisy keys. "I'm sure you'll be great at it."

"I could never do that," said Phil. "They'd probably take one look at me and run away screaming."

Phil was not a bad-looking guy, and I knew he was trying to be funny. But I never know what to say when people are self-deprecating in this way. I turned to show him the application.

"No, I don't think so. I think they'd be happy to have you. The woman on the phone said they need all body types, and there are no requirements. See? You just put in your height, your weight, your gender, and your hair color, and you're ready to go."

"I don't know," said Phil. "You must be really confident—that must be awesome."

Something like that. Phil was not wrong. I am not unconfident. Nor was he right. I might have just felt I had something to prove; what it was,

though, I couldn't say. In the boxes on the sheet I filled in five feet eight inches, 110 pounds, female, dark brown hair. Shivaun called me on my cell that same afternoon, and I was booked for my first class. I was to show up and get naked in less than a week.

Another question people like to ask is, "What was it like the first time you did it?"

The Corcoran Gallery of Art is located downtown, at Seventeenth Street—not far from the Lincoln Memorial and the Mall, not far from all the other D. C. sites and attractions—but the main campus of the Corcoran College of Art and Design is in Georgetown, high at the top of a hill, set on a promontory, surrounded by huge churches and historic buildings and a thrilling view. The day I was to make my debut, I walked there. I prefer to walk every time I have an assignment, as I prefer to do everywhere, because walking is exercise. It helps me wake up and think.

I entered the south side of the red brick building and climbed the stairs to the classroom. The January morning was crisp and white and cold, and the room was crisp and white and warm—white walls, white linoleum floor, white ceiling tiles embedded with white fluorescent lights, and a circle of a dozen or so students, voluminous gray-white sheets of newsprint attached to their easels like sails.

"Oh, hello. Are you new to the class?" asked the woman I presumed to be the professor, a kindly ex-hippie with sweet gray eyes and wild steel-wool hair, dense and black and spun-through with strands of delicate white.

"No," I corrected her, with what I hoped sounded like poised professionalism. "I'm the model."

"Ahh, that's right. I asked for two today. Wonderful. Pleased to meet you," she said, shaking my hand and introducing herself as I did the same. Her fingers were smudged with charcoal, and when she swept her hair back off her forehead, she smeared it on her face. "Well, we're almost ready to get started. There's a bathroom across the way for you to change in—you have a robe, right?"

"Of course," I smiled, thinking of the advice of a favorite writing professor: if you don't know what you're doing, just act like you do, and something will come to you. Fake it until you make it.

In the bathroom, in between folding my jeans and blouse neatly into my backpack and donning my boyfriend's robe, I paused to look at my

body. Suddenly, it didn't strike me as especially inspiring. Like maybe I'd go back in there and the students—some of them my age, some of them older—would laugh and point and ask for their money back and the teacher would be disappointed and Shivaun would fire me and that would be the end of my brief career as a live nude model. Standing there in my clunky brown lace-ups and nothing else, staring at the squares of the bathroom tiles in a spiral of self-doubt and self-pity, I heard the door open and someone saunter into the stall next to mine. A husky voice called over the top of the wall, cavernous and echoey:

"You the other model, sweetie?"

"Yeah," I said. "I'm almost ready."

"Oh, no hurry. I'm just getting ready myself. You want any lotion? Don't wanna look ashy."

"No thanks," I said. My skin was pale, but well-moisturized. I took comfort in this piece of luck. "What's your name?"

"LaNelle," said the throaty voice, and asked for mine, and I told her. "This your first time?"

"Is it that obvious?"

"Oh, honey, don't worry. I'm sure you'll be fine. Everybody's gotta start somewhere. Just follow my lead, Kathy. Just stick with me and you'll be all right."

"We'll start with some one-minute gestures before going into the longer, sustained pose," said the professor, back in the classroom, her flannel shirt swooping out behind her as she fluttered around, setting up the lights. Even LaNelle's robe looked more accomplished than mine: fluffy white terry cloth so fine it looked stolen from a luxury hotel. On the break, I asked her where she got it. "The Hilton," she said.

"These poses can be really dramatic," said LaNelle. "The more dramatic the better. Do all the stuff you can only hold for a short while and save the easier stuff for later. Don't wear yourself out."

We climbed atop the model stand, a boxy plank platform upholstered with nubby brown carpet and dotted with two small, sturdy crates for us to use as props. LaNelle was so close that I could smell her: musky perfume and sweet oily hair cream and something fruity in the lotion she'd applied in the bathroom. I hoped I smelled all right, too, but more than that, my heart pounded in the hope that I *looked* all right.

LaNelle began to untie her robe, and I—and everyone else—could see: my fellow model was beautiful. My heart sank. She was twice as old as me,

but her body was fantastic, her ebony skin even and tight and wrinkle-free. She was a former gymnast and her muscles retained a compact, sinuous, feline comeliness. She was in almost every way the opposite of me. I pictured my own body, light and scrawny, beneath my borrowed robe. Next to hers it would be nothing. An anemic root vegetable, slim and attenuated and lacking her authority, her forceful beauty.

My skinny is what I have always been. My skinny is how I always want to be. My skinny is me. But sometimes I distrust it. My breasts are too small; my nipples too pink. My butt is too big for my frame, curved and fleshy. My ribs are like a xylophone, and the knobs of my spine stick up like ponderous cairns in the landscape of my back. My hips are jutty wings.

"All right, Kathy, we're ready," said the professor, looking up at me expectantly. Her hand hovered over the timer, and I began to panic. I wanted to look her straight in her appraising eye and say, "No way. No way can I do this, not anyway ever, let alone next to her." But then I thought of how I needed the money and how I wanted the adventure, and I thought of Fred, that jerk, and how I was tired of being a chicken, and I swooped the plaid cotton off my narrow shoulders and let it go. No turning back.

To my surprise, nobody laughed. Nobody gasped in horror or recoiled in disgust. Such a study in contrasts, they said, such different types of beauty. The teacher reminded the students how fortunate they were "to have two lovely models today" and began lecturing them about contour and shadow and light, began telling them to "take advantage of these delightful compositional opportunities." David Bowie was singing from the stereo, low and distant but unmistakable: "Ch-ch-ch-ch-changes / (turn and face the strain) / Ch-ch-ch-ch-changes / Where's your shame?"

The timer beeped. "Change!" called the professor, echoing the CD. The class laughed. LaNelle twisted like a corkscrew, prone on the platform, and I raised my arms above my head like a ballerina in fifth position. I tried to remember and then imitate poses I'd seen in Greek sculptures, in bas-reliefs on neoclassical buildings, in allegorical oil paintings. I improvised.

"Strange fascination, fascinating me," said David Bowie. "Ahh, changes are taking the pace I'm going through."

No kidding, I thought. Again the timer beeped. Again the professor shouted out, "Change!" I turned and faced the strange faces, and I saw that they were concentrating intently, but that they were not criticizing LaNelle or me.

"All right, Kathy, LaNelle, that was great. It's time for the long break. Take fifteen," said the instructor. "I'm going to do a quick lecture on Rembrandt and then we'll start up again."

"These long breaks are the best," LaNelle said. "You can stretch, pee, eat a snack, have a smoke—whatever you need to do. You bring anything to eat?"

"No," I said. It hadn't occurred to me. Eating and then getting back up and sitting naked in front of a roomful of strangers—even appreciative strangers with open minds when it came to the idea of beauty—seemed unappealing.

"I brought some cheese and crackers. I brought some grapes," said LaNelle, rummaging through her massive black leather bag. "You want anything?"

"No, thanks," I said. In the future, when I was modeling alone, I'd use these long breaks to read, to give myself material to contemplate when I was back up on the stand. That day, though, since I had company, I asked LaNelle, "What made you decide to become a model, anyway?"

"Oh, I don't even remember anymore. I just needed a job, I think, and this was good money. I've always taken care of my body. I've always been proud of my body. I grew up in a family where nudity was accepted."

My household was not like that. In a book I would read on a future break—a book called *Nudity* that I would use to make sense of why I'd chosen nude modeling—a woman argued that there are "two major factors behind the ambiguity of nudity in the modern West: the Judaic and the Greek." The Judaic tradition, the woman explained, "envisaged transcendent divinity as clothed or veiled, and hence nudity as a loss or deprivation, a distraction from the Godhead—the state of slaves, prostitutes, the damned or the mad. The Greek tradition, on the other hand, represented in Platonic metaphysics as well as in athletic and sculptural practice, saw nudity as the state of the ideal human figure."

"That's great," I said to LaNelle. "You're lucky. My family never said that nudity was dirty, but I don't think we ever had a really healthy attitude toward our bodies."

"You raised Catholic?" LaNelle asked through a mouthful of grapes.

"Yeah," I said. "Pretty seriously."

"Well, there you go."

"I'm not sure that totally explains it," I said.

"I'm not sure that it doesn't," she said. "I've met a lot of recovering religious people in this line of work. And you ladies always seem to have

some of the most interesting—how shall we say it?—issues. No offense. I mean, we've all got 'em, our issues."

"None taken."

The professor's lecture was over and we hopped back on the model stand. We settled into the longer pose, the first of my life. For the next two and a half hours, LaNelle and I would move only minimally.

"Any moving you want to do, sweetie," LaNelle said as we arranged our limbs, "You'll have to do in your mind."

Last—because by that point we will have established a rapport, and because I can be fairly forthcoming when it comes to finances—people want to know, "How does art modeling pay?" Pretty well, but not enough for me to live off, though I've met people who do. The wages are generous, but in three-hour increments here and there; the work is irregular and it's tough to cobble together a traditional forty-hour-a-week schedule. It's also physically demanding to put your body through that much posing.

That first day, when Shivaun took out the gray metal cash box to pay me, I was struck again by how much I was earning and how the scratchy bills in my hand felt like easy money. At almost fifteen dollars an hour, I had nearly doubled the wage I'd been making at the gallery. And the Corcoran's rate was not atypical. The university rate, at least in the larger cities where I've modeled, tends to range between twelve and sixteen dollars per hour, and if you can break into posing for private groups and individuals, it's not uncommon to get twenty-five. But while I like this pay rate, the money is not why I do it, exactly.

A lot of people, usually female people, want to know how they can get into art modeling. This question I usually get asked in private, after the other listeners have left the bar or finished smoking and abandoned the balcony to go back to the party. Because I am not as protective of my work as some models—particularly those for whom posing is a primary source of income—understandably can be, I tell them. I also know that most of them won't follow through. They lack the willingness to do it. I don't want to say they lack the courage or the confidence; I don't know what they possess or lack that makes them disinclined to call the model coordinators whose numbers I readily give them. But I do know that they appear to lack my compulsion, and that of all the people I've given referrals to, only two have ended up posing nude for artists.

One of them is my friend Bruno, a composer who lives in Boston whose main job is working as a security guard and union organizer at the Museum of Fine Arts. Ever vigilant for flexible sources of income that leave him plenty of time for his music, Bruno took me up on my recommendations instantly. He poses regularly at Boston University, the Museum School, and a number of my other former Boston modeling haunts. When I ask him how he feels about posing, he tells me that he likes it; he's comfortable in his skin, he says, and artists and students react well to him. It's no big deal to him whether people see him naked; he's just pleased with modeling as a means to an end, a way to make some quick cash on the side so he can spend more hours by himself composing, away from the world and the demands of others.

Though I've been at it for years more than he has, my relationship to modeling, and to my own body, has never been so uncomplicated.

When I work as a professor, I sometimes teach a course called "On Beauty." A Writing 101 class, the purpose of the assignments is to help my students acclimate to college life and to learn how to be critical readers, writers, critiquers, and thinkers. The purpose for me is to read widely and think deeply about a subject that I find fascinating: what is beauty, what is its use, and what does it mean for women compared to what it means for men?

The essay "Beauty (Re) discovers the Male Body" by Susan Bordo often stands out as a student favorite, perhaps because most of the class participants wind up being straight women and because the essay contains abundant pictures of sexy male Calvin Klein underwear models. In the essay, Bordo observes the difference in the value that men and women place on being looked at. "For Sartre, our vulnerability to the objectifying and defining look of the Other is an occasion for shame, the 'hell' that other people represent," she writes. But, she continues, "it is striking that Beauvoir describes this vulnerability as a necessary condition of self-worth—for women. In *The Second Sex,* seemingly unaware that she was providing a counter-example to Sartre's position, she describes 'the woman in love' as 'hating' her lover's sleep [. . .] 'For the woman,' she says 'the absence of her lover is always torture; he is an eye, a judge . . . away from him, she is dispossessed, at once of herself and of the world.'"

I know my two-person survey is strictly anecdotal, but Bruno falls squarely in the territory staked out by Sartre, whereas the only other person I've helped get into art modeling could scarcely be more entrenched in

the turf claimed by Beauvoir. I'll call her Audrey. She was a student in a creative writing class of mine, and she was one of the coolest women I've ever met. Cool in the way art critic Dave Hickey defines cool, as a way of approaching public life that "aspires to ethical opacity and embodied conviction. It proposes that we shut up and act out our beliefs in public." This, Hickey says, is in opposition to warmth, which "aspires to emotional transparency and expressive sincerity."

Audrey was a terror, I was warned by fellow professors who'd taught her before and who'd heard she'd signed up for a class of mine. Her last name rhymed with bitch, one colleague said, warning that this was an apt coincidence. Audrey was cool in a way that women are not supposed to be cool. Confident in a way that women are discouraged from being confident. She was forthright, vocal, and extremely smart, and I probably liked her while being simultaneously really annoyed by her because something about her reminded me of me.

But she was not invulnerable. This was a mistake that her observers would make, the same kind that often befalls people who are simply shy when they get pegged as arrogant, stuck-up. Audrey had doubts, deep ones, and she wanted attention, lots of it—positive preferably, but negative if need be—though sometimes she'd come to my office hours and lament that maybe she was coming across wrong, as more abrasive in her classroom comments and attitudes than she intended. For someone her classmates and professors had pinned down as impervious and self-assured, Audrey was desperately concerned with the way her idea of herself—her ideal, really—differed from and fell short of the way other people saw her. When others perceived her in a way she felt was incorrect—or worse yet, seemed not to perceive her at all—she was dispossessed.

"I don't think my work is better than everyone else's," she told me once. "I just want people to be honest. I just want people to not be afraid of not being good girls, and to stop being bullshit and think about things."

Because it was a personal essay class, Audrey wrote about her personal life. Her first piece chronicled her transition from a chubby, mousy high-school nonentity into a curvy, brassy undergrad who had managed to, as former acquaintances told her, "turn hot" over the course of becoming a college freshman. She wrote that she hadn't even grasped the extent of the disapproval and criticism she had been subjected to as the Fat Girl until she began to notice the approving responses of her fellow undergraduates that fall, and of her former high school classmates when she returned

home briefly during that first winter break. She wrote of her mix of pleasure and frustration at how men who previously wouldn't have given her the time of day now wanted to date her. Her personality hadn't changed; she was still, more or less, the Audrey she had always been—opinionated, well-read, curious, and skeptical—but now she was hyper-conscious of herself as all this, but blonde and buxom, too, an object of male attention and female jealousy. Audrey wrote in her essay that she liked her body well enough, but wanted—like most of us—to be able to like it more.

Once the semester was over, Audrey asked if I could please help her get into art modeling. As it happened, I was moving away shortly after the end of the school year, and the art academy I had been a regular for was going to need a replacement. I helped see to it that this replacement would be Audrey, and she actually did it. She still poses, and every now and then she writes to tell me how much she enjoys it, how it's still going well, how it's still a rush to be seen and drawn by so many other people. How one day she'll quit, but for now it's giving her something she didn't even realize she needed.

Are Bishop Berkeley and Audrey and I all intolerable solipsists? No, we are not. Do we think that our selves are the only things that can be known and verified? We do not. Are we narcissists? Maybe, but to slap that label on our impulses is to easily dismiss them, and they are too complex to be dismissed so easily. A characteristic of narcissism beyond self-preoccupation is an unconscious and contradictory deficit in self-esteem. I'd say that Audrey and I at least, despite outward appearances, are probably fairly cognizant of our less than total self-confidence. We do think highly enough of ourselves to stand naked in front of other people secure in the belief that most of them will not find us aesthetically hideous. But we are not full of ourselves. An unsettling possibility is that perhaps we are not full of anything at all. Rather we may be trying to get full, after other, more conventional ways of seeking fulfillment have fallen short or failed. We may be trying to figure something out by repeating this action again and again.

It may not be the last question people ask about art modeling, but it usually comes up somewhere along the line: "Why do you do it? What makes you want to pose?"

Some questions are more difficult to answer than others.

Naked If I Want To

For the third summer in a row, I am sitting atop a gray rotating model stand in a straight-backed, clay-dusted chair in one of the stifling sculpture rooms at Boston University. As usual, Doug, the instructor, is putting the summer session students through their paces like a drill sergeant. As usual, I'm surrounded by butterfingered students who aren't art majors doing their best to create life-sized portraits of my head from the neck up. Unlike previous summers, however, this year I am topless.

Ani, one of the students from last year's class, has returned for another go-round, and she is the one responsible for my half-clad state. An Armenian immigrant working for BU so she can get her tuition paid, she's been fulfilling her degree requirements in scraps of spare time—evening classes here, summer courses there. Now that her skills are more advanced, she wants to turn her piece into a full-scale bust, including my bust: halfway down my torso, below my breasts, but above my belly button. Miraculously, by means of 365 daily visits with the spray bottle, she's managed to keep her piece moist and malleable for an entire year in the public studio, so there I am: skirt and shoes on, bra and shirt off, perfectly motionless and slightly slippery-skinned, like some sweaty blow-up doll.

These summer sessions are usually mind-numbing, but this year, as the students revolve around me, planets to my sun, I'm energized by the incongruity of sitting topless in a roomful of ten people, nine of whom are sculpting only my face. My conspicuous lack of a shirt is certainly more interesting than posing in my street clothes, but so too is it more stimulating than posing without any clothing at all.

Roland Barthes, who manages to make even literary theory sound all sexy and French, asks, "Is not the most erotic portion of the body *where the garment gapes?* In perversion (which is the realm of textual pleasure) there are no 'erogenous zones' (a foolish expression, besides); it is intermittence [. . .] which is erotic: the intermittence of skin flashing between two articles of clothing (trousers and sweater), between two edges (the open-necked shirt, the glove and the sleeve); it is this flash itself which seduces, or rather: the staging of an appearance-as-disappearance."

Generally, while posing for this class, I could swear that somehow time actually slows down; that if I don't watch it, the clock will sneak its hands backward. I often wish as I sit that I knew how to sleep with my eyes open. (I've even done research to see if I could learn, but no dice; apparently, sleeping with your eyes open just leads to terrible dry eye and can even be a sign of serious neurological problems.) But Barthes really nailed this one; intermittence keeps me awake, makes the session fly by. Here's why:

To the naked eye, I do not appear to be moving, but secretly I am building. I am making myself a Memory Palace to solve a mystery: How did it become second nature for me to do this? Why am I so comfortable displaying my own nudity?

Shortly before this class started, my fiancé left the book *The Art of Memory* by Frances A. Yates lying around the apartment. In it, Yates explains a mnemonic method based on an ornate wooden Memory Theatre built by the Italian philosopher and celebrity-scholar Giulio Camillo to illustrate the technique behind his own vaunted powers of memory. Essentially, the Renaissance art of memory assumes that we are naturally inclined to recall information in relation to location, even if there's no natural connection between the idea to be remembered and the place in which it is put. All you have to do is imagine a building and begin filling the rooms with the mental furniture you would like to remember. Particular memories can be placed on the tables and shelves of larger rooms to which they are related, so that picturing the place will trigger the memory. Although this *Teatro della Memoria* was promoted chiefly in Italy and France, vestiges of the method remain in the English language to this day, whenever we hear lecturers start a sentence, "In the first place . . ."

Initially, this trick seemed to involve putting yourself out unnecessarily. Why go to such elaborate lengths to store information? Why not write yourself a list or make yourself a spreadsheet? Then I realized why not: sometimes you just can't. I was failing to take into account the difficulty,

until relatively recently, of whipping out a notebook and jotting something down. Back in the Renaissance, paper was still comparatively scarce, loads of people couldn't even write let alone read, and the ballpoint pen was nowhere near being invented.

One pastime for an artist's model who happens to be creative herself is to use all that quiet time to think about her own work, which is what I often do, the chief drawback being that I have to stay on the stand until my mandated rest. No one likes a model who constantly breaks the pose to scramble for her Moleskine. So, while the physical restrictions and conditions that prevented sixteenth-century people from writing things down were not identical to mine, the more I thought about it, the more I could relate to their interest in a contraption of such Rube Goldberg proportions.

Doug rotates the model stand a quarter turn to the left, but it's like I'm hardly along for the ride. I am standing, dressed, and walking through my Memory Palace. On the corridor to my left? The bathroom, since this is the first location that springs to mind as I attempt to make the distinction between public nudity and private nakedness, and wonder why I and other models seem to have a higher tolerance for self-exposure than the average person.

Kenneth Clark, author of *The Nude,* reminds us that, "To be naked is to be deprived of your clothes, and the word implies some of the embarrassment most of us feel in that condition. The word 'nude,' on the other hand, carries, in educated usage, no uncomfortable overtone. The vague image it projects into the mind is not of a huddled and defenseless body, but of a balanced, prosperous, and confident body: the body re-formed."

So if naked is what I am in those old photos my parents took of me and my little sister as innocent toddlers in the bathtub—with shampoo devil horns, Little Twin Stars washcloths, and yellow rubber ducks—then nude is what I am when I purposefully strip down for a roomful of strangers for the sake of art.

Art history lore has it that, at least for a little while, the *Mona Lisa* smiled her smile from the wall of the bathroom of the French King François I. Although she was begun in 1503 and finished three to four years later, Leonardo took Mona with him in 1516 when he was invited by François to live and paint in the palace Clos Lucé, near the royal chateau in Amboise. The king is reported to have paid four thousand écus for the painting, which Napoleon, too, later took for a boudoir picture, borrowing it from the Louvre to hang in the imperial bedroom.

Less well-known than the *Mona Lisa's* association with the rich and famous is that a painting of a woman, this time unclothed and by Raphael, also made its way into the bathroom of a powerful man. According to Clark, "*Naked Venus* did in fact enter one apartment of the Vatican, Cardinal Bibbiena's bathroom, where she has remained in strict retirement until the present day." So she's there in my Memory Palace bathroom, too, along with *Mona Lisa*, my sister Beth, and me. I suspect that Venus is nude, though, not naked, because both the goddess and whatever model happened to pose for the piece would have been well-aware—even proud—that they were being looked at, and once that mindset enters into the equation, innocence leaves it.

In summing up his recounting of the fall from innocence of two of the most prominently naked people in the Bible, Adam and Eve, art critic John Berger asks, "What is striking about this story? They became aware of being naked because, as a result of eating the apple, each saw the other differently. Nakedness was created in the mind of the beholder." As the Bible would have it, "the eyes of both were opened, and they knew that they were naked; and they sewed fig leafs together and made loincloths for themselves."

Prior to the apple, Adam and Eve were certainly naked, but they were unaware that this should trouble them, just as Beth and I were naked and unaware of it, or rather unaware of any attendant feelings of guilt or shame. Given that we were something like one and four at the time, we were unself-conscious, even though the eyes of our parents and our parents' camera were upon us. Beth would no longer be comfortable knowing that she was being seen naked, let alone being recorded, by a roomful of others. Yet because I've opted to become a professional nude model, I am.

To make sense of this apparent contradiction, I stick two books on the tank of the toilet in the bathroom of my Memory Palace: in the first place, *D'Aulaire's Book of Greek Myths,* bursting with Art Deco drawings of beautiful, superhuman gods and goddesses, which I checked out of the library on a semiconstant basis throughout my elementary school years; in the second place, the *Precious Moments Bible*—leather-bound in pink and baby blue, awash in illustrations of baleful, saucer-eyed children acting out the scriptures—that I got from my Granny Marie in honor of making my First Communion.

"In olden times, when men still worshiped ugly idols, there lived in the land of Greece a folk of shepherds and herdsmen who cherished light and

beauty [. . .] The Greek gods looked much like people, and acted like them, too, only they were taller and handsomer and could do no wrong," begins the former. "Then God said, let us make man in our image, after our likeness; and let them have dominion over the fish of the sea and the fowl of the air, and over the cattle, and over the wild animals of the earth, and over every creeping thing that creepeth upon the earth. So God created man in his image, in his image he created them; male and female and he created them," states the first book of the latter.

I place these volumes side by side because they illustrate the paradox that many members of Western culture experience regarding nakedness and nudity to this day.

I also place them side by side because they represent the complexity of my own attitude toward nakedness and nudity. I've wound up being more Greek than Judeo-Christian about my body, but I still possess a mix of the two traditions, which explains some of my secretive, dishonest behavior early in my career.

Last but not least, since both baths and prostitutes factored significantly into the origins of nude modeling and into people's ambivalence regarding the display of the body, I choose to make Mnesarete, aka Phryne (390–330 BCE)—an Athenian Hetaera, or courtesan, and the world's first celebrity nude model—the final fixture in the capacious bathroom of my Memory Palace.

According to Muriel Segal, author of *Painted Ladies*—a delightful book from 1972 in which the author never lets the facts get in the way of a great story—"ever since her sensational career two thousand years ago the word 'phryne' has become the accepted term for a girl who earns her living by posing for artists." Segal asserts that to this day painters and sculptors "refer to a 'phryne,' and whether in Renaissance Florence or around the studios of Monmartre, one might hear among artists: 'Hasn't your phryne arrived yet?' or—only too often—'I owe my phryne for the last five sittings.' And many a pretty model called Jeanne or Marie would adopt the name of Phryne in the hope of acquiring some of the magic of the original."

Granted, I haven't been to Renaissance Florence or turn-of-the-twentieth-century Paris, but I've never known any of the artists I've posed for to refer to a model as a phryne, nor have I known any of my coworkers to apply that nickname to themselves. (While I'm at it, no model I know would pose on credit, certainly not for five sittings, but I digress.)

Segal also asserts that because she was a courtesan, Mnesarete was not permitted to use her own name, and therefore had to take a pseudonym, choosing Phryne, meaning "sieve," "because of the speed with which she ran through the fortunes of her rich lovers." Fair enough. Not unlike geishas, Hetaeri were well-educated women, trained to play musical instruments and to participate intelligently in philosophical conversations. One of her clients, the politician and orator Hyperides, for instance, paid more than one hundred times the cost of a usual prostitute (one drachma) for the pleasures of Phryne's company.

In reality, "Phryne" is Greek for "toad," a designation allegedly applied for her sallow complexion. Toad-colored or not, Phryne was lauded as one of the most stunning women of her day, and was determined to memorialize her beauty for eternity by having an eminent artist take her as his subject. The painter Apelles—a celebrity portraitist and kind of the early Athenian version of an Elizabeth Peyton or an Annie Leibowitz—was a natural target, so Phryne set out to catch his eye. Depending which anecdote you prefer, she went about it one of two ways. Some say she went bathing in the sea wearing only her lovely skin. Apelles, "up in the official vantage point, a type of press gallery from where he was painting the scene, decided instantly that she must pose for his *Aphrodite Coming Out of the Sea.*" Others tell the less-glamorous tale of how her plumbing backed up one morning, forcing her to perform her ablutions in the public baths; Apelles happened to be there that day, too, scouting for a fresh face. One thing led to another and before long Phryne had posed for what some (OK, Muriel Segal) have called "the greatest painting of antiquity."

Although said painting has long since been lost to us, it managed to win the attention of the contemporary sculptor Praxiteles, who wooed Phryne away to pose only for him. You can imagine her disappointment upon learning that working for Praxiteles proved not to be a reliable means of income, for he preferred to believe that the love he expressed for his model in awkward poems served as payment: "I gave myself to Phryne/ for her wages, and now I use no charms,/no arrows now, nothing but a deep gazing/at my love." Just as it would fail to please a contemporary model, all this "gazing" did not keep Phryne satisfied for long, and she began to "bargain for a piece of sculpture in lieu of hard cash." To ensure that her choice was lucrative, she woke Praxiteles up in the middle of the night and lied to him that his studio had been set ablaze. When the sculp-

tor replied that they had to save the Cupid, she knew which piece to request. (True or not, this story is more like it, because when all is said and done, if you're going to model, you've got to get paid.)

Praxiteles' greatest fame arrived in the form of a commission from the City of Cos for a sculpture of Venus. According to the Roman historian Pliny, Praxiteles used Phryne to create two figures of the goddess, one nude and one draped. Offended by the former—perhaps finding it inappropriate for a whore to represent a deity—Cos purchased the latter. The more progressive city of Cnidus (the present-day Knidos) snatched up the nude, and the statue went on to become immensely acclaimed. Pliny writes:

> Later, King Nicodemes wanted to buy it, promising that he would pay off the city's entire foreign debt, which was enormous. The Cnidians, however, preferred to suffer anything but this, and not without reason, for with this statue, Praxiteles had made Cnidus famous. The shrine she stands in is completely open so that one can view the image of the goddess from all sides, an arrangement (so it is believed) that she herself favored. The statue is equally admirable from every angle. There is a story that a man was once overcome with love for it, hid inside during the night, and embraced it, leaving a stain to mark his lust.

Phryne herself went on to notoriety, as well. Accused of the capital crime of impiety and the introduction of false gods—more because Athenian men and women were jealous and afraid of her beauty and unconventional power than because of any actual wrongdoing—she found herself on trial before the Areopagus, the highest court in Greece. Euthais, the prosecutor for the state, was allegedly one of her numerous rejected suitors.

When Hyperides, her unrequited lover and the only lawyer who would take her case, found himself making little to no headway with the Athenian judges, he quickly changed strategies: "tearing off her undervests, he laid bare her bosom and broke into such piteous lamentation in his peroration at the sight of her, that he caused the judges to feel superstitious fear of this handmaid and ministrant of Aphrodite, and indulging their feeling of compassion, they refrained from putting her to death." Their sudden decision to spare her is perhaps not so surprising when one considers that even Aphrodite herself was said to have been impressed with the perfection of

Phryne's body when she first laid eyes on the sculpture. The Greek histo-
rian Polybius records the goddess as exclaiming, "Where did Praxiteles see
me naked?" at the sight of her likeness.

Scandals aside, Phryne profited hugely by her beauty and wit, earning
enough money to offer to rebuild the walls of Thebes after they were
destroyed by Alexander the Great. Perhaps desiring immortality to be
attached to her own name, rather than just to Aphrodite's, her offer came
with the prerequisite that the gates be inscribed "Destroyed by Alexander
but rebuilt by Phryne" or, more colorfully, "Alexander may have knocked
it down, but Phryne the hetaera got it back up again." Her status as a
high-class hooker rendered her offer unsavory, and it was summarily
rejected. Nonetheless, after her death, they placed her statue in the temple
at Delphi with the inscription: "To Phryne who inspired all artists and
lovers."

Phryne's standing in my bathroom now because she encapsulates—
establishes, really—almost all the myths associated with art models and
their profession: beauty (albeit unconventional), wit, the hustle of making
a living independently, love, fame, obscenity, fear of nudity, jealousy,
money, power, death, and immortality.

Since I'm pretty sure that's all the bathroom can hold, I walk down the hall
to the next location in the Memory Palace: my childhood bedroom. In it,
I place a girl, twelve-year-old me, standing in her underwear and staring
critically into the full-length mirror. I didn't always think so, but now I feel
like I look slightly better—and I am definitely more comfortable—totally
naked than in even the skimpiest of garments. I can wear my own skin
confidently, but when I am in clothing of any kind, there's always a slight
chance that maybe it looks like the clothes are wearing me.

Anachronistically, on the nightstand next to me in the bedroom is a
copy of British *Cosmopolitan* magazine from 1978. It is open to an article
by gothic novelist Angela Carter titled, "If the nude is rude, why are knick-
ers naughty?" In it, Carter writes, "I remember reading somewhere how
in the 'Fifties, model girls were often reluctant to do lingerie jobs. Swim-
wear was fine, but respectable girls drew the line at modeling knickers on
the grounds that they should only be photographed in clothes in which
they might be seen in public in acceptable normal circumstances.'"

Although each of my modeling jobs has taken place in the 2000s as
opposed to the fifties, I understand the sentiment. On the rare occasions

that an artist has requested that I pose in my underwear—usually involving such phrases while I'm undressing as, "Ooh, those panties are kind of nice," or, "Let's go ahead and work with the bra"—I've felt pangs of self-consciousness of the sort I thought I'd left behind in middle school. Back then, I had a near-pathological fear and dislike of being seen in my underwear, let alone naked, which would have been an easy fear to keep under wraps had it not been for gym class and its attendant communal showers.

In fact, flipping lazily through the copy of *Cosmo* in my Memory Palace bedroom is one Ayesha Brown, the terrifying seventh grader whose gym locker was next to mine in Coach Mensavage's class, and who made fun of me on a daily basis for being "a skinny little white girl, flat as a board." As she pages through the glossy, Ayesha reads the sex tips and laughs; she's been having sex since our gym class days. The day after she did it for the first time with an eighth grader on the boys' varsity basketball team, she told me all about it as we changed into our blue and white Jefferson Junior High polyester shorts and cotton T-shirts. "It hurt so bad. It felt just like a fist. Now I'm a woman. Why are you looking at me like that? I could snap you in half." I hadn't even asked.

This blast-from-the-past feeling is passing, but it reminds me of a subtle, yet important differentiation I've learned to make during my modeling career: I am half-*naked* in my undies, but I am *nude* without any clothes at all. I remain super-shy at the gym to this day, yet have no qualms about stripping bare, hopping on the model stand, and twisting like pretzel for upwards of three hours. Actual nakedness? I shy away. Nudity? No problem.

This may sound like mere semantics, but the distinction has significant real-life implications: there's a power that comes with nudity, a naturalness, and an intimation of public acceptability, as opposed to nakedness, which is more personal instead of professional, and for me is best kept private, and which leads to a slight but unmistakable vulnerability if someone happens to publicly see me in that state. As Carter puts it, "The nude, dressed up to the eyeballs in a lengthy art tradition, is clad in an invisible garment composed of generations of eyes." What I'm getting at, I guess, is that I like that garment; invisible or not, it provides a lot of protection, a lot of freedom.

Carter continues:

Of course, the whole notion of the 'natural' is an invention of culture, anyway. It tends to recur as an undertow in hyper-culture

times as some sort of corrective to the excesses of those who see
life as an art form without knowing what an art form is. But to
say that nature as an idea is an invention does not explain the
idea away. Clothing as anti-nature—as [. . .] distinction [. . .] can
be seen in action in any circus. It is amazing what a number of
non-garments—bridles, plumes, tassels—even the livery horses
wear, to show what degree they have repressed their natural desire
to run away. The relations between the non-garments of circus
horses and those of strippers is obvious: they are seldom wholly
naked either.

This passage is fascinating for a couple of reasons. For one, it's hard to
believe that it was ever in *Cosmo*. (The smartest thing in the issue on news-
stands at the time of this writing appears to be "You Sex Goddess! Crazy-
Ass Moves He Wants You to do to Him *There!*") But beyond that, it speaks
to ideas and experiences with nakedness and nudity that I've arrived at on
my own.

When I first started, I couldn't get that Robert Herrick poem out of my
head:

Whenas in silks my Julia goes
Then, then (methinks) how sweetly flows
That liquefaction of her clothes.

Next, when I cast mine eyes and see
That brave vibration each way free;
Oh how that glittering taketh me!

And that's how it is, how I feel in real life. I do most things dressed, but
I'm good at nudity, too. Each way free.

In the mirror behind the twelve-year-old Memory Palace version of
me—on the bed making out with some guy, actually—is Tammy, the so-
called slutty girl from our neighborhood growing up. She is wearing a
bikini secured by thin ties. She lived with her single mom in an apartment
(a sure sign for us dwellers in single-family homes of her familial lassitude
and moral dissipation), and enjoyed virtually no parental supervision
whatsoever, and thus entertained a cavalcade of older boyfriends.

She and my sisters and I and all the other neighborhood kids spent
countless hot Midwestern summer afternoons at Hobson, the public swim-

ming pool just up the block. The summers I recall best are embarrassing, Judy Blume-esque. Tammy, one year older than me and going into eighth grade instead of seventh, got to wear a two-piece. My mother forbade me to wear anything racier than a one-piece, and I agonized daily about having nothing to fill it with yet. (I sometimes sort of still do, even though I can currently wear two-pieces all I want.)

Tammy and one of her guys—Pete, I think; a high school boy, pasty with freckles and a greasy black buzzcut—would go down to the end of the pool, the five-foot depth, and stand there, where most of the younger, shorter kids could not go without submerging their heads. Tammy was tall and coltish, whereas I remained right at five feet and perhaps seventy-five pounds for what seemed like several interminable years. I'd hold my breath and swim around with my goggles on, the huge uncomfortable kind that suck, leech-like, to your individual eye sockets. Surrounded by the muffled, roaring silence of the unnaturally blue water, I'd watch them touching each other below the surface. He'd stroke her sides, drumming his stubby, bitten-nailed fingers up her watery pale ribs. She'd twitch, ticklish, beautiful and convulsive, presumably giggling in the air above.

I put this memory in my palace is because it is an image—of desire, of coveted maturity, of whatever—that has stayed with me for over fifteen years, and which will probably remain with me, in all its eyeball-flooding sensory overload, until the end of my natural life. I don't have a lot of memories like that—so visually acute, I mean—and this makes me think that maybe that is why I'm a writer, because my memories are more verbal, more wordy. If I had more visual ones, maybe I'd be a painter myself, a sculptor, a filmmaker. Maybe I'd be one of the ones making the images instead of the one sitting for them.

I include Tammy, too, because she showed me firsthand, albeit unwittingly, some of what you can do, what you can have, and how you can feel, if you have a body with which you are confident, one you are eager to display. Tammy is the kind of girl my mom was determined to prevent my sisters and me from becoming. Whereas Tammy's mom could not have cared less what her daughter did or did not wear, our mom tried to instill in us the value of modesty, going so far as to insist, when she took us back-to-school shopping, on buying our outfits a size or two too large, not because we would eventually grow into them, but rather because that way we could never be said to be dressed in anything "revealing." She wanted us safely wrapped and securely swaddled as we walked the school halls, shambling and shapeless, impregnable to stares.

I still can't decide if I wound up a nude model in spite or because of the way our mother raised us. Posing, for me, is not some kind of deep-seated antiparental rebellion. If anything, my mother (although I'm not sure she'd agree) has pretty much won; she's gotten what she wanted. I haven't turned into that kind of girl, running around half-naked; rather I am nude. And as John Berger tells us, "To be naked is to be oneself. To be nude is to be seen naked by others and yet not recognized for oneself [. . .] Nakedness reveals itself. Nudity is placed on display. To be naked is to be without disguise. To be on display is to have the surface of one's own skin, the hairs of one's own body, turned into a disguise which, in that situation, can never be discarded. The nude is condemned to never being naked. Nudity is a form of dress." More often than not, although I'm a nude model, I'm dressed; my mom needn't have worried.

Last but not least in the bedroom of my Memory Palace is another of the women my mother would be less than thrilled if I imitated, one who might make outsiders associate nude modeling with the low life. Sitting at my old desk, wearing a stolen fur coat over a torn evening dress, looking gorgeous and noirish as she smokes a cigarette, is Gloria Wandrous, doomed protagonist of John O'Hara's *Butterfield 8*. Describing her trans-formation from a damaged sexual abusee into a sophisticated call girl, O'Hara writes: "Gloria won out on her refusal to go to college and on studying art in New York [. . .] That year she talked a great deal about going to the Art Students' League, but each time a new class would form, she would forget to sign up, and so she went on copying caricatures when she had nothing else to do, and she also did some posing, always in the nude."

Here, as elsewhere, O'Hara uses Gloria's proclivity for nude modeling to signify her wildness. Later, as Gloria waits in a speakeasy for the arrival of her latest john, there is "Ludovici, the artist, who had several unre-touched nude photographs of Gloria which she wished she had back." There's that suggestion that the profession of figure modeling represents a slippery slope, as though once a girl agrees to take off her clothes for money, there are other things she'll be willing to do for cash given enough time.

Gloria tamps out her cigarette in a Coke can on the desk and reads the following—an anonymous letter sent to the real-life model Virginia Mortimer, who sat for the painter Everett Shin in 1928—aloud, rolling her eyes: "If you were a *real decent* woman, you would be ashamed to parade

your nakedness before any man, although you pretend he was impersonal when he painted you. Would your mother, father, sisters and brothers approve of your naked posing? They ought to disown you, for you are no better than a woman of the streets, in fact not as good, because they openly flaunt their shame and are paid accordingly, but you haven't got their courage, you tried to hide your shame and rottenness under the guise of art. I suppose you are intimate and have sexual intercourse with every artist you pose for, if you don't you ought to, because you can earn more money that way. As long as you're going to strip for the boys you might just as well *screw* them."

Like John O'Hara, my mother, and loads of other people, the author of this letter is missing the point. Virginia Mortimer is not parading her nakedness; she's parading her nudity. And very few models—at least the ones I know—sleep with any, let alone every, artist they pose for. To his or her credit, the letter writer is right on one count: if artists' models did get paid to have sex with their clients, they could earn a lot more money, but the thing is, that's not the job they've chosen.

I have to admit, though, that the idea that the two careers—modeling and prostitution—can be conflated is sort of understandable. Peter Steinhart points out that "From Greek antiquity [. . .] female models were exploited courtesans and poor working girls. Caterina, a sixteen-year-old prostitute, modeled for Cellini. In the eighteenth century, one of Francois Boucher's favorite models, Louise O'Murphy, was a *fille de joie*. The nude female models employed at the British Royal Academy in the eighteenth century were either prostitutes or women whose economic state left them desperate enough to make prostitution a job prospect."

This idea that only a loose woman would take up a career in art modeling lingered a long while. John Sloan, cofounder of the Ashcan School, had to remind his students "as late as 1939 that 'the important thing to bear in mind while drawing the figure is that the model is a human being, that it is alive, that it exists there on the stand. Look on the model with respect, appreciate his or her humanity. Be very humble before that human being. Be filled with wonder at its reality and life.'"

I appreciate Sloan's kind-hearted sentiment, but the way he expresses it sounds like a badly dubbed old movie: *Tremble, mortal! Be filled with wonder at my reality and life! Mwa-ha-ha!* I can never imagine saying something like that myself, either on the job or to someone—like the 1928 letter writer—who is confused about what my job entails.

Still, it can be hard to explain to people outside the art community how the job differs from that of, say, a stripper. For that reason, the last item I place in my Memory Palace bedroom is the cell phone on which I received the following text message from a guy I met—now a friend—during a signing at the bookstore of the Museum of Fine Arts on Memorial Day 2005. He typed to me on the keypad of his phone as he flew home from Boston to Atlanta: "Did i tell u we went 2 some providence strip clubs? Enjoyable: no. Skanky women, gross men: yes. Can u relate as a nude model?"

As I leave the bedroom and start walking up the stairs toward my Memory Palace's second floor, I think about my e-mailed reply. "I've only been to two," I wrote back, "and the men were pigs and the 'girls' looked bored and tanned. In fact that seemed to be the only requirement for working there—just to be tan and look all right under the lights." I could have written more, but I didn't want to be a pedant, or to freak him out. But I actually can relate, just a tiny bit, insofar as women who strip are objectified and so am I. The difference—and it's a huge one—is that they are transformed into objects of lust, whereas I am transformed into an object of art. I'm not saying that strippers can't be artful, or that artists can't desire their models, but given the context and intent of the respective performances, the jobs can only be slightly similar.

Unlike a stripper, I am not trying to titillate, to give a hard-on to, or to otherwise arouse my viewers. Most artists stand when they compose—there are no laps, and even if there were, there would be no lap dances. There are no drinks in the studios, no pulsing bass, no pasties, no G-strings, no towering boots. Also? I'm pale pale pale, like a fish or a mime: the opposite of tan. And? My boobs are real, but small; not big naturally, not big via implants. The similarities between my line of work and a stripper's are superficial at most.

Doug, the instructor of this evening's sculpture class, has in the past told me how problematic it can be when a model fails to realize this. Back when he was in art school, long before he came to teach summer session sculpture here at BU, he had to draw from a model who liked to undress like a stripper—slowly peeling away her street clothes to reveal, very gradually, enormous fake breasts, thongs, and piercings—and to behave as much like one as possible on the model stand. "There was an exhibitionist model that was so—she was hot—that it was distracting and I couldn't draw," he told me. "I had to move to the backside of her. And she was one to make eye contact. With that going on, I just could not draw her objectively. As a student, it was hard to deal with."

Because it's my Memory Palace and I can put in it whatever I want, I decide that on my way upstairs I should pass—wait for it—the nude from *Nude Descending a Staircase* by Marcel Duchamp. I want to consider why, to most people, stripping—with its added element of dance and motion— is considered worse, that is, more risqué, than static nude posing. Robert Hughes explains that one of the most controversial aspects of Duchamp's *Nude* resided in the fact that the nude was *descending a staircase:* "Its very title was ironic, almost insupportable. Nudes, in art, were not expected to move, let alone walk downstairs. They were meant to stand or lie still, to imitate the chaste condition of statues. It suggested decorum fractured almost to the verge of pornography, even though this nude had no detectable sexual characteristics—not that the public didn't try to find them."

With striptease, Ruth Barcan points out in her cultural history of nudity:

the dialectic between clothing and undress [. . .] is far more than an interplay between visibility and invisibility. Like all live perform- ance, striptease puts the mutual dependence of nudity and clothing into greater flux than more static arts like sculpture or photogra- phy. Although Roland Barthes stressed the aestheticizaiton of the stripper's nudity and hence saw the nudity revealed in striptease as ultimately chaste, other commentators see the *movement between* nakedness and concealment as at the heart of the eroticism. Mario Perniola, for example, speaks of this movement as a 'transit,' argu- ing that neither clothing nor nudity is erotic when it prevails as an absolute value; only the movement or transit between them is erotic.

Drawing on my limited experience posing semiclad or in motion, I can assert that this transit between clothing and nudity can also feel ridiculous. I once modeled for a Figurative Abstraction class in which Geri, this instructor, told my fellow model Renée and me that instead of posing in the traditional style, we were to "meditatively walk amidst the chaos" of the filthy, easel-strewn classroom.

"So we're supposed to intuit, interpret, and inhabit the space?" Renée asked, gamely.

"Yes, move very slowly and stop sometimes to react to the room, the students, each other. Renée, what you have on is fine. Kathleen, you can be naked," Geri answered, pleased.

Me? I stood there in my robe, socks, and sneakers, biting back the urge to reply that this was one of the stupidest plans I had ever heard. Although I hadn't given much thought as to why, I considered the dignity of a motionless nude body to be greater than that of a moving one.

Geri flipped on the CD player, and *A Song for You* by the Temptations flooded the room with the soulful, funky sounds of 1975. A job was a job, so I nudely skirted the circumference of the cluttered room, although unlike the unitard-clad Renée, I refused in any way to dance. Walking around, I thought of the early photographic experiments of Eadweard Muybridge—me in motion, me as stereoscope. I took my time, flipped through the stacks of student paintings lining the walls, studied the emergency egress plan posted near the lights, and when I stopped to build a precarious little tower out of splintery wood scraps, I warranted a "Good, good! Go with that!" from Geri.

Encouraged, I headed over to a table piled with Drake's Devil Dogs that someone had brought in honor of this being the last class, but I refused to eat one. I did stand briefly reading the nutritional information on the side of the brightly colored cardboard box: *Mostly-Naked Skinny Girl Contemplates Chocolatey Fat Bombs*. Geri liked this too, "What a funny tableau," she said.

"Minus the Temptations," she explained, "this is very much what salons in Paris were like at the turn of the century. Picasso would keep the models there for hours at a time, and sometimes he drew them, sometimes not. A lot of times they would just walk around."

By the end of the class, what had initially seemed like an affront had come to be no big deal. I felt no more exposed than I typically did at a regular, still-modeling session, which is in keeping with what Barcan concludes, that "regular and repeated public nakedness [. . .] must of necessity alter the body image [. . .] 'Feeling naked' is thus a complex matter calling into play such factors as the heightened perception of temperature and air movement, the loss of a familiar boundary between body and world, as well as the effects of the actual gaze of others." It's funny because in some sense, I went into this line of work out of a craving for the attention of others, but over the course of doing it, I've managed to become somewhat numb to that attention.

As I reach the second floor landing of my Memory Palace, I look around at the knickknacks I chose to place on the shelves here, objects with which

my parents chose to decorate our home growing up: the music box that played the theme from the movie *Love Story,* palms from Palm Sunday looped prettily behind the crucifixes Mom hung over everyone's beds, the statue of Saint Joseph, patron of carpenters and fathers, on my dad's nightstand, and the statue of Mary from my mother's dresser. Nothing about the art and imagery that my sisters and I were exposed to as children would suggest that I'd grow up to be a professional exhibitionist. Our family was and remains modest and Catholic; we were always very careful about never letting any of us see the others naked.

A number of my fellow models say that they were raised in homes where nudity was simply a nonissue, where the body was shown and seen with barely a comment. My household was not like that. The bodies we saw most frequently in various states of undress were those of Jesus on the cross every Sunday and saints in stained glass windows and oil paintings: Sebastian shot full of arrows on a prayer card, Saint Lucia holding her eyes on a plate, Agatha with her breasts cut off in my book of saints.

My parents were not obsessed with the body as sinful or shameful—rather, the body in our household was merely taken for granted. Obviously, we all had one, but we mostly pretended like we didn't. None of us ever got involved in sports beyond the occasional gymnastics or dance class offered cheaply through the Park District. We read almost constantly, played board games, hung out, went for walks sometimes, and talked, but we could easily have been a family of disembodied minds: mom, dad, and three sisters, five brains in five jars.

I am closer to my younger sister Beth than I am to almost anyone else alive. We shared a room for years, have many of the same friends, and got married to our respective fiancés on the same day, at the same place. Sometimes it feels like we can read each others' minds. Yet growing up, even she and I rarely caught a glimpse of each other naked. Changing into our pajamas at night, one of us would always dash off to the bathroom for privacy, which seemed normal at the time, but which a lot of our friends—who would dress and undress around us and their own siblings without a care in the world—found to be a point of intrigue and oddness.

After all those years of ritually guarded privacy, the first time Beth and I ever spent any meaningful amount of time semidressed around one another was when I went to visit her in Athens, Ohio, in the spring of 2004. A photography major at the university there, Beth lived in an old brick house crowded with neohippies, punks, and artists with a penchant

for mild drug use and a passion for themed parties. The weekend I was in town, Memorial Day, her housemates Carol and Elise had gotten it into their heads that it would be fun, liberating, and—to use their favorite word—*intense* to host a girls-only Topless Party.

They were so right. The TP was a small gathering, made slightly less intense and more mellow with pot supplied by Carol. There wound up being eight of us. We kicked out the guy roommates before we got down to the business of getting topless. Summer camp–style rumors circulated that they might try to sneak back and spy on us, though the relative impossibility of their gaining access to the second floor without our noticing kept us from being too concerned.

We gathered in the scruffy, vintage-chic living room for cheap red wine and boob-themed food masterminded by Elise: reduced-fat Ritz crackers spread with EZ Cheese and vegan pepperoni, strawberry shortcake cups piled high with Reddi-wip and raspberry nipples. When our tops came off to reveal eight pairs of breasts of assorted shapes and sizes, the strangeness lasted for approximately (we decided later) thirty seconds before it became comfortable, preferable in the sticky southeast Ohio night to lounge on the couches, eating and drinking, talking and watching television, like guys got to do any time they felt like it without anyone raising an eyebrow.

Surveying the decorations in my Memory Palace, I'm reminded of how, as Kenneth Clark observes, "The nude had flourished most exuberantly during the first hundred years of the classical Renaissance, when the new appetite for antique imagery overlapped the medieval habits of symbolism and personification. It seemed then that there was no concept, however sublime, that could not be expressed by the naked body, and no object of use, however trivial, that would not be the better for having been given human shape. At one end of the scale was Michelangelo's *Last Judgment;* at the other the door knockers, candelabra, or even handles of knives and forks."

I can just imagine my mom, had she been around at that time, forbidding the use of such items in her house. We were not permitted to watch MTV, play video games, view R-rated movies, or even to watch *Pee-wee's Playhouse* on Saturday mornings. We had to illicitly indulge in those things at the homes of our friends, afternoons after school, or, better yet, at sleepovers. Consuming such media went hand in hand with sneaking Lucky Charms and other convenience foods that were also banned under the Rooney roof. Mom was horrified when I let slip that I'd watched the

decidedly R-rated Demi Moore-Patrick Swayze flick *Ghost* at the tenth birthday party of my friend Tracy Rubenson. And she was thrilled with vindication when her suspicions about Pee-wee and his playhouse were gloriously confirmed: Paul Reubens was arrested in 1991 for indecent exposure in a dirty movie theater, outed as the porn-ogling pervert she'd always known him to be.

Speaking of perverts, there have been periods of time when art models have been perceived to be in the same league as Pee-wee. At the California College of Arts and Crafts in Oakland "even in the 1960s, the models were required to register with the Oakland Police Department, because local officials worried that the college was simply hiring prostitutes. Male models were still required to wear jockstraps." Fortunately, this is no longer the case. As model and self-published author of *Rollover, Mona Lisa!* Theresa M. Danna, points out, "despite the profession's checkered past, it's unlikely that the vice squad will be on your tail these days. But beware that some members of the general public still believe that modeling is a disgraceful job. Your services will be most understood and appreciated within the creative community only."

While I can't say for sure that my parents understand and appreciate the work that I do, I can say that they did something right. I've somehow turned into a reasonably well-adjusted adult, and could never have lasted these six years as a model were this not the case. Yet nothing in my upbringing or background appears as though it would push me to be positively inclined toward this job. Since I was raised neither by hippie nudists nor by repressive conservatives, there was no pressure pushing me toward modeling as a natural expression of my liberal upbringing, nor as a backlash against having felt restricted and forced under wraps.

Then again, nothing I have found in my research suggests that any artists' models—renowned or unknown—ever said to themselves, "I want to be an artist's model when I grow up." Peter Steinhart writes that, "There have always been noble and irreproachable women who happily modeled nude for famous artists," going on to list Simonetta Cattaneo, sister-in-law of Amerigo Vespucci, who posed for Botticelli; the Duchess of Urbino who posed for Titian; Helene Fourment, who married Rubens and posed for over nine thousand of his paintings; Rembrandt's wife Saskia, and later his servant and mistress Hendrickje Stoffels; as well as the wife of Henry Moore. "A woman whose character was above reproach was more likely to model for an artist of fame and fortune," he continues. "But

most of the models in history worked only for artists-in-progress, and there it was a different story." Regardless of whether they wound up becoming muses and later wives to famous artists, or whether they posed only for artists whose names are lost to us now, most models found themselves doing that job out of circumstantial need or happy accident.

Like the aforementioned models, I never aspired to be one either, although looking back now, I can pinpoint the first time the fact of such a job's existence crossed my young mind. I proceed through the landing to the next room of the Memory Palace: the family room. Wood-paneled with stain-resistant, neutral carpeting, golden-glass shutters, a large color TV in a light wooden hutch with a folding screen to close when the set's not in use, and an ominous door leading back into the laundry room, this space is a replica of the family room in the basement of our home in Illinois where my parents still reside. It is in this room that I saw the episode of the sitcom *Growing Pains* that you could argue literally changed my life.

I have *Growing Pains* to thank for introducing an eight-year-old me to the notion that the nudes we see in art originate, in most cases, with real people with real lives. I haven't seen the show in ages, but the image in my head is that of an attractive blonde woman preparing to disrobe in front of a smallish roomful of visual art students, much to the shock and chagrin of Mike Seaver, played with extreme agitation by the boyish Kirk Cameron. Memory, as Giulio Camillo would hasten to remind us, is unreliable: before I had a chance to check my facts, I assumed that the character in question must have been Julie Costello, the Seaver family nanny and Mike's girlfriend, who appeared on the show briefly from 1989–1990. Julie was played by Julie McCullough, Playboy Playmate of the Month in February 1986. She was stripped (ha) of her crown as Azalea Queen of Wilmington, North Carolina's Azalea Festival because of her appearance in the magazine, so I figured that since the show's writers let her go by her real first name, they might also make a nod to her original career.

But eventually, in my hunt for this episode (God bless the Internet) I learned that the nude model character was not Julie Costello at all, but rather a character named CJ, played by Trisha Leigh Fisher, sister to the better-known Carrie. The episode entitled "Nude Photos" originally aired on Wednesday, November 30, 1988, on ABC, and in it "Mike's photography course includes nude studies." The embarrassment attendant upon situations involving live nude girls, even those who are nude in the name

of art, is pointed up by the Web site fortunecity.com, which summarizes: "Mike has won a prize for a photo he has taken for the photographer's course. But he doesn't like to talk about it, it's embarrassing [sic] for him. Visiting the exhibition, his parents now [sic] why . . ."

The discomfort caused by this fictional setup has spilled over, in at least one instance, to real life. For a while this episode was always skipped when reruns were shown on CTS, a Christian television channel in the Toronto area, although as of October 2004, "CTS has decided to air this racy episode instead of skipping it." Looking back, this controversy seems like much ado over very little, especially as any nudity is only ever-so-slightly suggested. According to tv.com, "In the part where CJ is getting undressed, we see a far away shot of her where she is completely naked behind the screen, but when we close up on her, she is wearing her shirt again, unbottoning [sic] the same buttons as before."

While the episode really didn't show that much, it made a lasting impression on me. After that I knew that nude modeling was a job that people could do, a job that might arouse a bit of discomfort, as evidenced by Mike's vehement reaction, but that was ultimately shown to be perfectly acceptable.

Or at least perfectly acceptable to clear-thinking people. An interesting footnote to the story, according to the Internet Movie Database, is that, "Between the 88–89 season cliffhanger and 89–90 season premiere, Kirk Cameron had a religious awakening and demanded that Julie McCullough's character of Mike's fiancée be written out of the show because of McCullough's real-life Playboy Magazine past." Jerk.

The next time art modeling really crossed my mind post–*Growing Pains* wasn't until college. My art-major friends would share stories about having drawn from the model. Honestly, though, they talked more about having crushes on their attractive teachers than on anything in particular about the other people in the classes or the people they drew.

Then one evening toward the end of sophomore year, my best friend Clark and I were sitting in the room he shared with our friend Jack on the sixth floor of Francis Scott Key Hall. We were hanging out before going out, surrounded by early summer air, twilight, and boxes, drinking Heinekens and talking about moving, since the school year was at an end. The conversation shifted and Jack's girlfriend, Suzie, talked about her day at work as a nude model in the George Washington University art department. (She attended Georgetown, so she could work at GW with no risk

of embarrassment or recognition). "They think I'm cute!" she said with the self-satisfied little-girl chirp and smug smile that Clark and I made fun of behind her back. Fair enough: she was cute.

Then I thought to myself, *But I'm cuter.* And although I wouldn't begin posing for over a year, this was the first time in my young adult life that art modeling registered with me as an acceptable means of earning money, a job that nice, normal people can and do do.

Not that everyone would necessarily agree with my application of the words nice and normal. There have been occasions where people have seemed eager to employ words like "kinky" and "desperate" and "not too bright." In fairness, some of these descriptors would be apt for models I've met, but for every kinked-out wannabe stripper I run into, there are a dozen down-to-earth, intelligent, confident models who have decided to supplement their incomes with what can be a fulfilling and satisfying second or third job.

And this debate over the acceptability of offering nudity for money leads me to the next room of the Memory Palace: the kitchen, because it was in a kitchen, or rather, in Zander's Café in Downers Grove, Illinois, where I took my mother to lunch to soften the blow of my coming out to her as a nude model. My mom is in the kitchen, sitting at the table, and so is Madonna, because she used to be an artist's model before she hit it big. Depending on who I'm talking to, this Fun Fact either makes my means of supplementing my income through nudity sound more legitimate or increasingly unseemly.

Writing about photographer Lee Friedlander's *Nudes*—which, incidentally, includes four semi-identifiable shots of Madonna—Vicki Goldberg states that the explicit pictures "don't embarrass me, nor do I see anything wrong with male curiosity about female anatomy, but no doubt some will think these pictures exploitative and/or pornographic, two words that increasingly elude a consensus definition." She wonders, as I do, about the "double issues of the photographer's intention and the viewer's reaction." How was an image made; how will it be seen? What does it matter if the creator is no smut-monger, if that is how an audience insists on seeing? Goldberg concludes that "as to intent, Friedlander's art credentials were impeccable and his models were consenting adults, fully aware of what was visible between their legs when they parted them, and so far as I can tell entirely undamaged by the images." This all sounds

OK. But the phrase "consenting adults" seems to imply that the act being consented to is a disreputable one.

This is definitely what my mom would think, and this is why I kept the truth from her for so long, over two years. Although my sisters knew, I lied to both of my parents about it—lies of omission mostly, which seems to be the preferred tactic among my fellow models who have also felt the need to keep their job hush-hush. My friend and fellow model Bruno, the one I helped get into modeling in the first place when he was looking for something to supplement his income as a security guard at the Museum of Fine Arts, told me: "Some of my relatives in Portugal, I don't even tell them, because they'd be like, 'Why are you doing that?' Older relatives [. . .] I don't think they see it as anything obscene and it's not that they disapprove, I just think it's not something that most people think about. I think in that way, some people might get the attitude that if you're posing nude for a little extra money, then you could do other things for money."

There it is again, this conflation of selling images of your body with actually selling your body itself. Interestingly enough, as Theresa M. Danna points out, "Historically, modeling for artists has been considered by those outside the art community to be a lowly profession—even lower than prostitution. It has been reported that a young girl in a French café who agreed to pose for a painter insisted, 'Don't tell my mother, she thinks I walk the streets.'"

It is also reported that on the other side of the channel, in England in the 1880s, slightly before the aforementioned influx of artists and models in Paris, "at the very time that female artists were gaining greater access to the living model, the crusade to ban the professional female model was at its height. Campaigners, we are told, trawled the streets in order to reform those women who earned, stated the *Times,* one of 'the most pitiable sorts of female wages. Not alas! The most pitiable of all, but one too often adopted as the only practicable means of escape from a still worse alternative.'"

"My parents don't mind at all," Bruno continues. "I think my dad is kind of into it, he finds it intriguing. Nevertheless, it's not something that most people do, so it does end up being something different. I've never been the one for normal-type jobs, and if they know me, they know I don't do things that normal people do. They kind of expect it."

Unlike Bruno's, my parents would never have expected that I'd take up such a job. Eventually, because modeling took up so much time and made

me solvent in a way that would otherwise have been impossible to account for, I lied more seriously, claiming I worked as a tutor, a classroom aide of sorts, a statement which was not, strictly speaking, untrue.

My mother in particular began to suspect. When I finally told her, there over enormous salads and iced tea in Zander's Café, she offered to give me money if I was really so needy, if I really wanted it so badly. I wasn't and I didn't, and money was never the whole point anyway. I wouldn't stop posing now even if I weren't rent-obsessed and close to collapsing under student loan debt. I keep posing because of the money, sure, but also because I like my job, sincerely and deeply in a way that I am terrified that most other people do not like theirs. Posing helps me to think, helps me to write, and is virtually the only time when I hold still and walk meditatively around the landscape of my mind; otherwise I tend to be fidgety, multitasking, preoccupied beyond compare.

My mom, like any good mom, has what she perceives to be my own best interests at heart. She worries that I'm being used, taken advantage of—a naked girl putting her good name and reputation on the line. I disagree, and refuse to perceive the way in which I sell myself as being any more morally dubious than the multiple other ways in which each and every one of us sells ourselves every day, as job-seekers, as valued employees, as human commodities. If anything, I tried to explain to her, my way of selling myself is more honest, less potentially damaging.

Also, I won't work if the price offered by the artist is too low, because then it can feel a bit too close to Mardi Gras, like I'm showing my body off but not receiving much of value in return, like maybe it's worth neither the effort nor the exposure. Then again, this comparison might exacerbate Mom's objections as opposed to assuaging them, so I kept it to myself.

She took the news stoically, hands in her lap, lips pressed tightly together, like she was trying not to say anything too critical, trying to let her adult daughter do whatever she wanted with her life. But I could tell she was unhappy.

"At least I'm not pregnant," I offered.

"I'm not a drug addict?" I tried.

"Um, at least I'm not telling you I've got an STD?"

"Why are you doing this?" she replied, not having it.

I tried to explain to her that, despite its superficial appearance of tawdry immodesty, art modeling was a legitimate career. Despite the popular past association of art models with depravity, in the twentieth century, it actually became kind of glamorous.

"It doesn't sound glamorous, Kathy, it sounds dirty."

I tried the religious route. "Think about David, Mom. Think about all the amazing nude art in the Vatican."

"David didn't have a mother," she said. Touché.

Finally, I tried to explain to her that for a while, in Paris in the early 1900s, figure modeling was actually a family affair. Whole—presumably good Catholic—Italian families earned honest livings that way.

By then, she was in no mood to split hairs and was as satisfied as she would ever be about what I could tell she hoped would be just a phase. We finished our salads, I settled up the bill, and we stepped outside into the Midwestern false spring. That was it, the last we said about it.

The final item I place in the Memory Palace kitchen, behind Mom and Madonna, to the left of the refrigerator and almost its size, is a naked female torso. The torso is by Doug. In reality, it resides in his childhood bedroom in his parents' house back in Missouri, because it is so big and because city living affords limited storage space for such extra-large art objects. Once, when he came home for the holidays, he walked in to find that someone had snuck in and dressed it in a T-shirt, emblazoned—without any hint of irony—"The Show-Me State."

"Now you know it's bigger than lifesized," he told me. "And the shirt is skin tight. It's like a wet T-shirt contest. Nipples popping out. And I ask my mom how this happened, and she said 'Your father did that. We had nieces and nephews over and he covered it up because he didn't think it was appropriate.' And at that point I made her step back and really see it. The statue's butt was hanging out. 'Let's remove the shirt,' I told her. 'There's nothing here. It's nude, but I don't think it's naked.' And then I had a long talk with my mom about the difference. And eventually I think she got it. Not with my dad, though. I just teased him. I'll never change his mind. To him, having clothes on it makes her less suggestive. There are so many times I've run into this kind of thing."

Me, too. I don't even try to explain what I do to any of my older, non-nuclear relatives. My mom has made me promise expressly not to tell Granny, and honestly, I've never been tempted. It's not that I think my aunts, uncles, and grandmas couldn't handle it—maybe they could. I just don't feel like having to start from scratch with the task of explaining myself, over and over, like I'm teaching a class.

If I were, though, I'd be sure to include Erika Langmuir and Norbert Lynton's definition of the difference in *The Yale Dictionary of Art and*

Artists. The nude is "a form of representation which is of special importance in the history of western art, having become in Graeco-Roman antiquity a prime vehicle of idealization. A nude differs from the representation of a naked human being *(see* e.g. *under* Pigalle*)* in that it suppresses individual resemblance and particular circumstances in favour of harmonious, or abstract, design and timeless generalization."

When we do, as they suggest, *see* e.g. *under* Pigalle, we discover more about the distinction between nude and naked, general and individual: "Pigalle, Jean Baptiste (1714–85) Leading French sculptor [. . .] His work is distinguished by its vigour and naturalism—most startlingly evident in his full-length statue *Voltaire nu* (1770–76) in which he depicted with the sagging muscles, stiff joints, and wrinkles of old age—in other words, 'naked' rather than classically 'nude,' and was posed for by an old soldier."

Over the course of my own career, I've been depicted generally far more often than specifically. It's fascinating to me, the way that men are more often depicted nakedly—as individuals or specific figures—than women, who are more often simply nude. Barcan asserts that this happens because "Female nudity is paradoxically both more 'natural' and more 'artistic' than male nudity. Female display is, likewise, able to be considered both more 'normal' and more 'pathological' than male display."

Part of this inequality may be a result of the fact that, as Peter Steinhart explains, "Live female models may have been hard to come by. Michelangelo's figures of Night and Dawn on the Medici tombs are females drawn from male models, the artist afterward simply adding breasts." Barcan corroborates that Michelangelo was hardly alone in this practice of slapping boobs on men and calling them women, for regardless of reputed sexual preference: "Renaissance artists often used male models even for female figures."

As recently as the spring of 2005, when I was signing up to pose for a class offered by the Boston Center for Adult Education, Basil, the coordinator, surprised me by saying they had plenty of male models, but that they were constantly looking for women. "I am always in need of female models, men are much easier to find," he said.

As Steinhart observes, "Artists have seldom had difficulty finding male models because males have traditionally posed in heroic and dignified postures, and there have always been athletes and soldiers who were proud of their bodies and happy to accept the affirmation offered by artists seeking to memorialize their grace, strength, and confidence. Victor Hugo cheer-

fully posed nude for sculptures, as did, at the age of seventy, Voltaire. But female models have only recently overcome a long-standing perception that they were women of ill-repute."

While I know that my evidence is largely unscientific, I have found that the women with whom I have posed are far more conventionally attractive than the men. I have encountered my share of big-is-beautiful girls and older women who sport their excess and/or sagging flesh with grace and dignity, but for the most part, these women's bodies are fairly well within the parameters of what "attractive" women look like—thin, graceful, shapely, and so forth. The men, on the other hand, tend to have a kind of love-me-or-leave-me, take-me-as-I-am attitude. Or they don't even seem to realize that such an attitude may be appropriate, so sure are they that they are hot hot hot, despite gut, paunch, hairiness, or sag. I'm not saying that we should not admire and respect the human body in all its many and varied forms; the greater diversity of body types and ages of models there are out there, the better served both the artists and models will be. But I have noticed that men seem to be more comfortable with their bodies, less concerned with being objectified or criticized for their appearance, less concerned with having their worth located only in their physicality—more confident, in short, that their individuality will not be effaced in the process of representation.

Done with the kitchen, I move to the last room, the attic at the top of my Memory Palace. The floor is splintery, the ceilings sloping, and the wall contains one small, dusty window, the light from which illuminates the single adornment to the otherwise empty room: a picture of me, made by a stranger, one of the only images of myself that I have ever been offered and accepted, and one of the only ones that I feel depicts me truly naked.

Unlike most of images of me, this one came as a total surprise. I hadn't sat for it; it hadn't been made while I was actually modeling. I was in Charlotte, North Carolina at the time, giving a reading from my first book at an indie bookstore on a sultry Saturday afternoon. The *Charlotte Observer* had run a notice about the event earlier in the week, along with a photo of me taken by a friend of a friend. When I arrived at the bookstore, there was the usual smattering of people holding copies of my book, waiting to attend the reading, but so too was there a quiet, nervous-looking man shifting from foot to foot, clutching a white plastic shopping bag. When the appointed time rolled around, I approached him.

"I'm about to head back and start reading," I said. "Are you here for the signing?"

"No," he replied. "I'm not. I just stopped by to give you this."

He handed me the bag. I thanked him, surprised, and then he was gone. Inside the plastic was a portrait of me, drawn from the picture in the *Observer*. Paper-clipped to the mat was a handwritten note: "Ms. Rooney, Please accept this sketch as a gift. I look for lovely, sensative [sic] features in a face. It was a pleasure to draw your picture."

The sketch was so pretty it nearly broke my heart. He had never met me—hadn't even stuck around to talk to me—but somehow, he managed to capture something ineffable. His gesture was so sweet, so unexpected, that it made me get sniffly in spite of myself on the shuttle back to the airport. I sent him a nice note. All I said, really, was thank you, because how could I possibly explain that he had drawn me naked, exposed, even though I was in clothes? That he had drawn me for me, as an individual, as opposed to an object or mannequin?

Ruth Barcan writes, "Bareness and nudity are not the same thing; bare flesh is not always naked. Can an elbow be nude? Or a face?" I wouldn't say that a face can be nude, but in this portrait, at least, mine was naked, absolutely.

I keep the portrait in the bedroom that I share with my husband, and when we look at it, trying to figure out how this artist managed to do what he's done, to show the Real Me, whoever she is, we decide that it comes down to the eyes, and that old cliché that they reveal something of our souls. The Greeks thought so.

As much as we are instructed not to judge a book by its cover, I think external appearance really can convey important information about what's below. My sister Beth and I try hard not to be shallow, but if someone is mean and nasty and hateful, and perhaps also ugly, we exult in declaring: "The outside matches the inside." This portrait makes me think of that match. This artist drew me as he saw me, which, through weird coincidence, is how I'd prefer to see myself at my best, how I'd like to think most people are, or could be: nice, pretty, candid, and in harmony.

But enough of that. I close the door to the attic and leave my Memory Palace behind. It's hot in the sculpture studio, even hotter now because Doug has come up to the model stand and is passing a bright light over my body and face, waking me from my thoughts and bringing me back to myself. The class is almost over and he wants the students to see the form

changes in sharper relief—the shadows that indicate where one bit of bone structure transitions into another.

The time runs out. It's nine o'clock and I'm free to go. I'm nude on the stand, until I hop up, and then I'm naked for a few seconds, in motion, walking to my bag, picking up my clothes. I put on my bra and my shirt, no longer topless, and I walk fully clothed into the humid night.

chapter two

Would You Like Me to Seduce You?

This is a story about love, or something like it.

Pliny the Elder tells us that the smitten daughter of the Corinthian potter Boutades invented the art of making portraits. Enamored of a young man who was leaving for a long voyage, she sat him down in front of a glowing lantern. Leaning past her lamplit lover, she drew a line around the shadow his face cast on the expanse of wall behind him, thereby providing herself with an image to treasure when he himself was absent.

She is sometimes known as Dibutades out of a confusion between her own name and that of her father, but she is more often known simply as the Corinthian Maid, thus guaranteeing, as so often happens in these early histories, that the man gets full credit for his invention while the woman gets only anecdotal mention. Although this story would seem to be about the origin of drawing, Pliny includes the tale of this resourceful young woman in a chapter on sculpture in his *Natural History*. For after his daughter created the likeness, Boutades pressed clay onto her line drawing, making a mold to fire into a portrait relief along with his pots, and, as Simon Schama points out, "wrecking, one imagines, the delicate shadowplay of his daughter's love-souvenir."

If the Corinthian Maid's long-gone paramour was one of the world's first artist's models, then I suppose that I am his latter-day descendant, at least in spirit if not in circumstance, as I stand here dressed to kill in an outfit I would never normally wear in polite company: a tight, sheer sweater, a wristband-sized miniskirt, and white fishnets, all atop tall knee-high boots

with teetering spike heels that thrust my hips from side to side, my breasts forward, and my butt back. This getup is not in honor of the impending Halloween weekend, but is rather my work attire. I am in the Sydney and Esther Rabb Gallery of the Museum of Fine Arts in Boston. I am not candlelit and being drawn by a single loved one, but instead surrounded by impressionist masterpieces and amateur artists. The masterpieces hang on the walls, holding as still as I do, while the artists sit in a ragged semicircle, concentrating for the most part on drawing me.

Their attention is surprising and pleasing, because posing with me at tonight's free Drawing in the Galleries is Norah, who is as buxom and curvy as I am thin and willowy. A student at the Museum School, she's been a fixture of this event for months, whereas tonight's my first time. Both of us normally work gigs where we pose nude, but the museum's a public place, so we each have to wear *something*. The rule here is pretty much anything goes, as long as you don't reveal those forbidden bits that would be blocked out by a censor's thick black bar. No genitals and no nipples: the rest is fair game. Most models keep it a bit more tame, but for some reason—although we didn't confer beforehand, and we barely know each other—we have both dressed more provocatively than is common at this particular program. Norah's doing this thing in only a thong and a scarf, the latter of which she somehow manages to keep wrapped discreetly around her considerable breasts, shifting and twisting and rewinding it about her chest with each gymnastic change of pose. Words can scarcely describe how much this impresses me, like she's a juggler, a magician, or a carnival act: Norah No-Nipple and her Spectacular Shawl Tricks! Step right up, folks, and it's safe to bring the kids!

As the name suggests, Drawing in the Galleries encourages museumgoers to grab some complimentary paper, sit down on a folding stool, and draw in whichever gallery happens to contain supplies and a model. Together, Norah and I work the room like pros. It's too bad people aren't allowed to tip, because we'd be raking it in. My sister Beth, a photographer who used to work in a suburban portrait studio specializing in corny yearbook photography, would call all my poses "Attitude Shots." This makes me stifle a laugh. I am hardly myself. I am someone else. Someone braver, brassier, more risqué—devil-may-care and icy hot.

Across the room, through the climate-controlled air, hangs Renoir's famed *Dance at Bougival*, in which a whirling couple spins at an outdoor café. "The woman's face, framed by her red bonnet, is the focus of atten-

tion, both ours and her companion's," states the plaque that I wander over to read on my break. I can relate. Even more absorbing, though, as I stand there, trying to pass the time, is Degas's bronze and gauze sculpture, *Little Fourteen-Year-Old Dancer.* Both young women are the center of everyone's gaze; they are both on display, yet in some way in their own worlds. At first glance they look flirtatious, revealing themselves for the admiration of others, yet they are each holding back—seduction as dance.

One man in the crowd is drawing me more intently, more adeptly, than any of the rest. He keeps making these compelling charcoal sketches of my ass, which might normally creep me out, but these studies are *good.* As the three hours pass, I try to keep my poses equally distributed, but I find that I keep bringing myself back to him.

Sometimes, when I'm working for a roomful of strangers, I'll secretly play the staredown game, the one where you gaze deeply into someone's eyes for as long as you can to see who jerks their head away first. Usually I win; the artist gets flustered. Psychoanalyst Darian Leader discusses this reaction using the example of commuters on the subway. "Many travelers," he explains, "pass their time covertly surveying their fellow passengers, often extending their surveillance into sexual fantasy. They might daydream of an exchange of dialogue, of phone numbers, a burgeoning romance or sexual passion. When the object of their reverie gets off the train, they might feel a momentary sadness, the sense of lost opportunity. But this sadness is nothing compared to the feelings of anxiety if the other person not only looks back, but fixes your gaze." True enough. But why? Because "when we desire in the visual field, we expect that the object of our desires remains just that, an object. The problems start when what is supposed to be a passive object shows that it is also desiring [. . .] Someone else's desire makes us anxious to the extent that we don't know what it is that they want."

But this guy is not flustered. He does not drop his eyes, or hasten to sketch Norah instead. He meets my gaze, eye to eye, and starts a study of my hair, my face. His hair is dark brown, cropped, and looks as though it would be curly if he let it grow longer. His face is smart, serious, with lips that press resolutely together as he concentrates. He has deep brown eyes. It is a contradictory face: tired and alert. A young-old face, boyish with the hint of a much older man, an innocent face mixed with experience. His posture is perfect, his carriage near-military. I will learn later that he is a man of immense discipline and self-taught restraint.

At nine o'clock, Norah and I are off. As a Halloween lark, and because I'm late to meet friends, I decide to stay in my present outfit, tossing on my scarf, my coat. I'm slower than usual because of the vertiginous boots. Footsteps squeak along the marble behind me, and when I turn around, it's him, the guy from the gallery. We are the same height, but not the same age. I will find out later he is seven years older.

"Hi. I'm Jeremy," he says. "What's your name?"

This happens a lot, during or after I've been modeling. People pull up like magnets, approach me to ask if I ever model privately and could they please hire me, or if I would like to go out with them to get dinner or a drink sometime. Often they mean the second thing even though they claim to be asking the first. Jeremy doesn't ask either, just starts to chat as we find we're both making our way to the T.

We wait for the inbound E Line together, talking about his construction company, my teaching. The trolley arrives, and as it lurches away from the stop, the two of us sitting together in a dingy bench seat. I hear an older female voice say, "Jeremy? What are you doing here?"

The woman glances at me pointedly. Is he still living with his girlfriend? she wants to know. And how is their daughter? Yes, he is, Jeremy says, and yes, she's doing fine. It feels like the two of us have just been caught, discovered at something. He has a girlfriend and a kid. And I have a boyfriend. But are we really doing anything that requires them to be mentioned?

The woman gets off one stop before mine at Copley, named for an artist. "Anyway," Jeremy says, "I have this studio up in Somerville, and I'd really like it if maybe you could come pose sometime."

"Yeah, sure. Definitely," I say, taking his phone number and e-mail address, while handing him mine, stepping down the stairs, and waving goodbye.

"According to the mythology," declares Lynda Nead in her book *The Female Nude,* "the artist's female model is also his mistress and the intensity of the artistic process is mirrored only by the intensity of their sexual relationship. This sexual fantasy has been so prevalent in the narrativization of the lives of male artists that its traces are now indissolubly attached to the image of the life class."

No wonder Jeremy and I had a hard time deciding if we'd been caught at something. Professional though contemporary artists and models may

be, we have our profession's history working against us, pushing artists—at least residually—to view their models as muses, and models to view their artists as would-be lovers.

As Francine Prose explains in her *Lives of the Muses,* after the Renaissance, notions about the source of artistic inspiration underwent a radical change from the divine to the corporeal, from the Lord above to the earthly lady. "In severing Eros from Agape, Christianity dug a chasm between religious and secular art," she explains. "There *were* no deities to oversee the lyric, the love song, the dance. Another source was needed, an alternate explanation for creativity—for what cannot be summoned at will and seems beyond the artist's control. [. . .] And since falling in love is the closest that most people come to transcendence, to the feeling of being inhabited by unwilled, unruly forces, passion became the model for understanding inspiration. Why does the artist write or paint? The artist must be in love."

Breaking it down even further than that, Paul Karlstrom, a California-based art historian and author of *Eros in the Studio,* tells me in an interview that, "In some ways it's pretty simple. Boys like to look at girls."

And in answer to a question I posed to him long after the fact, Jeremy admitted, "Why did I start? Well, partly I knew it was the tradition, a way to learn. And it was exciting and interesting. Partly, definitely, there was a sexual element, especially at first. Like, nudity: the *verboten.*" But he went on to add, as did Karlstrom, that there's more going on in the artist-model relationship than garden-variety voyeurism or the long-shot hope that one's sitter will turn out to be easy. The significance of the live model cannot be sufficiently encapsulated by the statement that everyone likes to gawk at naked ladies. For one thing, not everyone does. Not to mention that it could be cheaper to go to a strip club for a couple of hours and stuff a few dollar bills into G-strings than it would be to shell out my seventy-five dollar fee for the usual three hours' worth of posing. And it would be a much surer thing to call an escort service and be guaranteed a lay for an outlay of cash than it would be for an artist to hope that he or she will get lucky with his or her model. You could go to a peep show and see open poses with far more frequency than you ever would in a life drawing session.

The sculptor Alberto Giacometti, for instance, was "an assiduous frequenter of bordellos;" he enjoyed both models and whores, but did not perceive them as serving the same purpose. As his friend Jean Genet

recollected: "He is sorry that the brothels are gone. I think that in his life they took—and their memory still takes—too much room for us not to mention them. It seems he entered them like a worshipper. He went there to see himself kneel in front of an implacable and distant divinity. Between each naked whore and himself, there was perhaps this distance which his statues constantly establish between us and them."

Over a century earlier than Giacometti, the painter Eugène Delacroix pondered how the services models and mistresses provide may sometimes overlap, but are better kept separate: "I go to work as the others rush to see their mistresses, and when I leave, I take back with me to my solitude, or in the midst of the distractions that I pursue, a charming memory that does not in the least resemble the troubled pleasure of lovers." If, as he says in his journals, he occasionally slept with a sitter, he regretted it instantly as a waste of vitality better spent on his work. He rues of Hélène, a pretty model, that "she has taken away part of my energy for today [. . .] In truth, painting harasses and torments me in a thousand ways, like the most demanding mistress."

In any case, the artists I've worked for prefer not to sleep with their models, but rather to go the sublimation route. Darian Leader writes that the classical view of the concept of sublimation "goes something like this: sublimation is about a drive that has been diverted from its sexual aims. Instead of fucking, you go and paint a picture instead. [. . .] The energy that would have gone into sex goes into something tamer, more social."

Still, you need only spend the tiniest amount of time scanning your city's Craigslist to see that life drawing, or the imitation of it, tangles with sex in many people's minds. Some of the ads calling for figure models turn out to be legitimate, but many do not, using the call for a model instead as a means of soliciting a prostitute or acting out a fantasy—finding a partner with whom to role-play. Ads with titles like "Be My Muse" surface periodically, like ghost ships drifting among the other classifieds.

Sometimes when I do my job it's just a job, but often I'll make a connection that's something more. These close, contemporary artist-model relationships are not defined by sex or by romance. Yet they're intimate—intense and exciting in a way that a normal friendship could never be, since you rarely if ever see your good friends naked, and you certainly don't sit stock still in front of them while they study your every line.

This uncertainty—this notion that the artist-model relationship is neither friendship, nor sex, nor love, nor anything we really have a word for—

is why, when Jeremy e-mails me shortly after that night at Drawing in the Galleries, I am eager to see what will happen. We set up a Saturday session in early November: a flawless fall morning, blue and clear. I take the Red Line to the Porter Square stop, then call his cell. He will not give me his home phone number—or an e-mail address that includes his real name—until just before he moves away, before I stop working for him entirely.

Seeing someone's studio is like being invited up to someone's apartment for the first time, and although Jeremy is subletting his from another artist in a building full of other artists, the space already seems uniquely his—an extension of him, inviting but private. It smells piney, and the coarse hardwood floors are neatly swept. The walls—partitions, really, that don't go all the way up to the ceiling—are hung with his work and the work of others he hopes to emulate. A self-taught realist painter from Brooklyn, Jeremy turns out to be a devotee of John Singer Sargent and Lucien Freud. He likes to make paintings that look good, but he doesn't like to lie. If the images of the other models from whom he has been working are any indication, he is not forgiving. He paints people as they are.

Unlike other artists I've worked with, Jeremy does not insist on perfect silence or stillness on the part of his models. He likes to talk to them, to come to know them gradually, which is lucky for me since all I want to do is ask him questions like the ones he's asking me, so I in turn can assemble a more complete picture of him.

His father is wealthy. His mother is dead. She used to be an editor in New York City, and his dad is still a dealer, running some kind of art gallery. Jeremy had been around art his whole life, but it had never really occurred to him to take it up until recently. Maybe it had something to do with mortality, he muses, his thirtieth birthday, his need to do something creative with his life, and to leave more of a legacy. His construction company, he says, pays the bills, but doesn't fulfill him.

I get to see Jeremy naked before he sees me. Not unlike a first date, where you sense a definite chemistry but don't want to scuttle it by moving too quickly, Jeremy has insisted that I remain dressed for this, our maiden voyage, our first collaboration. Our first time, he said on the phone when we set this up, should involve, he thinks, our clothed cooperation. "Not to worry," he says when I arrive and he sees me eyeing up all the nude portraits adorning his walls. "We'll work our way up to R from PG."

One of the nude portraits is of Jeremy himself, and though I try to pass it by at the same rate of speed as I do the others, the nine-by-thirteen piece of unframed canvas holds my attention and I let myself linger. He is

good-looking. Very. In the picture just as he is in front of me. The painted Jeremy has the same frank face that he has in real life, the same candid bearing, same broad shoulders, and, one imagines, though one cannot confirm at this point, the same nice dick.

"I thought that'd be a neat trick," Jeremy says, coming up behind me, following, wryly, my line of sight. "Trying a nude self-portrait. I was afraid to hire models at first. I get shy. And they can be weird. And I thought I should know what it feels like to have that done to you before I tried to do it to anybody else."

His empathy is one of the reasons, I will come to realize, that he and I are able to establish such sympathy; why he is a painter and why I am a writer. We are drawn to—but baffled by—the experience of other people, thwarted by our inability to ever know what it is like to be someone else, but compelled by the duty we feel as humans to at least try.

"I just started painting earlier this year, so I'm still pretty new at this," he explains as we get the pose set up. This seems unbelievable, I tell him, because he is so obviously talented. I tell him I am new at this, too, relatively, having only been at it a year and a half. Lots of models I've met since moving to Boston from D. C. have been doing it for ages.

He shows me where I'll be standing and begins to set up his easel.

"Sorry I'm not more prepared," he says. "I had a job this morning that went long. I'll be set up in advance next time, so we won't have to wait."

As usual at the outset of a modeling session, I am wracking my brain trying to think of a pose that will hold his interest, but that will not be hard to hold. While he lays out his paints, I throw some practice gestures. Thinking he isn't watching, I'm surprised when, from across the room, he discourages them.

"Don't feel like you have to wrack your brain for anything really spectacular," he says, reading my mind. "I think we'll just have you sit. Like literally just sit for your portrait."

And this sets a precedent. Each time I come, Jeremy will be less into generic contortions or gymnastic feats, and more into me, which is to say into capturing me—not only how I look, but also, at the risk of sounding mawkish, the essence of me. And I am not saying he treated me uniquely; I am trying to tell you he was unique. He treated the subject as a subject, as opposed to an object.

For the next three hours, I sit atop the wobbly wooden table at one end of the studio, while Jeremy stands facing me from the middle of the room.

I have dressed simply, in jeans and a beige scoop-necked top, because later that afternoon I am scheduled to pose for another artist, Hilary, who is starting a sculpture in which I will represent a typical college student: young, feminine, archetypal, average.

When it becomes too intense to keep looking directly into his eyes, I turn away. I stare into a copy of a Sargent portrait of a stately, bearded gentlemen, and I am reminded of a Sargent anecdote told by another painter, Patrick, with whom I've worked in the past. Patrick, like many of the male artists I pose for, is an open appreciator of attractive women, and he'd tell the story of how, after the *Madame X* scandal, Sargent moved to England and became the top portraitist of that country's celebrities. As the "unrivaled topographer of male power and female beauty," he "excelled at women," and wrote in a letter: "Women never ask me to make them beautiful, but you can feel them wanting me to do so all the time."

I want Jeremy to find me beautiful.

He observes as he works that it is much easier to paint ugly people than beautiful ones. Beautiful people present a higher level of pressure: the challenge of capturing something already aesthetically lovely. Ugly ones you can shape into a beautiful painting through the transformative power of art, or whatever you want to call it. Jeremy says he doesn't want to uglify anything pretty. He concludes that I am extremely difficult to paint.

When this first session ends, he thrills me again by offering me a ride to my next gig. This offer is generous, unexpected, and will save me time, in addition to allowing me to spend more with him.

"Where are you headed?" he says, packing up.

"Fessenden," I reply.

"In Newton?" he asks, raising an eyebrow. "The boys' boarding school?"

"Yeah. Is that too much trouble?"

"No, it's no problem. I just didn't think they were so . . . progressive."

"They're not. I'm not posing for the boys. I'm posing for this artist, Hilary. Her husband is the art teacher. They get to live there rent-free. That's where she has her studio space."

We drive back across the Charles River, sparkly with sunlight and studded with rowers, and he recounts his own days of sex, drugs, n' boarding school.

"I was wild back then," he says. "An angry young man."

I feel a pang of disappointment that this seems no longer to be the case.

He drops me off, we say goodbye; we say see you soon, and we mean it. Next week.

When Hilary comes down to meet me, we laugh about the schoolboy fantasy Jeremy was confused by: me posing not clothed for her, as is the plan, but nude on the platform before dozens of virginal K-ninth graders.

Since it is Saturday, there are no students around her studio, but there are signs of them everywhere. We can hear them at their weekend practices for elite sports I'd hardly heard of before I moved to the East Coast—squash, lacrosse—and the more familiar touch football; their shouts drift in through windows left slightly ajar. Hilary and her husband David are Hall Parents, meaning they colead field trips and summer camp programs, and comfort lonely boys who miss their own parents, helping them to feel as at home at Fessenden as possible.

This conspicuous domesticity is what strikes me most about the contrast of Hilary's situation and Jeremy's. While my three hours with him were uninterrupted by any demands of the broader world, the same amount of time with Hilary is punctuated by phone calls about carpools, a movie they're taking five or six boys into town to see that night, and a quick pause to take her dog Porter (named for the beverage, not the Square) outside. The rhythm of these distractions is in counterpoint to David's periodic walking in and out, sometimes to offer advice—"The nose looks a bit high"—sometimes to ask a favor—"Hon, can I borrow the car keys?"—and sometimes to hammer out plans for the none-too-distant future—"Hilary, sweetie, what do you want to do for dinner?"

Granted, Jeremy does not have, officially, a lawfully wedded wife. But he does have a live-in girlfriend—the mother of their child—whom he will eventually marry. Yet while I end up seeing David countless times as the sculpture takes shape, I meet Jeremy's wife Samoa in person only once over the course of our lengthy collaboration.

Historically, this set-up—the model in isolation from the other parts of and people in an artist's life—has long been the norm, for dubious reasons. We mostly have the Victorians to thank for the lingering notion that models are the kinds of girls you don't bring home to mother, or to anyone else. In 1867, for instance, the Pre-Raphaelite satellite painter Sir Edward Burne-Jones "moved to a rambling eighteenth-century residence in Fulham, then still virtually in the countryside. While the house was difficult enough to reach, the studio remained out of bounds even to the artist's own family, his grandson recalling only that 'sinister people called "models" lived

there who had trays taken up to them at lunch and tea time.'" And although they were not associated directly with the Pre-Raphaelites, the painters Whistler and Tissot "openly set up house with their respective model-cum-mistresses in Chelsea and St. John's Wood." Wives could expect to be cheated on, and models could expect to be treated as pets or side projects.

Such lopsided arrangements are no longer the norm. Jeremy wasn't trying to hide me from anyone—he was just being efficient. I did see photos of Samoa, and the one or two drawings for which Jeremy had convinced her to pose. When I asked him why, with such a beautiful wife, he did not depict her more often, he said that for one thing he liked the variety, and for another, she hated sitting still for any substantial length of time. Hilary, on the other hand, has a more integrated home and work life out of necessity, and a much greater capacity to multitask. She and David are both artists, and both alternately help each other out and get under one another's feet.

Looking back, I see that this disparity is not entirely unexpected. If I look really far back, like "over the history of Western art," as Peter Steinhart suggests, I'll "find that very few artists managed to repeatedly portray their spouses. Rubens and Rembrandt did it magnificently. In both cases, the women they drew had been their models before they were wives. Once Renoir married his model, Aline Charigot, she gradually ceased modeling for him."

The Pre-Raphaelite painter and poet Dante Gabriel Rossetti notoriously declared all models to be whores. He did not necessarily mean this literally —although Fanny Cornforth, the model with whom he cheated on his wife Elizabeth Siddal (and who served as the model for his painting *Found*, in which she appeared as a whore) was both a farmer's daughter and a prostitute. What he really meant "was that models were treacherous: they had bargaining power, the ability to withdraw or refuse. They were no longer simply prostitutes. Thus, in a rough-and-tumble way, modeling became a profession."

Some artists I've worked for have been covetous of my time and energies in this regard. They have seemed put out, annoyed, when I have had to refuse a request for a session because I had other plans or was already booked with another artist or school. Jeremy never behaved this way. Of course, I rarely found myself saying no to him, but he even went so far as

to help me find other work with artists like himself—serious people who could afford to pay well.

He put me in touch, for example, with Eso Poppo, a retired teacher, now the leader of a drawing group that met Saturday mornings at Pine Manor College out in Newton.

"I used to be in that group when I first got started," Jeremy explained in early December when I was posing for him in his studio one morning. We were still working on the enormous portrait of me that he had begun during our first session. He had sunk hours and hours into the nearly life-sized canvas, continually painting and repainting the same details over and over in different ways: replacing a red background with a black one, adding my earrings and taking them off, having me look straight ahead, and then toying with positioning my eyes to be gazing to the right of the viewer.

"Why don't you go anymore?" I asked.

"We had a falling-out," he said. "I respect Eso tremendously. But some of the other people in the group I just couldn't deal with. It's an older group. People are mostly retired, set in their ways. Rather than grate against them, I just chose to remove myself from the situation."

"Um, yeah," I said. "No offense, but maybe I won't call them. You're not exactly giving me the hard sell here."

"No, no, no," he said. "It's not like that. They'll love you. They'll be ecstatic to have you. It was just a personality conflict. Probably having mostly to do with my personality. Plus, you'll find them fascinating. Eso's a Holocaust survivor. He came here as a refugee. He's an amazing guy. You'll like being around him."

Jeremy, I was coming to see, had had fallings-out with a number of people over his thirty years. Some might take this to mean that he was fickle, a loose cannon, not to be gotten close to. I took it to mean he had exacting standards for the relationships in which he chose to invest himself. I felt pride that he appeared to find ours worth investing in. I felt understood; he was one of the few people who came close to getting what it was that I got out of modeling besides the cash. I got to be around people like him, people like Eso.

When I did end up posing for the Pine Manor group, I learned who some of the people he'd fallen out with were. One of them, a slender and high-handed Daughter of the American Revolution with a brittle voice, an old-money accent, and dyed auburn hair, approached to me after the group had adjourned for the day, while I sat on a folding chair tying my

shoes and putting on my coat. She told me to please thank Jeremy for recommending to them such a wonderful model. I blushed a little, stood, and returned her thanks.

"And you tell Jeremy," she said, reaching up to put a hand—liverspotted, impressively powerful—on my shoulder, "You tell Jeremy that we're over it. You tell him he can come back to draw with us any old time."

When I posed for him the following Monday, I told Jeremy what she had said, but he never went back.

That day, he and I were having a hastily scheduled two-hour session. He had finished a contracting job a few days ahead of schedule, which meant he had extra money and extra hours, so he had called me over the weekend to squeeze in some more sessions. I was booked that week to pose in the afternoons for a sculpture class at BU and I was deep in the heart of finals at my MFA program. For anyone else, I would not have had time, but I made it for Jeremy.

"Do you have your robe?" he'd asked when he picked me up as usual at the Red Line T stop.

"Yeah," I replied. "I'll need it at BU. Why?"

"Well, you can say no. I mean, obviously you can say whatever you want, but I thought today we could try something nude."

"Sure," I said, in a voice I prayed would sounded breezy, but feared sounded breathless, unconfident, scared.

As usual, though there were signs of their having been around—notes posted by the main phone, rent checks tacked to the corkboard, new oil paintings set up to dry along the halls—there were no other artists in the building when Jeremy and I arrived. As usual, I hauled my stuff with me to the bathroom to change. I tried to hurry, not wanting to keep Jeremy waiting, but I took an extra moment to tidy up my hair—coiled and pinned up like a dancer's in dozens of tiny black bobby pins—and to reapply the red, red lipstick that I almost always wear, even though I had already touched it up when I had arrived at the station.

When I returned to the studio, Jeremy was set up, waiting. He looked more bashful than I had ever seen him. He favored full frontal nudes, not just in the sense that their nakedness was front and center, unhidden by modesty poses or drapery, but also in their gazes. He preferred his nudes to disconcert, to chafe against tradition by looking straight out—almost stridently—at the viewer. I knew how to stand without his asking.

"Perfect," he said as I positioned myself, standing, in front of the table I had sat on that early November day when we'd had our first session. My butt barely grazed the table's edge, and my hands rested lightly on its painted surface, at either side of my hips, providing the slightest horizontal in the vertical composition and the barest minimum of support to the rest of the pose which would fall most heavily on my micro-bent left knee—*contraposto,* as was my natural tendency.

Jeremy never filled our sessions with flattery or patter, with the coaxing little "You're beautifuls" or "You look so lovelys" or "You're so thins" that other artists sometimes did. Not that these remarks didn't sound sincere, but I always felt like maybe—even though I wanted them to be true, not just in being vocalized, but in the art produced—I was being a little coerced, like they thought I needed to hear those compliments because of what they were attempting to get from me.

"Ready?" he asked.

"As I'll ever be," I said, peeling off the robe and setting it in a loosely folded flannel ball to my right.

"Thanks, Kathy," he said, and smiled a little. I hoped I didn't look as discombobulated as he did in that instant—unsure, clumsy, fumbling with his brushes—though I certainly felt that way. I was naked before him, not nude as I preferred, but vulnerable in a way I had not felt since my debut session back at the Corcoran in Washington, D. C. In those thirty seconds, before I righted myself mentally, I felt insecure, adrift. I felt worried, inadequate, meager even, comparing myself—against my rational will—to his wife in my mind: her dark beauty, her perfect black hair, her thin-but-curvy body, which in the drawings looked flawless, even though she was the mother of a four-year-old child. *Shut up,* I said to my stupid, self-sabotaging brain, then forced my hands to relax and unclench upon noticing that I had crumpled them into anxious fists. Bringing my fingers back into casual contact with the top of the table, I reminded myself there are an infinite number of ways to be beautiful. Samoa was beautiful in a Paul Gauguin manner: exotic, voluptuous. I was more along the lines—or so I'd been told by Patrick—of an Egon Schiele: exaggerated, delicate, scrawny maybe, if you wanted to be uncharitable.

After our initial uncharacteristic silence during which Jeremy laid down the sketch with typical intensity, we settled back into our easy conversational rhythm. Maybe because he felt that I was suddenly revealing so much, he should be somewhat revealing in kind, I learned more about

Jeremy's personal life that morning than I had during any of our sessions to date. He had an older brother, Noah, from whom he was estranged. Unlike the litany of other people—lost friends, former colleagues—from whom he had come to feel alienated, Jeremy expressed regret at the lack of closeness between him and his sibling. While he seemed content to excise these other offenders from his life—like those effaced faces in old Soviet photographs—Jeremy was not satisfied to pronounce his brother dead to him.

"I still keep hoping we'll get through it eventually," he said, looking down at his palette, lightening his flesh tones.

"Sometimes it gets easier when you get a little older," I offered. "A lot of things do, or at least it's starting to seem that way."

"Wise twenty-three-year-old," he said.

"What can I say?"

Noah had graduated from a top-flight university. Noah was a really intelligent and established guy. Jeremy had tried college—along with an array of other controlled substances—but discovered within a semester that higher education wasn't really his Thing.

"What made you come to Boston?" I asked.

"I came to join a commune," he said.

"Are you serious?"

"Stone cold," said Jeremy. "You ever hear of The Mel Lyman Family?"

The two hours of our abbreviated session seemed to pass in a heartbeat, and I forgot all about my nudity as Jeremy recounted his decision to join a commune in Boston's poor and ethnically diverse Roxbury neighborhood. Mel Lyman had been a folk singer back in the sixties and was notorious as the guy who had played an acoustic harmonica solo at the end of the 1965 Newport Folk Festival after Dylan had thrown the crowd into upheaval by going electric. In Boston, Lyman had gone all Timothy Leary, gobbling LSD and establishing himself as a spiritual leader, reigning over an urban hippie community with himself as the patriarch. Some people called it a cult.

"There was this big exposé in *Rolling Stone* in, like, 1971," Jeremy said. "It made the place sound like the Manson Family or some other bullshit. Lyman died in 1978—he was only forty or so. But the commune stayed put."

"Do people still live there?" I asked.

"Oh yeah. Absolutely. They've just taken on a lower profile. You know the Fort Hill Construction Company?"

I did, definitely; I'd seen their trucks and signs around the city.

"That's them. That's how the commune supports itself. That's their money-making industry. That's how I got into construction in the first place."

"God," I said. "That's amazing. You could write a book about that."

"Nah," he said, waving his brush. "That's not really my line—it's more your kind of thing. Besides, it's a hard place to write about. I'm really ambivalent about the time I spent there. About the things they stand for. I mean, living there in Roxbury made me who I am—it's where I met Samoa, it's how I learned my trade. In a way, you could say I owe them my life. But I don't like feeling like I owe anybody anything. Now that we're out, I don't know."

Surprising as it was to learn that Jeremy had once counted himself as part of The Family, it made a certain sense, crystallizing some of the vaguer impressions I'd gotten from the other parts of his past he'd shared. The pattern was logical, now that I knew to look for it: trading the wildness of his youth for the structure of the commune, then trading back again for independence but continuing on with his self-imposed discipline, discipline of which this solitary and determined painting regimen was a part.

At the only break I took that morning, right between hour one and hour two at eleven in the morning, Jeremy offered me black tea as he usually did. He had a curtained alcove that he'd made into a pantry stocked lightly with nonperishable foods and a collection of herbal teas he prepared with a graying electric teakettle. Jeremy had told me before that he'd given up not only drugs and booze—which he'd been clean of for a few years—but also, more recently, cigarettes and caffeine.

"It was rough to quit, so rough to quit everything," he had said. "But now that I'm not beholden to even the littlest things, I feel better than I ever have."

Hearing how exactly Jeremy had managed to arrive at this near pure freedom made me appreciate even more how kind of him it was to keep the black tea around at all, even just for me.

"Are you totally self-taught then?" I asked. "Did you just go straight from construction to painting?"

Jeremy smiled, shrugged, held both hands around his mug, and began to tell me about one more person with whom he was at odds, but to whom I was about to become close, or at least as close as most people reasonably could. Jeremy had signed up for a class at the Cambridge Center for Adult Education the previous spring. He had decided at the outset that he didn't

want to be overly instructed, that he wouldn't go in for his MFA or any-
thing so formal. But he wasn't so vain as to think he couldn't benefit from
a little basic direction, a little light anatomy. The instructor had turned
out to be David Andrus, an eccentric artist who lived in his studio in
Cambridge's Central Square. The recipient of a Pollack-Krasner Foundation
Grant in 2000, he'd stretched every penny like a rubber band. He'd made
the cash last as long as he could, forced it to carry him as far as it would
take him—to India and back and all around the world. Now he had
returned to teaching anatomy and life drawing just enough to scrape by.

"He was a superior teacher for the one class I had him in, but I'll prob-
ably never talk to the guy again. Our personalities don't really mesh. In
fact, they clashed."

"I have never met anybody who has been in so many fights," I said.

"They're not fights," Jeremy said. "They're conflicts of interest."

"Whatever. What happened?"

"Not telling," he said.

"What is it with you and all these people you're no longer speaking to?
You're not going to turn into the king of the cold shoulder with me some
day, are you?"

"Don't worry about it," he said.

"Back to work?" I asked.

In comparison to the serious—and seriously wealthy—amateur artists
Jeremy put me in touch with, David could not afford to hire me very often,
or to pay me terribly well. But Jeremy thought I would find David capti-
vating. He was right. I still don't know for sure if David found me capti-
vating back, though I think maybe he might have.

I only posed once for David in the context of a class, a small life draw-
ing course offered on Tuesday and Thursday mornings by the Arlington
Center for Adult Education. By car, Arlington was not far from my apart-
ment in Allston. By public transportation, it required a frustrating series
of subway-to-bus transfers, plus a half-mile walk. The class itself was
standard—a small conglomeration of middle-aged women and retired men
taking up a new hobby later in life, or rekindling an interest in an old one
that had been pushed to the wayside by kids or careers. Nothing to write
home—or make an hour-and-a-half commute—about.

But David himself was anything but average. Within the first ten min-
utes, it was plain he was wasted on the students of the Arlington Center.
Or, not wasted, I corrected myself, feeling presumptuous—it wasn't that

these students didn't deserve a gifted teacher. But it was disappointing that so few people knew about David, or would ever see his work or have the pleasure of studying with him.

Squirrely, wiry, and underfed, David had a lean and hungry look. That was the line from *Julius Caesar* that ran through my mind when I first laid eyes on him, when I began to do thirty-second gestures at the beginning of that class. I never saw him dressed up, never saw him wearing anything other than crappy clothes and a scrappy ball cap: drawstring pants that he yanked up continually, unconsciously, or ripped blue jeans, belted with a piece of white rope. Perpetually ill at ease. Sardonic. Owlish glasses in front of sharp eyes, darting everywhere at once, taking everything in and judging it.

Like Jeremy, David gave me little to no direction and no encouragement. I was on my own for the three-hour session, following my instincts. Halfway through, during the long break, I felt an inexplicable sense of missed opportunity. David was supposed to notice me; we were supposed to hit it off. Why else would Jeremy have recommended me; why else would I have come all this way, so obnoxiously far north?

At the end of class, after I came back to the room to say goodbye, having gotten dressed again, David asked me how I was getting home. I told him.

"Ah, that's arduous," he said, his voice snarling, nasal. "This guy's going to give me a ride back to the end of the Red Line." He gestured to a student, a bulky man with salt-and-pepper hair enjoying an early retirement. "Got room for one more?"

The student agreed, and we piled into his convertible Volkswagen. David talked up a storm; no one else could get a word in edgewise. When we reached the Alewife station, he seemed to have realized who I was, at last.

"So you're the one who heard about me from Jeremy?"

I was.

"How is that guy anyway? He's got a lot of talent."

I told him Jeremy seemed fine, but that maybe he should call him up himself and inquire.

"Nope. Can't do it. Won't. We're not speaking."

Obligatorily, I asked why, not anticipating an answer; good thing, because I wasn't going to get one.

"I can't say. But Kathy, artists live in labyrinths. They are navigators, negotiating the maze of ego and expectation."

David said stuff like this all the time. He seemed to suffer from logorrhea. What in most people would be an internal monologue became external with him. His turns of phrase were bizarre and elegant, his stories unpredictable, rangy, engaging. Ezra Pound said poets are supposed to make it new. Victor Shklovsky said artists are to make it strange. David was capable of being new and strange for hours on end. We talked the whole ride back to Cambridge.

"Anyway, it was nice posing for you," I told him as we neared Central Square. "But just so you know, I'm never hauling myself all the way back there again. It's way too far. It's not worth my time."

And that got the response I'd been gunning for. "Oh no, Kathy. That I can't abide. You've got to come to my studio then. You work for Jeremy, you must work privately. I probably can't pay you as much as that guy, but maybe we can cut a deal. I can give you some drawings of yourself or something."

"I don't want any drawings of me," I replied. "But yeah, sure. We can work something out."

As we set off through the already failing gray and wintry early afternoon light, him back to his studio, me trekking over the bridge to Allston, I could hardly justify to myself why I'd just agreed to that. I had come to have enough work and high enough standards for myself as a model not to pose privately for anything less than twenty bucks an hour. But I still felt—even though I realized just by looking at him that there was no way he could afford my fee—that I had gotten what I wanted in the offer from David.

The next time I pose for Jeremy, we put on some music. The last time we met, he gave me a gift, an album by his wife, who is a singer. Sometimes she performs at Club Passim, a folk venue in Cambridge. Her voice is lovely, soprano and sultry. This week, I have a gift for him: a mix CD. It is kind of a girlfriendy present, but it could just be friendy. Either way, Jeremy seems pleased.

We are talking, indirectly, about David. Both men press me for information, now that each knows I am working with the other regularly. I have filled the CD with older artists—Billy Bragg, the Pixies, the Replacements. Nostalgic bands Jeremy had been just old enough to catch the first time around, but that I'd only been able to find in used CD bins.

"The ones who love us best, are the ones we'll lay to rest," Paul Westerberg yowls from the speakers. Any idiot can see that both Jeremy

and David care for each other's well-being, for their artistic talents and potential for success. I imagine all kinds of Byzantine reasons for their present moratorium on contact or communication: some elaborate father–son style relationship gone sour, some dreadful betrayal, some harsh words that, once spoken, can never be taken back.

"The ones who love us least, are the ones we'll die to please," sings Westerberg. "If it's any consolation, I don't begin to understand them."

I haven't yet begun to understand, as I will later, another part of the reason I am drawn to both of these men.

I am now visiting David in his studio on a regular basis. Visually, he seems to find me no more or less interesting than the stool or fruit he poses me with. He seems as content to paint a bare lightbulb rolling atop his coffee table as he is to paint my bare ass. But when I pose for him amid doll parts and mannequins in his cramped junk shop of a studio above Central Square—mounted animal heads on the walls, pins all over the floor—I relish the thought that, visuals aside, he at least finds me interesting as a human being. I love how he can't bear to part with any of his paintings, his babies, so they're all there, or at least it looks that way, piled one atop the other, end to end, strewn around—the room's most prominent feature, freckles on a face. Sometimes we talk so much that he forgets to paint me, and he just shows me his work, old and new, and we talk about travels, the one's he's made, the ones I intend to make. I am fairly certain he is a genius.

With both Jeremy and David I let down my guard, permitting myself to be more naked with them than with almost anyone else for whom I pose. I am trying to show them something; something they can't see physically, but that they are capable of seeing in other ways. Something I can see in them, as well, as if we are all in on a joke that nobody else gets. As if we are part of a club that facilitates a meeting of the minds. Like when we are together, I am not merely an object and they are not merely artists, but like we are collaborating. Like we are in what F. Scott Fitzgerald calls "ecstatic cahoots."

I get songs and phrases stuck in my head all the time, especially while posing. That phrase lodged in my brain as I bounced that year from job to job, from David to Jeremy. It comes from *The Great Gatsby,* the scene where Nick sees Gatsby alive for the last time: "'They are a rotten crowd,' I shouted across the lawn. 'You're worth the whole damn bunch put together.' I've always been glad I said that. It was the only compliment I

ever gave him, because I disapproved of him from beginning to end. First he nodded politely, and then his face broke into that radiant and understanding smile, as if we'd been in ecstatic cahoots on that fact all the time."

It might have been an illusion, but I didn't care then. I still don't now. It meant so much.

Literary critic Roland Barthes has observed that "the professionals of strip tease wrap themselves in the miraculous ease which constantly clothes them, makes them remote." He writes of their "icy indifference" and how they "haughtily tak[e] refuge in the sureness of their technique: their science clothes them like a garment." As a model, I too have trained myself to have some of that. I keep it around, putting it on like a coat whenever I need it. This professionalism can be seen as unfriendliness at first, especially in big classes where I have found holding oneself apart to be crucial to getting the job done. You cannot talk with every student and expect to hold still, and you do not want any of them getting the wrong idea about why you are there. You are present to pose, not to make friends or to get phone numbers.

The first time I worked with Doug, the sculpture professor at Boston University, he was convinced that I hated him. The class was actually another instructor's, not his, but since he ran the shop, he'd been called in to discuss armatures while I was posing nude for a fall semester junior sculpture project. Knowledgeable, attractive—piercing eyes, floppy hair, lithe-muscled body—and almost regimentally adept at his job, which he approached with the precision he'd learned when he'd been in the Army, he was popular among the students, to whom I was closer in age than he was. Doug grew up in Missouri—like Brad Pitt, he liked to point out—and he did look like a heartthrob. I kept my distance, reading books on break, scarcely speaking to him at all. Over time, he came to realize I was just playing it safe, as I think the best models tend to. Rather than coldness for coldness's sake, I prefer to think of my behavior as being similar to what Dante Gabriel Rossetti's brother William considered Lizzie Siddal's "dignified insistence on her privacy—or, alternately, her standoffishness."

I feel safer from sexual predation in the art studio than I do when I'm walking down the street—where I and my female friends may find ourselves subjected, for instance, to carloads of men who think it's funny to drive up and ask, "Do you like penis?"—or riding the T—where, for

example, the drivers sometimes ask you what you're doing later, after they get off work. I feel less vulnerable in the studio than I do when I'm walking home through Kenmore Square on a Red Sox game night, past the New England School of Photography, as big thuggy townies—drunk, beefy-faced, and hamfisted—pass by, say boozily, "I love you," when really that is last thing they mean.

Each time you pose, you hurl yourself headlong into the unpredictability of human nature: you never know when someone will do something unexpected, unsuitable, wild. But you know, too, that as a model, you will always be safe, because you are protected, clad in your nudity; because you have power. And thus you are free—and it is fun—to fantasize.

In modeling, France Borel observes, "There is a subtle perversion at work. It defies natural order by putting a nude woman at the artist's disposal, a woman which he 'uses,' which he looks at but cannot touch." It's partly this perversion—this combination of my naked vulnerability with the impossibility of my actually being touched—that makes me love modeling so much. So maybe this is my ultimate kink? Maybe I model because I can expose myself to strange, intelligent, fascinating people with virtually no risk whatsoever? There is technically no touching, but modeling can make me feel as though I am being touched. And that in being touched, I am being added to.

I'm added to financially by being looked at regardless of who is looking, and regardless of whether I attach myself to them as a friend. Still, sometimes my fantasies—in which I wonder what it would be like to spend time with Doug, with David, with Jeremy, with insert-name-here—come true in real life, and when this occurs, I am added to in the way one is added to in any friendship. Outside the classroom, I will drop my icy reserve, because I want to get to know the person on the other side of the canvas.

After working together a few times, Doug and I began to hang out on our own, coming to spend so much time together that some of his friends, and even some of mine, thought we must be dating, at least on the sly. We weren't. But we were driving everywhere together in his truck: taking trips to the Harvard Museum of Natural History, the DeCordova Museum and Sculpture Park outside the city, the New England Aquarium. Doug liked to sculpt natural forms—mammals, birds, fish—so he'd whip out his sketchpad and take notes, whip out his camera and take pictures of me. He gave me drawings, photos, and pieces of art, best of all a dragonfly

sculpture made of a single piece of twisted wire that hangs to this day over the door to my kitchen.

I liked the erotic tension. But as the months went by, whatever early attraction I may have felt decreased every time I saw him. We were just good friends—one of whom happened to see the other naked on a regular basis. Characteristics which might have been deal-breakers had we been trying to have a romantic relationship—he could be infuriatingly conservative, and if you substituted the word progressive, I'm pretty sure he'd say the same about me—could be brushed aside because we were just artist and model, just special friends.

In the end, what really made me stop thinking of Doug erotically was that to become his lover would have been too logical, too easy. I no longer wanted him because I knew having him was within the realm of possibility. This hit me when he asked me to be the model for a female torso, an undertaking that required several hours of my sitting nude atop a high table in his studio while he drew me from behind, as well as his taking a plaster cast of my back and butt.

The casting proved to be an elaborate task. Doug and his two assistants —undergrads, a girl and a guy—had to smear me first with Vaseline and then with plaster of Paris. To my surprise, none of this—Doug's warm, bare, callused hands slathering petroleum jelly across my naked skin, the cool roughness of the plaster-soaked burlap scraps—was sexy. In fact, it was all I could do to breathe shallowly and not laugh, because I am perhaps one of the world's most ticklish people. Under nonprofessional circumstances, mere looks have the capacity to set me convulsing. As the burlap strips set against my back, the plaster grew hot, but the situation didn't.

At the same time, I've also known attraction or arousal to crop up in unexpected circumstances. For some reason, posing for an artist who was sculpting me in chocolate in order to Make a Statement about how our society sexually consumes women was not sexy at all. Yet standing quietly in Jeremy's studio drinking tea, and sitting on David's paint-stained sofa looking at his packrat hoard of drawings from India, made me fall in love with each of them, if only for a second.

But whenever I find myself thinking this way, like a fairytale—like Snow White, like Sleeping Beauty, like a prince will come and want passive me—I snap out of it and think about sublimation. In his novel *Snow White*, Donald Barthelme writes, quoting Freud, "The value the mind sets on erotic needs instantly sinks as soon as satisfaction becomes readily

available. Some obstacle is necessary to swell the tide of the libido to its height, and at all periods of history, whenever natural barriers have not sufficed, men have erected conventional ones."

Once the gaps in my knowledge about Doug were caulked with personal information, my desire decreased. Less fantasy and more reality guaranteed that the initial sense of possibility, of the forbidden, was lost. Not so with David, or with Jeremy. Although we became close, I never hung out with them outside the context of being paid to pose. As a result of holding them at a greater distance, I am able to this day to keep them as objects of pleasant speculation. My thoughts about them can continue to open out, to swell to mysterious heights. This mystery, this deferral of satisfaction, is why I feel my collaborations with each of them were so seductive. That was sort of a typo. I meant to write *productive,* but I'm going to leave it, because I think they were both.

Life drawing, obviously, is very much about the body, the interactions of bodies. Look at that flesh, represent it, but don't touch it. Show your skin, but don't succumb to lust. Make yourself a vehicle for sublimation. Art and modeling are ways to fill a central human void, the empty places all of us are always trying to plug, by pursuing our desires through sex or music or TV or food or God or the Red Sox or the Psychic Friends Network or eBay or whatever. When post-Freudian psychoanalyst Jacques Lacan "turned to the question of sublimation, he emphasized less the myth of a sexual instinct than this idea of a zone of emptiness, of a void that is constitutive of our becoming human." Some people gamble, shop, shoot up, sing in the church choir. Me, I write poems, write books. Art's ties to sex, religion, death, and, of course, to love, are not original concepts, but they are inextricably part of why I try to make my own art. Also? They are why I take off my clothes for a nonstop string of strangers and ask them, for a little while, to love me as I love them.

I pose because it can be erotically frustrating and fulfilling at the same time—the safest sex of all, I've heard it remarked. I also do it because I am lonely and scared to death of death. I do not want to die. I do not want to be alone. So I find these relationships, and have them, and move on to more and more and more. It's a strange compulsion, maybe even an addiction, but I don't want to get over it, and I don't want to be cured.

Long after we've both moved—him to upstate New York with his wife and daughter, me to Provincetown with my husband—Jeremy and I have a conversation in which he brings this sensation into sharp, metaphoric

relief. "I think the relationship aspect of it," he says, "can be really incredible. Like for me that kind of intimacy is almost narcotic. I like that brand of intimacy with a quote-unquote stranger. I almost like that better than with a lifelong friend. Which maybe puts me in the category of being creepy, but it's true. I like the idea of having just met somebody and then getting involved in a really intimate conversation." Intimate? Yes. Narcotic? Me, too.

Jeremy's tendency to say stuff like that is why I loved posing for him. That ability to say the exact perfect thing at the precise right time is also why I love David Andrus. Just before I moved to Provincetown, I tried to set up one last session with David, one last time to pose and to say— temporarily at least—goodbye. In the middle of a gentle snowstorm on December 2005, I struck out on the walk from my apartment in Allston to the Cambridge Center for Adult Ed, filled with nostalgia and excitement: thinking about the life I was leaving behind. Stamping snow off my boots in the hallway of the CCAE one cold hour later, I found nobody present but the classroom caretaker. David had stood me up. The caretaker, Bill, was kind enough to help me call David's home number, but the man never answers: he's an obsessive phone-call screener. As I listened to the Bollywood preceding his cranky voice on the machine—"Leave a message!"— I knew he wasn't screening this time; he was actually gone. Bill believed otherwise: "I bet he's there, he just feels bad he made you come all this way."

But I was right. He resurfaced in January, called me up, and explained. "I just had to go to Egypt," he said. "You're catching me coming from the desert sands. I'm telling the truth." That's what David's like. I wasn't mad, and it was like nothing had changed; our conversation galloped off, effortless as ever.

His voice crackled over the line. "Some models are just an object to me, maybe because I'm not into them as a person. Other models have a kind of energy, and they walk in a room and strike me in a way. I'm convinced once I draw or paint someone, I know them in a way no one else does. It's subliminal, like Aborigines communicating across thousands of miles of desert sand," he said. "It's an intimacy, but not in the sense of a relationship. But it is an intimacy. It doesn't always click, and I don't understand it. It's chemistry with certain models. It's not a criteria you can look at and tell. It's magic, and I'll be drawing and everything's perfect, and some models evoke that, and other models I can't draw at all."

The exact perfect thing. What's not to love?

After all, according to the story of the Corinthian Maid, love has been at the heart of the desire to capture people's images since the very beginning. Starting in the 1700s—thousands of years after her supposed lovesick invention of the art of portraiture—many images of the Corinthian Maid began to depict Cupid as guiding her hand. I have yet to see a winged cherub hovering above the artists who draw me, but I do feel that there's something like love involved in what we do.

Matisse's biographer, Harriet Spurling, writes, "The French expression for thunderbolt—*coup de foudre*—means 'love at first sight,' with all the undertones of violence and risk that were an intrinsic part of Matisse's passion for painting." *Coup de foudre*. I'm addicted to being struck.

Don't Fall in Love with Everyone You See—the title of an album by the band Okkervil River. I put a song of theirs on the last CD I made for Jeremy, a CD I didn't realize would be the last. Don't fall in love with everyone you see—good advice, easy to ignore. It was August 2004. The artist from whom he had been subletting studio space had returned, and we had taken to posing in Jeremy's house, a homey building in Somerville, divided into a duplex in which he and his family occupied the first floor.

I was lying on a futon in his living room, my nude body draped prone over a stark white sheet. The futon had been folded out from couch to bed, a bed that maybe he had had sex on, or that somebody had at some point. Resting on my elbows, I leaned over a book that I'd brought. Jeremy had said I could read it if I wanted, but unavoidably, we ended up listening to the CD and talking.

And that's when he said it.

"I didn't want to tell you on the phone because I hate goodbyes," he said. "But I'm moving. We're moving. We're moving away. This will be the last time I'll see you for a while, I think. We're going next week."

He had been talking about leaving—so had I, for that matter—for as long as we'd known each other. I knew that a relocation was in the works for Jeremy, but I hadn't thought it would be so soon. Neither had he, but events had taken on a charmed inertia: he found a renter for this place, a house up there, with built-in studio space and good schools for his daughter. Woodstock, New York. Goodbye, goodbye.

I felt like crying, though of course I didn't.

"That's great," I said. "I hear it's a really artistic community. I bet you'll find lots of people to paint. I hear there's tons of galleries."

"If I can find models up there who are half as good as you, I'll consider myself lucky."

I thought of the book he'd given me. Loaned, technically. *The Mirror at the End of the Road,* an idiosyncratic book by Mel Lyman himself, published in 1971, yellowed, cracked, and long out of print. I hate it when somebody borrows a book and never returns it, but I knew then that I would deliberately forget to return this one to him. If this was the last I would see him, then I was not going to give it back. No way.

I haven't seen him since.

We have talked on the phone a little. And I have gotten exactly one e-mail from him, and one voice-mail, and I keep them like secrets in their respective in-boxes. The latter begins, in his raspy, boyish, sandpaper voice, "Hey, Kathy, it's your old friend, Jeremy . . ."

Years later, in 2006, during one of our infrequent phone conversations, I asked Jeremy about how hard it was to put into words the strange connection you can find with someone just by looking at them. He said, as I had learned I could expect, that he knew just what I meant. "Generally I think I place less judgment on appearances as being superficial. I think they're not superficial. I think I've always felt that way. People are always saying beauty is skin deep, and it is and it isn't. There's a grace we associate with people, posture and gesture, that isn't skin deep, and it's not less beautiful than great poetry [. . .] I think I meet people who are really beautiful—people who are not just beautiful to look at, but there's something I find attractive that comes from what kind of person they are. The people I'm caught by walking down the street or in a restaurant—they're not fucking Republicans. They're not fascists. They're the kind of people I think are beautiful."

"Exactly," I heard my own voice reply into the receiver, as it felt I had done already a hundred times in person. "Exactly."

The relationship between artist and model is inevitably almost always temporary. Like the commuters, someone gets off the proverbial train, and there is a sadness, yes, at the sense of a lost friend or a change in the status of a relationship, but so, too, is there a relief. The relationship was thrilling, but always unfulfilled, and in a way that removes the pressure of a more conventional relationship. You will never sleep with or fully get to know or completely get tired of the other party, and so the relationship, though it may end, will never be really messed up. It can stay perfect, special forever.

I've been thinking about all this—why I feel so driven to take my clothes off for and share all kinds of personal business with strangers—for a while, and am still working my way toward conclusive answers. That is why I am pleased to report that in late 2005, I discovered hard socioscientific evidence as to why I get off on art modeling without, you know, literally getting off. The article opens with the question: "Americans put a premium on sustaining intimate relationships, but could it be that they gain as much emotional sustenance from the relative strangers they meet on commuter trains, in the stands at softball games and even at strip clubs?"

Yes, continues the source, they certainly can:

> In *Together Alone: Personal Relationships in Public Places,* sociologists [. . .] present a collection of essays stressing the importance of the interactions that occur in public spaces, like bars and gyms. "Fleeting relationships," [researcher Calvin] Morrill explains, are brief interactions that nonetheless are "colored by emotional dependence and intimacy." Morrill's researchers visited strip clubs and found that customers paid not just for the eroticism but also for the sense of connection they felt with the dancers. "You can tell a dancer who really cares about the people she dances with," one customer said. In another chapter, a singles dance designed to foster serious romance was instead used by regulars as an enjoyable, safe, commitment-free place to socialize with strangers and then head home—alone.

I've often felt this way: that fleeting relationships—such as the ones I have with the members of an art class I pose for once—can be just as, if not more, satisfying than permanent ones. Now I was being corroborated by *The New York Times*. I ended up sticking the article on our fridge, where it remained until we moved.

The sociologists also discuss "the value of 'anchored relationships,' which are more enduring than fleeting ones, but fixed to a single location" such as the ones I have with artists like David or Jeremy in their studios or homes—or, in the present instance, over the phone. At the end of our post-Egypt chat, David thanked me for the conversation and told me, "It's good to have an intelligent life form out there who understands you. We live in a planet full of idiots, and it's good to have you there. I like talking with

you. I feel like you understand me." Likewise. Each time I model, I am grateful for yet another opportunity to find someone who gets me, or at least to spend time with somebody who spends hours of painstaking effort on some level *trying* to get me.

Long after we'd stopped working together, Jeremy told me, "You definitely were an exceptional model." Needless to say, this pleased me, but it also made me laugh, because I felt like I spent a ton of time not being very still and talking talking talking about all kinds of intimate stuff—his and mine—instead of being "professional."

Am I concerned that he might read this and get the wrong idea? Not really; I don't think this is that weird. Do I consider him some kind of great unrequited love of my life? No, probably not. But I do consider our relationship for those few months to be something for which there really are no words.

Once he had me pose for what is, I think, my favorite of his paintings I've been in. First I stood—clothed—on a hot July day near the weedy railroad tracks just south of Central Square in Cambridge, near an abandoned-looking brick warehouse labeled FIREPROOF. Later, in his Somerville studio, I posed nude in the same attitude: hand on hip, facing away from the viewer, a tiny unclad human in a looming industrial landscape.

The impact of setting such a defenseless yet defiant figure in this unexpected context put me in mind of *Atocha (esparto)* by Spanish realist painter Antonio Lopez García and his painting of a couple making love at dawn by a train station: so inappropriate, yet so perfectly right.

Always his own harshest critic, Jeremy himself wasn't wild about the piece, but I found it beautiful, and I found it scary. Maybe that's just because I was able to personalize it, to read it as an allegory: me, revealing myself, trying to be more connected in a disconnected world. Addicted to exposure. Trying to achieve some sort of sympathy. Before moving on.

chapter three

You Only Live Twice

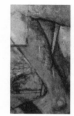 I've never been to China. But I have been to Forbidden Gardens on the rice fields outside Katy, Texas. Built in the late 1990s by a Hong Kong real estate mogul who was concerned that his children were not learning enough about their heritage in school, Forbidden Gardens is a forty-acre outdoor museum showcasing some two thousand years of Chinese culture. Billing itself as "a must-see for everyone who wants to embark onan unforgettable journey to a faraway land without stepping outside of Texas," the place is still and timeless: koi fish lurk in the lagoon below the bridge you must cross to enter, incense hangs in the air, and mysterious plinking music emanates from invisible speakers.

I happened to visit on the dull, sunny day after Thanksgiving 2004, but it could have been any day, any time, so postmodern and Las Vegas-like are the grounds, with their forty thousand square feet of miniature palaces, pagodas, concubines, and courtesans. Still feeling stuffed with Tofurky, my fiancé, my soon-to-be brother-in-law, and I set off to roam the Temple of Heaven, the Forbidden City of Beijing, the Calming of the Heart Lodge, and the canal city of Suzhou, also known as the Venice of China—long famous for its beautiful women, according to the guides. We soon had to shift from lackadaisical strolling to crowd-conscious vigilance, because the park was packed to its hand-painted gills. Native Texans, recent immigrants, and Chinese tourists swarmed the courtyards and corridors.

Apparently, the Chinese government makes travel within China so prohibitive that it's easier to fly to the United States and see a tiny replica than it is to stay home and see the real thing. And so, thanks to the largesse

of the Hong Kong businessman, the Chinese immigrant population of Houston—the third largest in the country—can experience the country from which they have absented themselves, as could we.

Their slogan? "Journey back to a time when Emperors ruled . . ." The Emperor to whose time you journey back the most is Qin Shi Huang, who lived and died with equal panache in the third century BCE. When our number was up for the guided tour, our perky teen guide, Jennifer, led us out to a sunken pit teeming with short, sun-bleached clay men the pink-orange color of the koi: the first emperor's six-thousand-piece terra cottta army reproduced in one-third scale, made from earth taken from the original site, an elite fighting force marshaled to defend not only the eternal life of an individual emperor, but also that of an entire culture. Like the originals on which they were based, these fierce simulacra once wielded spears and swords. "But we had to take them away," drawled Jennifer, "because our guests kept fighting each other with them. People were getting hurt."

She went on to explain that aside from the missing weapons, each and every one of these figures was an exact replica of one of the original terra cotta soldiers, who were themselves exact replicas of actual soldiers in Qin's terrifying army, the one with which he set out to unify China, conquering its seven warring states one at a time.

When he ascended the throne at age thirteen, Qin was already obsessed with his own mortality. Even though he brought unity to China by standardizing currency, weights, measures, and laws, establishing a bureaucratic system that lasted until the twentieth century, and building roads and canals to connect the far-flung states, the Forbidden Gardens Web site tells us that "few would call him a great man. His brutal reign was filled with death, betrayal, punishment, and horror." Perhaps bearing in mind the nasty, brutish, and short lives of his subjects, Qin began preparations for his own afterlife almost immediately upon becoming emperor. Covering three acres outside the city of Xian, his tomb is believed to have been built by seven hundred thousand workers over the course of eleven years in the third century, but the site remained undiscovered until March of 1974, when farmers found it while digging a well. His tomb itself has yet to be opened, although it is believed to contain not only his body, but also "jewels, miniature cities and rivers of mercury," as well as "the bones of the 'interior designers' of the tomb, who were sealed alive inside [. . .] to prevent them from telling anyone of the contents [. . .] or the location of its entrance. Also buried alive with the Emperor were all the women from his court who had not borne any children."

Most impressive to me were the clay warriors themselves, in various poses: the standing infantry, the charioteers, and the kneeling archers, all of them—all of them!—said to be based on living, breathing models, all of them slightly larger than life and distinguishable from one another by their heights, hairstyles, facial features, and expressions. No molds were used. Every long-dead warrior wears a long-dead artist's rendering of his particular face, or so the story says. Before they were given second life by the well-diggers, the terra cotta warriors' existence proved as perilous as that of their flesh-and-blood counterparts. Archaeologists estimate that just fifty years after their installation, the figures were burned in a fire set during a peasant uprising. When the wooden roof over the pit collapsed, the sculptures were crushed, and their realistic paint jobs charred away.

As my fellow tour-takers filed across the flat pit-side paths, back toward the arcades of the main complex—some of them casually ignoring the "DO NOT TOUCH" signs—I lingered. I felt an intense kinship with these fake men, thinking how big the world, how small my view of it, and how weirdly connected the experiences of such seemingly disparate individuals can sometimes be.

My experience at Forbidden Gardens was pretty much par for my sightseeing course. In fact, I found myself experiencing the chills of déjà vu. Growing up, our family vacations were paradoxically cheery-yet-morbid affairs, weighted more heavily toward National Historical Parks than themed ones. Some of my fondest memories of my formative years involve tooling around the Great Plains and the wide open spaces of the West, Dad behind the wheel of Mom's oxblood Oldsmobile station wagon, carting us to such merrily named destinations as the Badlands and the Black Hills. We went to Deadwood to see the site of the saloon where James Butler "Wild Bill" Hickock was shot in the back of the head by Jack McCall with a double-action .45-caliber revolver. Hickock's hand at the time? Aces and eights, all black cards: the deadman's hand. Also viewed by the vacationing family Rooney? Wild Bill's grave amid the tall pines of Mount Moriah Cemetary overlooking Deadwood, featuring an oft-rubbed bronze bust of the legend himself.

The sculpture is a replacement of a replacement, a copy of a copy. Early visitors gradually destroyed poor Wild Bill's original tombstone by either carving their initials into, or hacking pieces out of, the marker to take home as souvenirs. A nine-foot-tall red sandstone statue placed on the site in 1891 by the sculptor J. H. Riordan met a similar fate in fewer than

ten years. A life-sized sandstone statue by Alvin Smith erected in 1903 also came close to destruction, even though it was surrounded by a security fence. Now, the headless remains of the statue sit on display at the Adams Museum in town. Eventually, the cemetery caretakers got wise and installed a more sturdy and enduring monument. Thus, the sculpture that the fam and I—and other contemporary visitors—enjoyed is a solid metal facsimile of the 1891 version, famed for its depiction of Wild Bill with a far-off look in his unseeing eyes.

At Yellowstone National Park, while my younger sisters accrued geodes and miniature pewter figures of the local fauna, my prize purchase was the book *Death in Yellowstone*, a gripping and gory catalog of all the myriad ways various hearty pioneer folk and tourists met their Maker amid all that breathtaking panorama. Also prominent on our handy AAA TripTiks were the majestic and obscene Mount Rushmore—grandly dynamited out of the granite of South Dakota's towering Black Hills—and the nearby studio of Gutzon Borglum, Rushmore's Idaho-born, Paris-trained sculptor who died of a massive heart attack in 1941, just before the completion of his masterwork, which ended up being finished by his son, Lincoln Borglum. Also worth noting is that the four huge presidential heads— George Washington, Thomas Jefferson, Theodore Roosevelt, and Abraham Lincoln—are carved from rock long considered to be a sacred Lakota site.

Thus, as a side trip, Dad and Mom thought it was important to drive us over to Thunderhead Mountain, site of the considerably less complete and therefore way more poignant Crazy Horse Memorial. Begun in 1948 at the urging of several Lakota chiefs, the project was planned and initiated by sculptor Korczak Ziolkowski, who had helped Borglum with the construction of Rushmore. Whereas said presidential heads are sixty feet high, Crazy Horse, if he is ever finished, will be the world's largest sculpture: 563 feet high and 641 feet wide. Since Ziolkowski died, also of a heart attack, in 1982, and since the project—continued by his children— has a long history of refusing government grants (perhaps because of the government's role in the eradication of the culture the monument is intended to memorialize), it remains in doubt whether this day will ever come.

I realize of course that these are hardly unique, or even uniquely death-obsessed, American family vacation destinations. But listen: my parents actually arranged for us to stay in the barracks at Fort Robinson, Nebraska, infamous site of Crazy Horse's murder. After enjoying a tradi-

tional camp breakfast of eggs, beans, toast, and other heavy, slow-burning fare in the Fort Robinson restaurant, we struck out to the site of the Adjutant's Office, where Crazy Horse met his tragic and untimely end. Here we learned from the historical interpreter that—in exactly the kind of muddled, unnecessarily wasteful turn of events that typified late nineteenth century conflicts between Native Americans and the United States Army—Crazy Horse returned to Fort Robinson to quell rumors spread by enemies that he had fled the fort illegally. When he showed up again on September 5, 1877, the soldiers on duty tried to arrest him. In the scuffle, Crazy Horse ended up stabbed near the left kidney by the bayonet of skittish twenty-year-old private named William Gentiles. Crazy Horse, the guide informed us, died of his injury either sometime during the night of September 5 or the early morning of September 6, while being cared for by his father and Army doctor Valentine McGillycuddy.

I've been raised to be mindful of how death surrounds us, of how it will happen to all of us—even the most heroic among us—and of what we as a culture do to comfort ourselves about this fact, erecting and visiting these shrines and replicas across the land, regardless of whether we fully understand our reasons for doing so.

No surprise, then, that there I was, on the weather-beaten plains just twenty-five miles west of the exurban sprawl of Houston, having an uncanny moment of identification with men I would never know and would never be able to understand. I too have had life-sized, one-of-a-kind statues modeled from my own face and body. Granted, in my case, it was only six and not six thousand, but for fourteen weeks in the winter and spring of 2003, I sat for hours each day at the center of a bright airy room at Boston University, which gradually came to be filled with an army of me.

Saint Paul says we die every moment, so we can disarm death by rehearsing it. In the Middle Ages, there was a popular meditative activity known as *contemplatio mortis,* "a dramatized medieval exercise in imagining one's own death that prepared one for the inevitable end and helped one enjoy the life that remained." I tend to think of this a lot when I'm posing: how each of these images—especially the sculptures—with proper care and treatment stands to exist far longer than I do. I will age, dimpling like a plucked turkey, rumpling like a punching bag. But I have left a little fossil record of my body through the years, a string of former selves, silly and brave.

Gerry Hoag, an artist and professor who assisted during the creation of the life-sized sculptures of me at BU, says that the production of such works can be meditative for the artists as well as for the models. When I asked him, over two years later, whether working from the model affects his level of self-consciousness about his own body, he said, "I think it does. I've been involved with orthodox Buddhism for about thirty-five years, and it's kind of about that anyway. I used to assist in clinical autopsies, and it was kind of a dual-purpose activity for my dharma exploration about the impermanence of the body and the breakdown of the body, and it was also about art, and the understanding of the figure [. . .] I'm hypersensitive to mortality and impermanence."

Most of us are familiar with the stories of Renaissance artists drawing from cadavers to advance their anatomical prowess, but the tradition continued well into the nineteenth century, and—as Gerry can attest—into the twentieth and beyond. The British artist Henry Tonks (1862–1936), for instance, derived his "expertise in anatomical drawing from his training as a surgeon, some of his first serious attempts at drawing being made from cadavers in hospitals." It was said that "If he could not draw the living, he would fall back upon the dead; by bribing the post-mortem porter, he induced him to fix a corpse on the table for his benefit, which he could then draw at ease." Fortunately, thanks to more evolved attitudes about, and greater availability of, live nude models, Gerry and his fellow contemporary anatomical artists no longer need to resort to bribery and grave robbery. As for Gerry, he adds that "It's actually pretty interesting, too, to work with models over a long period of time, and see them change, and how that's inevitable."

Gerry's fond of telling the story of a Boston-area model named Charlie who worked in the business for about fifty years. At the end of his unusually lengthy career, several local artists organized a show comprised exclusively of images of Charlie through the ages. "It didn't matter when they took place, just as long as he was the subject of that work, which I thought was really a cool idea. To see Charlie over fifty years. And I've seen ones of him when he was about eighteen years old, if I understand correctly. And I drew him when he was in his mid-seventies," says Gerry. "There's this kind of ceaseless change. Somebody said once that every cell in your body is replaced at least once in your lifetime. It's more like you have a blueprint, and even the blueprint is constantly changing," Gerry adds. "So the question is like: who are you?"

Who are you, indeed. And what will happen to you after you die? These questions are the reason I take comfort in the *contemplatio mortis*–like drama and repetition of my work as a model. All spirituality and religion—categories which some would say encompass art—are really a means of attempting to find an answer for death. John Berger writes that art is "an affirmation of the visible which surrounds us and which continually appears and disappears. Without the disappearing, there would be perhaps no impulse to paint, for then the visible itself would possess the surety (the permanence) which painting strives to find." I'd add that without this constant threat of disappearance—with death, of course, being the ultimate disappearing act—there would be, perhaps, no impulse to pose, either.

Ariel Kotker, a fellow Boston-area model who posed for the life-sized sculpture class at BU in 1997, when she was twenty-eight, says, "I like the hard lesson of seeing things how they are, no matter what they are, even though it's always tempting to see things as something else—whether it's what your rent is, or what you look like. I'm a young lady. I'm thirty-six. But I sort of almost revel in being up on the stand and feeling ugly. Or feeling human. Feeling mortal. It's comforting, too. I can see myself close up, and it's not pretty. I mean for me. At least not mine. I really value that, because that's life, and I love feeling that every day. I'm really scrawny and my ribs stick out—I have all kinds of blemishes."

As we commiserated about our modeling experiences which—like our body types—were similar, despite the over ten-year gap in our ages, she exclaimed, "I was trying to explain how I associate modeling with mortality to my mom, and I just couldn't."

I'm not sure I can either, but I'm prepared to try. For while very rarely is the relationship between art and death so overtly stated as by Charlie and Ariel, the religiosity of art—the idea that art, like religion, is an answer to death—has deep foundations in both the Western and Eastern traditions. Through posing, I—like Charlie, and Ariel, and the terra cotta warriors—am made special; the artists transform us through their efforts, making us into objects that, though they will age, can never really die. The painter David Andrus used to try to convince me to pose for free, or rather, for a few of the images produced during one of our sessions. "That would be so vain," I would laugh, and press for my hourly rate. "What am I going to do with a bunch of naked pictures of myself? Hang them in my living room?"

"Some day," he insisted, "when you're a little old lady, you'll be glad you've got 'em. You can show the grandkids. Granny, back in the day." He may have been right, but I never accepted.

I rejected a similar offer from Doug, the sculpture instructor, to keep one of the leftover life-sized sculptures of me a couple summers after that class. I said no, for all the aforementioned reasons, and also because the thing weighed several hundred pounds and would in no way fit through the door—or be supported by the rickety, already sloping floors—of my 1940s apartment in the student ghetto of Allston. Plus it would have reminded me too much of that ugly Jeff Koons sculpture of Michael Jackson with Bubbles the Chimp, insofar as it was about the same size, albeit unpainted. Last but not least, it would have been too much like having my own ghost, my double, my astral projection sitting around the apartment, whether I was there or not. And while I like to contemplate my own mortality every now and then, I don't want to feel like I have to face it all the time.

I'll always keep the memory of that class, though, because it was the closest approximation of a death rehearsal I can imagine. When the students began their sculptures in the short dark days of mid-January, I spent three hours each Monday, Wednesday, and Friday from ten to one sitting. Toward the middle of the semester, as the days began to lengthen, we kicked it up to six hours a day by adding a two-to-five shift. By the end, when they were frantic to finish and I was more than happy for the extra money, I would frequently spend nine hours a day, every day of the week, atop the rotating platform near the windows where the April light streamed in.

According to the mission statement for a Bachelor of Fine Arts in Sculpture on the Boston University Web site, "Great works of sculpture have a powerful presence. This presence, or illusion of internal life, allows sculpture to speak about our most important feelings and ideas and to present those ideas viscerally and forcefully. In the sculpture program, the faculty focuses their efforts on teaching students to create that illusion of life inside the form of their work." So while the six junior sculptors in that semester's class were struggling to make their lifeless, gray clay look alive, I was struggling to make my living, nude body look inert. I had worked with most of these students—John, Kalman, Kate, Caitlyn, and Laura, anyway—as well as their instructor, Isabel McIlvain, during the previous semester as they created bas-reliefs from my standing figure. They knew

what I was capable of as a model: what poses I could hold, which ones were flattering, aesthetically pleasing, and challenging to re-create in clay. The pose we eventually settled on was extremely pretty, and above all, holdable. But initially I was gripped with trepidation. Try it sometime: sitting absolutely motionless for more than twenty minutes at a stretch. You'll find that there are precious few postures that feel natural, let alone comfortable, and many that would actually be excruciating to maintain, not just for twenty minutes, but for the approximately 111 hours—6,660 minutes—that I calculate I held mine for. The stakes in such a situation are high. Pick a bad pose and you risk ruining your body if you succeed in holding it, or ruining their art if you fail.

And that is why I thank every single one of my lucky stars that we chose a seated pose. The bas-relief had been a standing one, and it had nearly destroyed me, or at least my knees. "Just be comfortable. Be yourself, be natural. This has to last a long time," Isabel urged as we tried a variety of attitudes, taking suggestions for compositions from the students. Sitting poised and attentive, yet also thoughtful, I looked how I felt at the start of the semester—curious, alert, on the brink of something I'd never done before. I wasn't supposed to *be* anyone but myself—not an allegory; not a historical figure. Unlike other jobs where I'd been Nefertiti, Lot's wife, a Tufts undergraduate, or the embodiment of Autumn, I was just me. But it was completely unrealistic, of course. In real life, I would never sit around naked in the middle of a Boston winter on top of a low wooden box, itself atop a rotating model stand, torso twisted just so, bare legs delicately askew, arms taut, head gently tilted looking off into the distance at something mysterious, unseeable to anyone but me. I couldn't help feeling like a statue in a manicured English garden, a carving on a birdbath, an angel on a tomb—a tragic young woman, dead before her time—or like a body in a funeral home. I resembled myself, but I was not myself, just as the dead never looked in life as they do when viewed in an open casket.

The process of setting up was elaborate. Gerry built a box for me to sit on, and he and Doug helped the students construct their armatures out of rebar and wire and wooden *X*'s called butterflies to support the most clay-heavy parts, like my head and chest—butterflies inhabiting my brain and my heart; "butterfly," which in ancient Greek means "psyche," or "soul," or sometimes "breath." And while likeness was clearly not an issue at that early stage, I still had to be there, posing, so they could study not so much

what I looked like, but the skeleton beneath, to build the support systems for the six figures that would eventually become a fleet of me.

To pose for Isabel is to feel oneself in the presence of brilliance, although not necessarily companionability. In her fifties (maybe), bespectacled, with a tousled brown bob streaked with strands of gray and held back by a cloth headband or a spare pair of glasses, she dresses in loud knit sweaters and colorful pants and lives outside the city with her husband, where they apparently keep peacocks. She was a relative newlywed when I began working with her. She was and is fastidious about the models she recruits. She never hires men, and a shadowy rumor circulates the College of Fine Arts that a lecherous male model made a crude pass at her long ago, disgusting her so much that she foreswore them forever. She only employs women, and skinny ones at that, because she wants to see—and wants her students to be able to see—the finest details of the model's musculature.

Throughout the life-sized sessions, in fact, Isabel punctuated her lessons with, "You are just the skinniest person I have ever seen. It's lovely! I can't tolerate working with fat models." Intended as praise, her comments would occasionally make me and some of the students—mostly the female ones, who were hardly fat, but nowhere as thin as I—squirm. She would proclaim her dislike of heavy models, and would remark that my stomach had grown visibly "fatter" when I returned from my hour-long lunch break—during which I would, as is customary, eat lunch. She warned her students to watch out for this enlargement, to pick a size and stick to it and not keep changing it as I changed. I began to eat less and less for lunch in order to escape this scrutiny, but I suppose that ultimately that was my problem and not Isabel's.

Though not tactfully made, her point was a pedagogically sound one, articulated by another great art teacher, Robert Henri, who writes: "The living model is never the same. He is only consistent to one mental state during the moment of its duration. He is always changing. The picture which takes hours—possibly months—must not follow him. It must remain in the one chosen moment."

Isabel was a proponent of capturing, but not fruitlessly chasing, the pose, emphatic in her pursuit of the correctness of the form. Never before and never since have I been so thoroughly plumbed and probed as I was over the course of those fourteen weeks. She and Gerry wrote mathematical equations for the calculation of distance and scale up on the blackboard. And the instruments—there were so many: calipers, wire-cutters,

levels, scalpels, clay knives, and plumb bobs. I felt more like a participant in a surgery or a rocket launch than a sculpture, and the results were undeniably fruitful because of this meticulousness. Through it all, I remained Isabel's mannequin, the body splayed out on the dissecting table.

As Dale Carnegie reminds us in *How to Win Friends and Influence People,* "a person's name is to that person the sweetest and most important sound in any language." Being addressed by my name as I work makes me feel more human, more involved. To hear myself referred to only as "the model," especially in a class where I knew that Isabel knew me, and especially when she addressed me as Kathy when I was not on the model stand, made me feel slightly less than a person and more like an object. I felt there but not there, like when a dead relative is referred to in hushed tones by the funeral director as "the Deceased."

Most artists call me by name when I pose for them, and most professors make a point of doing so in front of their students and urging them to do the same, which of course I appreciate. Not Isabel, though, no way. To her, I was almost always "the model," or maybe "the figure." I can't say for sure whether this was an effort on her part to encourage a critical distance, or whether it was just the social carelessness that appears to be attendant upon certain people's artistic quirkiness. I have reason to suspect the latter. Once, for a birthday, Isabel brought in a round gold tin of *petit fours,* which she proceeded to hand out ceremoniously to everyone in the room but me; buttery and sweet, they smelled delicious. Again, it was not so much like I wasn't there—I clearly was, although I couldn't move—but rather like I was simply not alive. Dead people do not eat. Why would she offer one food?

This is not to imply that she was utterly thoughtless, or that I did not enjoy working for her. To her credit, Isabel did go out of her way to buy some spongy foam-core and cut out a pink cushion perfectly molded to the form of my posterior for my sitting pleasure. The human butt, if you think about it, is sort of heart-shaped. I came to think of the pad as Isabel symbolically giving me her heart, as though I was sitting atop her squishy and reticent little Valentine to me.

If Isabel was distant, Gerry and Doug and Hilary—her fellow teachers—were not, and the students themselves were super-friendly. I got to know them well, especially since we were so close in age. They were twenty-one and I was twenty-three, so we became almost like siblings or peers. There was Kate, who went on to become Hilary's studio assistant and who was

every bit as blonde, sunny, and skillful as her mentor, and Kate's friend Caitlyn, her tall brunette cohort, quiet and observant, less of a chatterbox than her partner-in-crime. There was Laura, an intensely focused break-neck double-major in art and literature, and her polar opposite Punk Rock Girl—her real name escapes me—who, though talented, was perennially absent, perpetually on a smoke-break, and highly accident-prone. At one point she managed to break her ankle (a drunken weekend fall on an icy patch), which necessitated her struggling to finish her piece while on crutches. There was Kalman, tall and gangly, seeming younger than his classmates. A fan of contemporary literature, Kalman was affiliated with the BU literary journal *AGNI*, so we talked about how it compared to the Emerson journal, *Ploughshares*, where I had my assistantship. Finally, there was John, compact and redheaded, an adept handyman who attacked his clay with ferocity and precision, and who inevitably wound up helping Doug and Gerry with technical matters.

Whenever Isabel wasn't in the room—which turned out to be often, since she was simultaneously overseeing the senior life-sized sculptors in a studio across the hall—we'd listen to music that either I would bring in, or they would: The Smiths when it was gray and rainy or snowy, Kalman's Jimmy Cliff albums when it was brighter, and John's mix tapes anytime.

Once, early in the fourteen weeks, John stuck in a mix tape with Nick Cave and the Bad Seeds performing Dylan's "Death is Not the End." The song is from an album called *Murder Ballads*, but it's just really, really funny. At first, we tried to maintain our composure. We were in the middle of something serious; we were trying to Be Professional. But by the time we reached the end of the song, the part about "When the cities are on fire/With the burning flesh of men/Just remember that death is not the end," and the chorus of backup singers so irreconcilably upbeat as to sound plausibly like Muppets came in singing "Not the end, not the end/Just remember that death is not the end" over and over again, we all broke down and laughed our faces off. I suspect it was so ridiculous and hysterical and disturbing because we'd all been thinking of death because of the work at hand, and because none of us were totally sure that we agreed that death was *not* in fact the end.

The sculpture studio is such an intimate place anyway that I think it would have been hard for us not to become attached to one another. Sculpture tends to be more hands-on than other arts, with the sculptors continually approaching the model stand to rotate you slightly so they can

get a better angle, like you're on the world's slowest and most boring Teacup Ride. They clip you gently in their calipers, and use your limbs to steady their plumb bobs, dropping lines from your elbows, nose, and knees. When it comes out of the package, the gray clay is thick and slippery, like Crisco in the sculptor's kneading hands. You can picture each sculptor as a god, creating a form in his or her own image, or at least as someone doing a God imitation, concocting a golem that looks like you. As the clay is added to the armature, it begins to dry and harden, so they must mist it with water from their spray bottles. Sometimes they miss their sculptures and the fine drops settle on your skin.

As we entered the last few of the fourteen weeks, the pieces began to grow heads, hands, and feet: the most intricate, difficult, and therefore final parts. Because of their fine detail—eyebrows, fingernails, nostrils, and ears—they were also the parts most likely to dry out, so Isabel got the sculptors in the habit of always covering these parts with cloth or plastic—wet cotton rags or tarps—whenever they left the studio, no matter for how short a time, be it to go to lunch, another class, or just to the bathroom. In this state, my fellow Kathys, as I by then felt inclined to think of them, took on the appearance of cadavers, who also have their faces and hands kept out of sight for the sake of their dissectors.

Since these other Kathys now looked so human, and so much like me in particular, it was extraordinarily upsetting when John—dissatisfied with having sculpted my head at the wrong angle with a neck that looked afflicted by a case of scoliosis—suddenly took my head in his freckled hands and yanked it off so hard that he fell backward from the force. Because of the position of the model stand, he was directly in my line of sight, and I was so aghast that I broke the pose, cringing. John's five fellow sculptors also stopped what they were doing. "What the hell was that?" asked Punk Rock Girl. Shaken, he explained himself, apologized, and we all ended up laughing, but it was an uneasy laugh. We had all just seen me in an oddly affecting light: in effigy, decapitated, and definitely dead. The incident became a joke, the stuff of classroom lore, and Doug tells me it still gets recounted from time to time to upcoming generations of junior sculptors as a lesson in sensitivity to one's model and to one's fellow artists.

And even though, since we were all friends, we spent a lot of time talking, I still had to spend the majority of my time letting them work, silent and still and thinking to myself about cars on the highway, trains going by, pigeons on the windowsill, and workmen outside; everything seemed to be

in motion but me, frozen in a kind of purgatory. Thoughts like that were
no way to make the hours fly, so I had to encourage my brain to wander a
bit farther afield. A relatively recent transplant from Washington, D. C. to
Boston at the time, I compared the cities' public sculptures in my mind—
both cities are lousy with them—and the way we erect images of our note-
worthy dead to keep them present in our national memory.

A couple years later, doing research for a class I was teaching at North-
eastern University, I learned that Isabel herself had sculpted such an image,
a bronze statue of John F. Kennedy, erected on May 29, 1990. Her JFK
stands on the grounds of the gold-domed State House on Beacon Hill,
amid sculptures of fellow martyrs Anne Hutchinson, banished in the early
seventeenth century for questioning Puritan theology, and Mary Dyer, who
was hanged for her Quaker beliefs. These sit just across the street from
Augustus Saint-Gaudens's memorial to Union Civil War colonel Robert
Gould Shaw and the Fifty-fourth Regiment, better known as the nation's
first regiment of African American soldiers.

As part of that fall semester's first assignment, I showed my first-years
the film *Glory*, then piled them onto the T, which we rode together to the
Park Street stop on the Boston Common to look at the bronze relief. A lot
of the students found it puzzling at first, this field trip in college, especially
to a place that so many of the native Bostonians among them had already
been on previous school outings. But then we talked about how the place
is really kind of amazing. It is a sculpture of the dead who have been dead
for well over a hundred years, having died in terrible ways, but who live
on at the corner of Beacon and Park streets amid the quacking Duck
Boats, the Beantown Trolley tours, and my students themselves. Some of
them moped and were bored, but others got into it, taking pictures with
their camera phones, putting their arms around my shoulders and the
shoulders of their classmates with the monument in the background:
memorials of a memorial. Some of them wanted a souvenir, which, remem-
ber, means "remember" in French.

After I thought to myself, "Boy, Robert Gould Shaw really does look a
whole lot like Matthew Broderick," I thought of Robert Lowell's poem
"For the Union Dead." I handed it out to my freshmen, and we read it
aloud. The part where Lowell writes:

Two months after marching through Boston,
half the regiment was dead;

at the dedication,
William James could almost hear the bronze Negroes breathe.

Their monument sticks like a fishbone
in the city's throat.

gets me every time.

Such images—both historically specific ones, and more anonymous ones like the sculptures of me—are so pleasant and creepy because they are messengers of the past and reminders of the inevitable passage of time.

Once the heads, hands, and feet were attached to the replicas of me, to walk into the studio each morning was to walk into a world of colossal uncanniness. This presence of the *unheimlich* is attributable, I think, to Isabel's prowess as a teacher. Since then, I've walked into numerous other sculpture studios full of Kathy statues and felt not the least bit odd, but this has been because while the figures were *supposed* to look like me, they hopelessly did not. In these cases, the students lacked the discipline and skill of my beloved junior sculptors, and their instructors lacked the commitment and gravity of Isabel.

I've walked into studios to find rough images of me getting adorned with wings, halos, or horns. One summer, in Doug's portrait sculpture class, there was an elderly student who'd recently had eye surgery, and she kept facing the wrong direction, not even bothering to sculpt what she saw, but just what she knew, which of course was her own face. Her sculpture ended up looking like pretty much no human being, but any resemblance it did have to a real person was to her, down to the huge witch's chin, as Doug called it, and the poor squinty eyes. It was sad, her sculpture: monstrous and touching.

I've been sculpted with elephant ears and mountain-crag noses. When students begin to go overboard on these features, I remember what Doug told me, that your ears and nose, because they are cartilage, keep growing long after everything else has stopped, and has maybe even begun to shrivel and shrink. That's why old people have such disproportionately big noses and ears: Dumbo men and beaky women. Having inherited the strong nose and prominent ears of my father's side of the family, if I survive long enough, I'll have ears that will most definitely hang low, wobble to and fro, etc., and a nose that will enter the room full minutes before the

rest of me. Easily spooked though I may be, these freak-featured images just don't have the power to disconcert the same way images that put me in mind of looking into a mirror do.

That first semester of 2003, I often found myself thinking of Dante Gabriel Rossetti's superbly melodramatic painting, *How They Met Themselves,* in which a dewy young velvet-clad couple in an attractive sylvan scene (one half of which consisted of the marked-for-death Lizzie Siddal) happen upon their sinister, gold-glowing doubles. The real woman faints in fright into her lover's arms because she knows that these imitations can only mean one thing: the two of them are about to die. And so I thought of doppelgängers—sechsfachergängers?—and how they are said to be harbingers of their viewer's impending demise. I wondered if it could possibly be good for me to see myself so much, living eye to clay eye, all these mes but not-mes, like walking into a morgue full of Kathys. The experience had been so much fun at first, and on the whole it still was, but I began to psych myself out, talking about it all the time, probably driving my friends crazy.

These impassive, funhouse-mirror versions of myself make me wonder whether posing makes me dead or immortal. If I am being vampirized— my life force sucked in service of a greater, longer-lasting version of myself —or if I am in fact the vampire—a being neither living nor dead, who will exist, albeit in a not-quite-human form, forever.

I'm not the only one to have contemplated the vampiric nature of posing, although others have concerned themselves more with literal as opposed to metaphorical implications. According to a vignette on the peculiar, clever, wholly fictional Web site of the Federal Vampire and Zombie Agency (bear with me), Botticelli's favorite model Simonetta Vespucci—the face of virtually all of his Madonnas, Venuses, and allegories, and the relative of the famous navigator Amerigo—herself became a vampire shortly after all that posing. After Simonetta succumbed to tuberculosis at just twenty-two years of age (as the poker-faced FVZA tells the tale) her lover Giuliano de Medici "decided that keeping Simonetta alive as a vampire was better than letting her die." Things don't go quite as planned for Giuliano: he ends up dead, his beloved is destroyed, and Lorenzo de Medici is presumably forced to cook up the story of the Pazzi Conspiracy (in which Giuliano wound up getting stabbed an impressive nineteen times) to cover up his brother's fatal traffic with dark forces.

Vampirism aside, Botticelli continued to work from Simonetta's death mask throughout the rest of his long career, and legends of somewhat more ancient vintage than FVZA's hold that he insisted on being buried at her feet. Although Botticelli loved her from afar, before and after her death, her real love—and here the FVZA was on the money—was Giuliano, Lorenzo the Magnificent's brother. After both Simonetta and Giuliano were dead— Simonetta of disease in 1476 and Giuliano of assassination in 1478— Botticelli used their likenesses for his *Venus and Mars* of 1485.

Like so many other models—perhaps in keeping with notions that beauty cannot last forever—Simonetta seemed eerily marked for death. Those around her, even those who loved her, seemed almost eager for her to die so that she could become immortal. Sforza Bettini, who, unlike any of us, laid eyes on the body of the real Simonetta, wrote that her newly dead corpse "was carried through the streets of Florence to her tomb at the Ognissanti with her face uncovered, 'so that all might see her beauty, which was even greater in death than it had been in life.'" Thanks to Renaissance Florentines' melancholic interest in the ephemerality of all that was lovely and mortal, the deceased Simonetta went on to be "the only artist's model in history to be painted more often after her death than during her lifetime."

Botticelli's Dante-esque love for his Beatrice stand-in was said to be so pure that he only painted her nude once, and that too was from memory, and almost certainly from imagination. Completed in 1485 or 1486, nine to ten years after she perished, his iconic *The Birth of Venus*—also known as "Venus on the Half Shell"—presents his beloved as both an individual and as the embodiment of classical beauty. Conveniently, Simonetta really was born in Portovenere, said to be the place where the goddess of love emerged dripping and incandescent from the ocean. In Botticelli's memorial, allegorical figures of the wind to her right blow gently on her bare flesh like a radiant birthday candle, as the hands of a beautiful—although not so beautiful as Simonetta—servant reach in to her left to cover the goddess up.

Ultimately, Botticelli fell in with the followers of the Dominican priest and iniquitous book-burner Savanarola. In the 1497 Bonfire of the Vanities, Botticelli himself tossed untold numbers of his posthumous images of Simonetta into the flames along with dirty pictures, pornographic books, mirrors, jewelry, makeup, and other fripperies of the earthly world. Savanarola went on to be simultaneously hanged and burned at the stake.

Botticelli, meanwhile, lived until 1510, and his final works happened to be illustrations to Dante's *Inferno* in which "in Beatrice we see a striking likeness to Simonetta," still young, still being duplicated over thirty years after her death.

In the end, my friend, the poet Sam Wharton, was the one who helped me see all those other Kathys not as enemies or evil messengers, but as protectors. In fact, he's the first one to have seen the connection to the Chinese emperor's sculpted soldiers. In his poem, "Artists' Model," which appeared in *GSU Review,* he writes:

> Her doubles ring the room, stare blankly
> through the image of their completion:
> her warm and breathing being. Moving
> from figure to figure, she caresses
> a cool cheek, traces the curve
> of a hip, spine, scapula. She thinks
> of that Chinese emperor, Qin Shi Huang,
> who commissioned an army of terra cotta
> warriors to guard his tomb. *Would you give*
> *your un-lives to save me?* she whispers,
> laughing, willing them off their platforms.
> Imagine the soft, slurred sucking
> as they free their feet, the slow liquid movement
> of unfired clay. A host of unfinished
> herselves preceding her into the world . . .

Since the ghostly double of Lizzie Siddal was already haunting my mind, Sam's poem made me remember Dante Gabriel's sister Christina's own ode to "the Sid," as Siddal's artist-husband liked to call her. (Terrible as "the Sid" is as a nickname for one's beloved, Dante Gabriel's other pet name for his former shopgirl—"Guggums"—was even worse.) In "In an Artist's Studio," Christina writes of the model's potential loss of identity in the process of representation, as well as the dangers of idealization at the expense of ignoring the real woman:

> One face looks out from all his canvasses.
> One selfsame figure sits or walks or leans:

We found her hidden just behind those screens,
That mirror gave back all her loveliness.
A queen in opal or in ruby dress,
A nameless girl in freshest summer-greens,
A saint, an angel—every canvas means
The same one meaning, neither more nor less.
He feeds upon her face by day and night,
And she with true kind eyes looks back on him,
Fair as the moon and joyful as the light:
Not wan with waiting, not with sorrow dim;
Not as she is, but was when hope shone bright;
Not as she is, but as she fills his dream.

While I might not have been totally real to Isabel, I was to my junior sculptors. As spring came to Boston and the session wound down, they banded together to get me a thank you present, including a huge home-made card by Caitlyn and Kate with a collage on the front and a Tim Burton–style image of a saucer-eyed, pigtailed me inside, signed by everyone involved with the class.

When the statues went on display for the end-of-the-year show, the BU College of Fine Arts building became a tourist attraction among my friends and acquaintances as people flocked to see the naked me. Once, the following summer, when I walked by the Kathy guarding the entrance on my way to pose for Doug's Summer Session One class, I noticed some smart-ass had put a copy of Foucault's *The History of Sexuality* in my unclad lap. It pleases me to think that I could be in more than one place at once, that I could have a staff of selves seeing all the things I'll never get a chance to see, reading all the books that no one could hope to have the chance to read in just one lifetime.

I consider myself a fairly optimistic person, and yet my life has been spent thinking about death early and often. It has always struck me as phenomenally unfair that regardless of whatever afterlife you believe or do not believe in, this particular lifetime you are living now is the only one you will get in this world as we know it. I realize that a lot of people feel this way, but I blame my harder-core morbidity—all my gothier obsessions with graveyards and suicides and mysteries of the unexplained—on a) Catholicism, and b) my much-loved Granny Marie.

Granny is the most devout human being that I know who does not also happen to be a member of an actual holy order. The youngest daughter of a deeply religious Nebraska family of Czech immigrants, her older sister Elizabeth became a nun and three of her four brothers became Redemptorist priests, with the youngest winding up as a bishop in Brazil.

Granny Marie is always on about religion and death. Before she moved to an assisted living facility, her walnut china cabinet was packed with delicate knickknacks, each with an eloquent and melancholy backstory—her secular imitation of a Catholic reliquary. That cloudy crystal bulldog with the dull gold eyes belonged to my great grandmother's youngest brother, dead of leukemia by the age of eighteen. That porcelain box held a cousin's baby teeth. That ring stand was where some young aunt had placed her engagement ring until her one true love died before he got the chance to marry her. And that pocketwatch belonged to my grandfather's father, killed when the crank from his Model T impaled him in the stomach, rupturing his intestine when he was in his forties.

The footstool nearby was piled high with stacks of *Reader's Digests*, back issues crammed with my favorite segment, "Drama in Real Life," the more lurid the better: stories with titles like "Just a Cold or a Killer Virus?," "A Rabid Grizzly Ate My Face," and "Moose Attack!" I'd park myself on the davenport and read until my eyes hurt and my mind reeled, my elementary school heart thrilling to tales of doomed conjoined twins and imperiled female joggers.

Granny was our tour guide on loads of day trips, guiding my mother, aunts, sisters, and me to the eastern Nebraska Czech enclaves of Touhy, Weston, and Dwight, where we visited churches our ancestors had built. The adults would always throw in a stop at a Czech pastry shop called the Kolatche Korner to sweeten the deal, but for me the best part was the death-hunting itself. We made rubbings in cemeteries full of our relatives' bones and paid our respects at grottos and shrines, including one in Dwight, a copy of Lourdes, built by male relatives including Granny's own father as a petition for healing, seeking cures to rare and hideous diseases and injuries untreatable in or inflicted by rural Nebraska living. I watched Granny pray before rough-hewn crucifixes on which Jesus was most definitely suffering immeasurably.

And while I didn't really get it at the time, I understand now that, as critic Margaret Walters writes, "In Christian art, the naked body is a symbol, not of pride but of pathos. To be naked is to be vulnerable, sexually

self-conscious and guilty. Images of suffering, humiliation and death, rare in Greek art, are central in Christianity. Naked Adam is a reminder of our lost innocence; Christ naked on the cross redeems sin and conquers death, but only by himself enduring a brutal and bloody death." That pretty much sums up a big part of why Granny's always been encouraging us not to be terribly attached to this life—to take the really long view, if you will. Also, "Christian art [. . . .] is based on a dualistic view of the world. A sense of being divided between body and soul goes back to Plato; but in the late Roman Empire, increasing numbers of pagans, as well as Christians, felt like aliens in the world and strangers in their own bodies. [. . . .] The body must be mastered and subdued because its very existence degrades us, holds us unwilling exiles from eternity." In other words, Granny has always felt, I think, that this world is not her home; she's just passing through, and it's inevitable that I've come to inherit some of that. It's part of why I pose.

I think of Granny while posing more often than you might expect. She pops up on the rare occasions that I'm modeling for an overtly biblical piece, as when I posed for the artist Ed Stitt, who was working on a trip-tych about the three types of love: Eros, Philia, and Agape. Taking as his subject the tale of the Prodigal Son, Ed cast me in the Eros panel, where I was supposed to be a whore, nakedly clutching the son at his most prodi-gal. Granny came unbidden into my mind as I lay there, because for one thing she'd be scandalized, and for another, the topic of the piece—whether we choose to waste our lives in the thoughtless pursuit of earthly delights or to spend them in prayerful and forgiving anticipation of the next world—would satisfy her taste in art.

I think of my grandmother, too, though, at other less scripturally inspired times, because of how, by posing, I'm carving out a space to stave off temporarily the death about which she trained us. Fittingly, in no situa-tion do I think of my own grandmother more than when I am posing for a group largely comprised of other people's grandparents. This group, led by retired art professor Eso Poppo, consists of other retired professors and their friends, and meets Saturday mornings in the art studio at Pine Manor College, an all-girls institution in the affluent Boston suburb of Newton. As when I've posed with skeletons, this setup makes me think both of death and of my gratitude for the life I have before me. Several of the group members have taken up drawing late in life, but quite seriously. The members of the Pine Manor group pursue their work with an exceptional

zeal, perhaps because they know that someday, maybe sooner rather than later, they won't be able to. Each time I pose there, someone is missing, unable to make it because of a broken hip, pneumonia, an ailing spouse.

The last time I posed at Pine Manor was in October 2005. One of the group members, Ephraim, was sick with a brain tumor, gradually dying in weird, alternately wordy and wordless stages, but still drawing. He continued to speak in sentences, but sometimes their syntax was tortured and they made no sense. That day, though, he was lucid, and he told me that he was glad to see me, and that my being there was a funny coincidence. Of all the sketches he's done, he told me, of all the hundreds and hundreds he's finished over the course of his fifty years as an artist, he has only just recently hung one up in his home. As luck would have it, it is of me, and now here I am, their model today. His wife, he said, insisted that he put one of his works up before he died for him to enjoy while he's still here and for her to remember him by after he's gone.

I have a friend named Godfrey, whom I met while posing, who's fond of a quote that he thinks is by Auden (I can't substantiate),* about how every year, you pass through the anniversary of your death. The members of the Pine Manor group are, statistically speaking, probably closer to reaching those dates than I am. Unlike my granny, few of them talk *ad infinitum* about their ailments and spiritual beliefs, but I do feel as though, if I look hard enough, I can see that death is all around them, driving them on. If you cannot be a perfect body, the subconscious rationale seems to go, you can at least paint and thereby possess a perfect body; whereas one disappoints by aging and fading, the other lasts forever.

I agree that this is often the case. But the Pine Manor group consists of an even balance of men and women, and they hire models of all kinds— not just nubile young things—so unlike other sessions I've encountered where the most palpable tension is perhaps sexual, the Pine Manor group is really pretty wholesome. They are comfortable with what they do, and that is why I was so comfortable working there.

Historically speaking, the whole Eros–Thanatos mess has not always been so smoothly sublimated. Suicide fascinates me, and always has,

*I couldn't find any attribution to Auden online, but I *did* see it attributed to Buckaroo Banzai, the protagonist of the classic 1980s sci-fi spoof *The Adventures of Buckaroo Banzai Across the Eighth Dimension* . . .

mostly because I could never imagine committing it myself. Part of why I pose is actually bound up in my irrational superstition that even if, heaven forefend, I meet an untimely end, I will be able to enjoy some kind of earthly immortality, if only in the surviving works for which I've posed. Fortunately, art history is full of famous love-death spirals between artist and model to satisfy the rubbernecking desires of such people as myself. My favorite—if that's the appropriate word—art-historical endgame is that of Amedeo Modigliani and Jeanne Hébuterne. Star-crossed from the start, Jeanne and Modi's relationship ended when he died of tubercular meningitis at the age of thirty-five. Jeanne, eight months pregnant with their second child, was taken from the apartment she had shared with the artist to her family's home. There, just two days later, at approximately three in the morning of January 26, 1920, she flung herself to her death from a fifth-floor bedroom window.

I've never gotten the impression that any of my artists would kill themselves over me, nor have I ever felt in danger of killing myself over one of my artists. Yet I do on occasion feel as though I might be putting life and limb on the line for the sake of a pose. Once, Nathan and Harriet, two members of the Pine Manor sketch group, hired me to take the train out to their home and studio in Framingham so they could shoot photographs of me to paint from later. After standing for about fifteen minutes in the freezing wind and snowy drifts left over from the previous day's blizzard, I had to call Nathan from the station because he'd forgotten me. (I'd say that this was a result of his being older and therefore more forgetful, but I'm inclined to say he forgot me just because artists of all ages tend to be, in my experience, naturally flaky.) As soon as I got into his car, Nathan started to tell me the news of David, another artist from the group who had died recently of the leukemia that he'd had for ten years, and how he had worked on his art right up until the end.

You might think that with this news of death hanging in the air, the shoot must have been a bit of a downer, but all in all it was pretty upbeat. After Nathan shot a couple of rolls of me in various costumes, we headed back into the house, where Harriet would shoot me for the last hour of the session. This is where things got dicey. Harriet and Nathan have two enormous dogs named Scout and Luke, both Labrador retrievers. This breed of dog is known for being affable and encouraging, even in their coloring—one chocolate and one yellow, like types of cake. Unfortunately for my "Drama in Real Life"-reading peace of mind, at this particular

juncture in current events, so too were labs known as the breed of dog that had recently mauled a thirty-seven-year-old woman in France, thus allowing her to go down in history as the first lucky recipient of a human face transplant.

Granted, the dog responsible for the attack had been a *black* lab, but still. When Harriet had me pose—or rather, tried to have me pose—with the yellow dog, all I could picture were the headlines that would surely follow my own gruesome accidental mutilation. Sitting there in their library, posing in my petal-pink nightgown, practically naked and exposed, concealed dog treat in one hand, full-blown silk rose (a Pre-Raphaelite emblem of mortality, I might add) in the other—what else was I supposed to think? The dog treat was supposed to encourage Scout to stop scratching at my legs and licking my face, but alas, he was "just too hyper," as Harriet put it.

Ever the professional, I remained collected on the outside. Harriet kept telling me I was "such a good poser." Meanwhile, on the inside, my freaked-out mind kept returning to the irony that, if I were to be irretrievably maimed while modeling, my face and body, the assets with which I earn so much money, would be ruined. Clearly, I escaped the episode unscathed, and I ended up going back to pose for Harriet and Nathan again. But the incident got me thinking about how even if my face doesn't wind up getting eaten off by dogs, said face will not always look quite so nice as it presently does. Even though I believe that I get hired so frequently because I am dependable and hardworking, and even though art is a field in which all ages and body types are welcome, I realize too that my getting a lot of work and my being young, thin, and feminine are not unrelated.

Like many women—and men, I suppose—I'm nervous about getting old, and feel like I am already, even though I'm just twenty-seven and still get carded, sometimes even at the movies, where *nobody* gets carded. I do not look forward to gray hairs, crow's feet, and cellulite, the loss of clout and influence, and the invisibility and lack of desirability that come with these natural developments. Our culture fetishizes youth and is populated by consumers who sculpt their bodies with as much rigor as my junior sculptors sculpted their Kathys, many going so far as to put themselves willingly under the plastic surgeon's knife, plumping boobs with saline or chopping flesh out of them, cutting off extra nose, sucking away excess flesh like so much clay. We think we are a culture obsessed with youth, but everyone is death-obsessed, not just me.

I read the *New York Times* magazine every Sunday at breakfast, and when Deborah Solomon interviewed Austrian Nobel laureate Elfriede Jelinek, I stopped, set down my coffee, and jotted this quote in my notebook: "I describe the relationship between man and woman as a Hegelian relationship between master and slave. As long as men are able to increase their sexual value through work, fame or wealth, while women are only powerful through their body, beauty and youth, nothing will change."

And I realize that because of my age it is ridiculous, even obnoxious, of me to be so apprehensive about aging, and I realize that it's absurd, the way we are trained to fear and despise what is natural. But I also know on which side my bread is buttered, and that my success as a model can't and won't last forever. When we were discussing our life-sized posing experiences, Ariel said, "I used to think I was all set, that I could do it as long as I lived in a city with an art scene. But my body is aging quicker than my spirit. I'm thirty-six. I can do a thirty-minute standing pose, but not a one-hour or a three-hour."

According to France Borel, Renaissance humanist polymath Leon Battista Alberti "was among those who emphasized the fact that painting had a major role in transmitting the image of the absent and in particular those who were absent forever—i.e. the dead."

Growing up, the young-adult novelist Gary Paulsen was—come to think of it, he kind of still *is*—one of my favorite authors. In sixth grade, my teacher, Ms. Murphy, had our class read his book *The Monument*. I cannot forget the scene in which Rocky, the protagonist, a mixed-race adopted teen with a bum leg, is going through a book given to her by a visiting artist. She is suddenly struck like a punch in the gut by the realization of the titanic absence hidden in a painting of a troupe of dancers. The book she's looking at, of course, is a Degas monograph, and here is what happens:

> I was still trying to work, trying to see the colors and the way Degas had drawn things until I turned the page and just stopped, stopped dead. It was a painting of a group of young women practicing ballet, called *The Dance Master*. [. . .] On one side there is an older man leaning on a cane—an instructor—and he is watching them, studying them, and still I would have been all right except for one girl. She was standing to the side of the dancers, but almost

in the middle of the painting and she is watching them, worried about something, with her hand over her mouth, and I looked at her and started to cry. She looked like me, but that wasn't it—at first I didn't know why I was crying. Then I thought of what they were, all of them, dancers, and that all of what they were was gone. The painting was done in the late eighteen-hundreds. They were all gone. All dead. I wanted to know the girl, wanted to watch them practice. I wanted to see the dresses move and hear the music, wanted to know which ones the dance master picked for perform-ance and if the girl who looked a little like me was one of them. [. . .] I wanted to know their dreams and hopes and all of them, all the girls in the drawing and the dance master and the people sit-ting in the bleachers and the light and maybe even the building were dead and gone. I would never know their names or their favorite colors or what kind of music they liked or what they thought of school or what they had for supper. Gone, gone, gone.

It is a damp and frosty night in the middle of December 2005, and I am posing at the Museum of Fine Arts in Boston for the Drawing in the Galleries event offered on Wednesday evenings, when admission to the museum is free. That evening, we happen to be in a gallery featuring early American art by John Singleton Copley and his contemporaries. As I lay there, an odalisque in black tulle atop the faux-leather bench I've comman-deered as a makeshift model stand, being drawn by dozens of patrons, I study at the art on the walls. Directly across from me is a Copley oil por-trait of one Mrs. Ezekiel Goldthwait (née Elizabeth Lewis) circa 1774. At first I am envious of her, since her outfit is a lot more seasonally appropri-ate than mine. Then I think of how very little she must have bathed, and how bad she must have smelled. She is as round as the fruit in the bowl atop the dark wood table at which she sits, and her doughy hand rests palely atop some heirloom apple. Her wide white face is maternal, kind. I want to touch her dress. She is about to say, "You must be cold, dear; you'll catch your death. You should wear more clothes, you know, winter in Boston. The way they make you work like that—what are they thinking?"

Next to her, on the opposite side of a piece of period furniture, hangs her husband, Ezekiel himself, a stern-faced settler, quill in one hand, paper in the other, not looking at me, at the viewer, but off into space some-where, presumably at the great ideas of a great man. As I count down the

seconds of my final twenty-minute pose of the night, I hope he treated her right, that he didn't beat her, or sleep with their hired help, or wear her out by making her have an ungodly number of colonial children.

There is another Copley at my feet, a portrait of a Mrs. William Coffin (née Ann Holmes) who looks every bit as fun and lively as her name suggests. She looks as though she is about to speak, too, like Mrs. Goldthwait, only she might be meaner, nastier, and comment on what kind of girl I am, lying there like that, where surely the people at my feet, including herself, can see straight up my skirt, thank you very much. To her left is a portrait by Charles Willson Peale: Timothy Matlock, circa 1790, in tight blue breeches and a scarlet topcoat, his finger resting elegantly alongside his face, his appraising eye saying that maybe he'd like me to sit in his lap, like one of my groping bosses at the gallery in Washington, D. C.

I have no idea what kind of people they truly were, but imagining them as they might have been passes the time, and as the last of the twenty minutes of the pose slips by, all I've concluded is that—like Rocky's dancers—they are all of them dead, every last one.

Godfrey has come to meet me, draw me, and afterward to take me out for goodbye drinks, because I am moving away. In the long corridor on the way to the water fountains and bathrooms where I'm heading to change, one last image catches my eye. Godfrey waits patiently while I gape at the painting, read the plaque, and take some notes. It's an 1805 self-portrait by Washington Allston, also known as the American Titian, a romantic painter and sort of winsomely terrible poet after whom my Boston neighborhood—the neighborhood I'll be leaving in just a few days—was named. It is rumored to be the only area in America named for an artist. He's young and handsome, his eyes shining and his hair tousled in a way that, were you to button him into a vintage shirt and skinny jeans instead of a waistcoat, high collar, and cravat, might make him fit in at any number of the shows that now take place nightly in what's affectionately known as Allston Rock City. If I met him now, maybe we'd hang out. He's actually pretty hot, although I wonder if it might be because he's been flatteringly painted, given the artist's understandable bias. He was only twenty-six at the time, one year older than I am at the moment, and now he is dead, too. He passed away in Cambridge in 1843.

That night, instead of Auden, Godfrey's on about Saint Augustine. He shows me a quote from the book he's been reading, *The City of God.* Augustine says that on the eighth day, when God completes his work of

creation, "There we shall rest and we shall see. We shall see and we shall love. We shall love and we shall praise. Behold what shall be in the end and shall not end. For what other thing is our end, but to come to that kingdom of which there is no end?" And we sit there in the bar, knowing we can't really have immortality, and that eternity is mind-blowing. And we think about where we've just been, why we draw and why we create, why we leave little records of ourselves and of others behind.

Take a Picture — It'll Last Longer

I found Jon on Craigslist in Boston, then he came to find me in Harvard Square. I was standing near the Red Line subway stop, carrying an umbrella and wearing my red raincoat. I was not wearing socks and I was not wearing underwear.

Lacy unmentionables, boxers, panties, briefs, leave marks in naked skin—strap lines from bras, tracks from elastic waistbands. Barely consequential to the naked eye, these traces can ruin a nude photo shoot. So, as my soon-to-be employer had commanded, I was going commando. I would have known to do so anyway, even had he not mentioned it—his baritone hesitant, sheepish, through the earpiece of my cell phone—because I'd engaged in this weird transaction, conspicuously lacking in foundational garments, dozens of times before.

As I stood on the slick gray bricks beneath the drippy rain, I was nervous. Any time I hooked up with an artist through Craigslist, the rendezvous had an outlaw vibe: it was an underground setup, and I got paid under the table. I had not met this individual through another artist, through a school, through a group or a class. There was no referral, no background check, no institutional backup. It felt kind of like buying weed.

As I called Jon on my cell to tell him I was there, I stared at the Out of Town News stand in the old subway kiosk, bustling with customers, people in trenchcoats, in peacoats, in hats, onion people wrapped beneath layers and layers of clothing because it was still damp and chilly, even though it was early spring. None of these readers buying journals and magazines from all over the world knew my secret. No one in the entire square knew

my secret. No one but my fiancé, Martin, whom I'd brought along for the sake of safety, knew my secret: that I was as poised and prepared as a flasher beneath my jacket. Every time Martin exhaled, I could see his breath. Every time I exhaled, he could see mine. That was why he was there: to see for himself that I would be safe, to see for himself that I would stay alive.

A boxy blue Volvo pulled to the curb and the middle-aged man inside waved, as spastic as his windshield wipers. The rain began to fall harder as we opened the doors and darted inside.

"You must be Kathleen," Jon said as I hopped into the front passenger seat.

"Yes," I said. "I must."

I introduced Martin and explained why he was along for the ride. I'd been worried that Jon might be annoyed, but he understood. He said he'd be happy to show Martin the studio, but once the shooting began, Martin would have to leave. That seemed reasonable to me. It was peculiar enough to strip naked and cavort photogenically for a strange man and his camera, but having my fiancé there observing the proceedings would have kicked it up from a photo shoot into the realm of theater of the absurd, maybe even theater of cruelty, depending who you asked.

"You're right to be careful," Jon said. "I could be a psychopath."

He seemed to be sweating slightly, tiny beads on his high, pale forehead, beneath the steely curls of his receding hairline, but it might have been the rain. I could smell his leather jacket. Everything seemed filmy for a moment, stained. I attempted a cool laugh, but it came out edgy, jagged like glass.

"Right," said Martin. "And you're a brave guy, too. You don't know us at all. We could be Bonnie and Clyde."

Now it was Jon's turn to look anxious. I laughed again, for real this time, as I pictured the preposterousness: me pulling out a pistol and saying *Drive, art man, drive!*, making Jon take us to the nearest bank, robbing from the rich, giving to the poor, heading off into the bloody sunset.

"But seriously," Jon said, recovering nicely. "I respect that—your caution about safety. You'd be amazed how many people just show up alone. People will do anything when they're desperate, I guess."

I didn't consider myself desperate, but I guess I was—though not for money. I didn't know for what. Having worked steadily as an artist's model for the past several years, the majority of my gigs had been with life

drawing classes, printmakers, painters, and sculptors. Only very occasionally did I agree to pose for photos, and almost never with photographers I didn't know, by referral or reputation. This time I'd conceded to the arrangement because the pay was excellent, and also for the thrill of it.

Unbidden by us, with pistols or otherwise, Jon had started to drive. The watery light of that early Saturday made the city of Cambridge look black and white, all concrete and gray, few trees and little grass. But as we drove north the streets grew tree-lined, and we realized it had suddenly become spring without our noticing. Martin and I were not drivers; we did not own a car. Insurance was expensive, and there was no place to park. We walked or took the subway everywhere, and now heretofore unseen parts of our greater geographic area were adding themselves to the maps in our minds. Yardless apartments built right up to the sidewalks gave way to lengthy driveways and lavish homes owned and resided in by single families. Saucer magnolia buds had appeared and opened on the trees as if by magic, or time-lapse photography. The breeze blew through them. It sounded affluent. Maple leaves swished against each other greenly, like feathers or money. I commented on their prettiness.

"Color is very important to me," Jon replied, his ice-blue eyes fixed on the rain-slick asphalt. "I like to work in color."

I learned from Jon that he was a small-business owner, something to do with architectural interiors—hardwood floors, ergonomics, and antique furniture—and that he used to be a rock photographer back in the seventies. The trees along Mass. Ave. grew more massive, and the shops more specialized. Yoga and tea and aromatherapy and boutiques offering goods and services of the kind Martin and I would joke to each other that you would not want to be caught shopping for when the revolution finally arrived.

"Sex, drugs, and rock 'n' roll," Jon muttered, his soft, round hands at ten and two on the steering wheel, like a driver ed video. "Those were the days." Martin asked him questions about his job, and Jon talked about speculative sales and buys and colossal sums of money that I couldn't fathom having. Now he lived in a northern suburb, filling his days with business, nine-to-five and beyond. Weekends, Saturday mornings like this one, were the only time for him to do his "snaps," as he called them.

"Snaps," as in: "I was telling my wife the other day, 'Honey, I appreciate family time and all, but I've got to leave space for my snaps,'" and on the last word, he whipped his two o'clock hand from the wheel and snapped

like an audience member at a Beat poetry reading, or a restaurant customer summoning a tardy waiter. I was the one about to strip down to my skin, but already Jon had begun revealing himself. Hopes and traits that might not be visible in his everyday interactions—with his kids, with his colleagues, with his wife—were nakedly on display right here in his Volvo. I turned my gaze from his still-quivering hand to the passenger side window.

The scenery had changed again. DeVito Funeral Home, MIRAK Hyundai, then MIRAK Industrial Park on the right, looming and anonymous—a perfect place to dispose of a body, maybe.

Jon's cute and bricky studio was behind the nondescript monstrosity. The two- story structure was crumbling, but in that well-kempt New England way, a style of decay that wasn't really decay at all, but a badge of age, significance, and history. The place used to be a leather factory, Jon explained, but the new owner had rezoned and converted it to studios. There were two or three other artists in the building with him, but he didn't know any of them, not very well. He parked the Volvo and said, "Well, now, shall we? Step into my office," and we followed him up the cobblestones, not knowing what to expect.

Each artist was different, and so were their expectations of me. I wondered how many times I could try my hardest to be exactly what someone else wanted. I wondered how many times I could do this before it would seem routine.

Partway down the Craigslist community message board under the heading "artists," Jon's ad had stood out like a spectacular roadside attraction. The night I found it, I'd been working my part-time job at the Museum of Fine Arts Bookstore. It was a Friday night, and the place was desolate. My colleague Stephan, a snarky painter with a floppy haircut and a wonderful bad attitude, had just found a five dollar bill on the thin gray carpet near the architecture section. No one else but me in sight, he finders-keepersed it, thrust the windfall into the front side pocket of his impossibly tight pants, and called out in delight, "Hooray, hooray for this glorious worker's paradise! I've just doubled my hourly wage!"

Stephan was exaggerating, but only slightly. The job was fun, prestigious, easy, and—in a city like Boston, with its limitless supply of arts and humanities scholars willing to be underemployed while they became overeducated—extremely difficult to get. An employers' market, in other

words; our wages reflected that. Unable to count on a steady supply of forgotten fives myself, I chose to use the computer at the info station—the ancient white one we were to use to find books for customers—to hunt for additional means of gainful employment.

Strictly speaking, I didn't *need* to pose nude for photographs. I had two steady jobs already, the bookstore and a tutoring gig at Berklee College of Music, not to mention as much modeling as I wanted for art classes at local universities. There was still never enough money, but I could have figured out something else to do. Yet as much as I disliked posing for nude photos, some part of me wanted to. I couldn't say why, but I felt compelled, like I was my own cognitive behavioral therapist making me face my fears again and again. Or maybe it was less wholesome, less healthy, a what-can-I-get-away-with thing, a cheating death thing, a drug thing: a high, a hit, a thrill, a kick, a rush, a fix. Yes, a fix, like I was broken, and the photos would patch me. Then I'd break again, and sign up for another session.

Sneaky and silent, I zipped across the Craigslist landscape while my manager wasn't looking, my eyes peeled for the words "nude female model wanted." That night, as usual, most of the postings were from amateurs and students with nothing to offer by way of compensation, or from kinky lonelyhearts: thinly veiled calls for partners in mildly pervy fantasies, hungry, seeking, and badly spelled—"Glamor, pinup, fashion, swim wear, lingeried, nude. You know you have always dreamed of it!"

But suddenly, there it was, majestic and alluring as mountains rising from the plains, gleaming like a Vegas billboard in an otherwise dark sky—Jon's ad: "I'm a photographer in search of a female who would be interested in doing a beautiful, sensual photoshoot. I'm looking to create a beautiful set of images. Full nudity will be required, and your comfort level is always my number one priority. If you'd be interested in learning more, please send an email telling me about yourself, age, looks, etc. In addition to a beautiful CD of images of the shoot (or shoots) we do together, a generous hourly rate will be paid. Please get in touch and we can discuss the details. Have a wonderful day."

A little cheesy, maybe, what with all the beauty and the sensuality and the wonderful day. Jon's post was nothing fancy, but it contained the words "generous hourly rate," and it lacked the photography model's most hated abbreviation: TFP. Short for Time for Prints, TFP meant there was no chance—no chance—I would get paid for my effort, for my body. TFP meant there was no way the photographer could possibly interest me.

Another female model I worked with on occasion, a petite redhead with nebulous dreams of super-stardom, traded Time for Prints on a regular basis. She tried to convince me that pics for no pay could actually be a beneficial arrangement. She told me she'd heard a rumor that Julia Roberts got her start at a TFP shoot. I listened politely, but figured that a) that had to be bullshit, and b) I wasn't looking to be Julia Roberts anyway. I didn't totally understand what I was looking for, but I did know that I wanted to be able to pay my rent along the way.

I responded to Jon's ad immediately; Stephan wasn't going to be the only one getting lucky that night. About to hit send on the message containing my details—tall, young, dark-haired, thin, with experience—out the corner of my eye, I saw Stephan waving, flapping his skinny thrift store tie, an art school scarecrow. He was trying to warn me that Bill, the manager, was coming, snooping to catch me in my nonwork-related act. I snatched up the telephone next to the monitor, cradled it against my shoulder, and pretended to be deep in conversation with an art book customer. "Yes sir, thank you for that special order. I've typed it all in and saved it to the computer. Your book should be in within seven to ten business days. Why yes, sir, thank you. We'll call you when it arrives."

Jon wrote back right away and asked for a picture; I e-mailed him a headshot when I got home that night. He liked what he saw and we set up a date. But first I asked him how generous, exactly, was his generous hourly rate. Two hundred dollars cash for under an hour of work, he said. Sold, I said.

The door in the side of the old leather factory was wooden with a window at the top, blocked by a curtain. Jon fitted his key in the brass knob, twisted and pushed, and the door swung open on the base of a staircase, paralleled in its incline by an old conveyor belt. Jon started up first, and Martin and I followed. When we reached the top, Jon was puffing slightly. "I'm not as in shape as I used to be," he said.

Breathing easily, we followed him to the end of the hallway. "There's a bathroom on the right if you need to use it," he said, jangling through his key ring. "This studio here is mine."

The white-painted door bore a Hamsa, a Hand of Miriam: three stylized fingers pointing upwards, framed on either side by two symmetrical thumbs. A wide blue eye, unblinking and inscrutable, stared out from the palm and into my brown ones.

"It's to ward off the evil eye," said Jon.

It was cute—the eye on the photographer's door—but also sinister. Lots of cultures would say that I had invited the evil eye onto myself by being an artist's model, identifying my body as an object to be studied and admired. Possibly envied. Gazing at the Hamsa on Jon's door, I could not entirely disagree. Maybe I was trying to tempt the evil eye. Maybe that's part of why I wanted to do what I was about to do.

Jon gestured for us to walk in before him. A hula hoop hung above the threshold, and heavy black velvet dangled from the hoop, to provide privacy during shoots. Martin and I parted the fabric and stepped inside. The studio was loftish, comprised of what must have been a lot of square footage. If you were to shoot a movie about a weird photographer—and you were maybe in high school, with a passing knowledge of European modernist cinema—then your set probably would have looked like Jon's studio. The décor was half *Blow-Up* by Michelangelo Antonioni and half dicey dot-com startup, the spawn of a one-night stand between Swinging London and a white collar home office.

The right wall of the space was occupied by Jon's desk, atop which rested a sleek white Mac, his CDs, his phones, and files, and over which hung his calendar, his dry-erase board covered in a sloppy hand, and his forest of yellow Post-Its scrawled with names, dates, and phone numbers. The rest was pure bliss—or rather bliss as imagined by a man whose e-mail address, once the anonymous tag of Craigslist fell away, involved the phrase "chasing bliss."

The furniture didn't indicate the taste I imagined him exercising in his day job—no sumptuous hardwood, no stately antiques. The majority of the tables, chairs, and nightstands were supported by the dismembered limbs of god only knows how many ill-fated department-store mannequins. The majority of the upholstery was velour: zebra and leopard print. A faux-polar-bearskin rug lay prone and deflated on the floor, next to a lamp with a pink fur shade and a shapely female leg for a post. The room looked like somebody had tossed a Technicolor Pucci dress in a blender, then strewn the gauzy, clashing, wrinkle-free silk strands from surface to surface. The result called to mind the aftermath of a fight between a rainbow and wildcat, in which the rainbow had been shredded, beaten decisively.

The chaos of color was punctuated by naked baby dolls, the kind with real hair and eyes that blink, as well as candles in various colors, sizes, and

scents. "To give some alternate light sources, and to put my subjects more at ease," Jon explained. I considered telling him that the place would be more soothing if it felt less like a doll hospital trapped in the sixties, but thought better of it.

The room was dominated by state-of-the art equipment: lights, scrims, screens, backdrops, tripods, flashes, lenses, filters, cords, three-head umbrellas, batteries, softboxes, bags and carrying cases. But the most expensive piece of equipment of all was probably the stereo.

"Mind if we listen to some tunes?" Jon asked, and popped in the Ramones.

The walls were exposed brick, adorned with concert posters and framed matted photographs of seventies rock stars. Joey Ramone beamed benevolently from above a cheap-looking bed in the far left corner, frothy with white institutional sheets.

"So what's with the bed?" Martin asked. "Do you sleep here? Do you nap?"

"Oh no. It's just a prop. For reclining poses," Jon said.

I nodded and made a face at Martin to show that this was legit, acceptable. Martin shrugged.

"Anyway, I thought I could show you guys a few examples of my work, and then we can get started. Martin, there's a Starbucks just a few blocks up the street, if you walk under the overpass. We can pick you up there when we're done."

We gathered round his Mac, and he gave us the slideshow, accompanied by a monologue not unlike a travelogue, like he was a wealthy relative returned from an exotic trip, inflicting his "snaps" on those who hadn't been there. His work was clearly backed by serious cash, but mediocre nonetheless: bright Photoshopped nudes of attractive women floating in oceans of psychedelic color, stylized snaps of skinny unclad twentysomethings.

Over the slow-fade cycle of radioactive-looking women—overexposed, color-corrected, and heavily made up—interspersed with the occasional arty black and white shot of a single body part, an extreme close up of a butt-cheek or a breast—Jon was saying, "Thanks so much for answering the ad. These are just a few of my latest snaps, which I think explain my approach best. I'm trying to capture beauty, sensuality and eroticism. But hopefully in a manner that allows the viewer to feel those attributes rather than being more obvious. The work is still evolving. I'm glad to have you be part of that process."

What am I supposed to be getting from this? I wondered. *You're show-ing me these pictures of mediocre glamour photography, which makes me feel neither better nor worse. This is exactly what I expected. And yet, as usual, I can't believe it's happening.* I noticed as well that, as in *Blow-Up,* Jon's work included lots of full-frontal female nudity, but never any male equivalent. And that's when I saw it: a face I recognized.

"Wait," I said, as the pancake-powdered skin framed starkly by dyed blond hair flashed from the screen. "Who was that?"

"Oh—that was a snap I took last weekend. Striking, isn't she? She's the lead singer in a local band. Really crazy. A real free spirit."

"That's the chick from Fluttr Effect," said Martin.

"Yeah, man," Jon said admiringly. "You dig them?"

We did not dig them. We'd recently seen them open for a band we actu-ally liked, and they just about drove us crazy, mostly because of the singer, whose serpentine body now hovered inertly before us, suspended on the screen against a field of blood red. Her band was solid—obviously commit-ted and serious—but she played nothing, just noodle-danced spasmodically, knocking into her bandmates, kicking their instruments, almost falling off the stage. The musicians seemed barely able to contain their frustration, though she remained oblivious, spinning like a top and screeching into the microphone, dressed like trashy vagrant from a nineteenth-century chil-dren's tea party in a tattered satin skirt and an age-stained lace-up whale-bone bustier. "Oh my god," my friend Christen had leaned over and whispered. "She's too obnoxious to live. She thinks she's a fairy." And now here she was, the would-be princess in all her naked glory, twisting cornily and making eyes at the camera, basking in every second of it.

But I responded diplomatically. "We saw her open for the Dresden Dolls. They're another local band. We really like them."

"Oh yeah, man," Jon said. "That was at the Paradise Rock Club, right? I love that venue. I mean, it's got nothing on the Ratskeller—that place was like a Mecca in the seventies. But the Paradise, yeah, it's still got some of that old grit. God, I could talk about the old days all day long."

Accidentally, I made a face.

"Yeah, I know," Jon said. "We should get going." He paused awk-wardly and looked at Martin. "OK, man?"

"Sure, man," said Martin, who never calls anyone "man," raising his eyebrows at me and waving goodbye. "See you in an hour."

"Sure thing," said Jon. "Catch you at the Starbucks, man."

The black velvet curtains fell shut, and Martin closed the door to the

studio behind him. There Jon and I were. Jon stopped the Ramones album as I retreated to the screen he'd set up for me to change behind.

The Dresden Dolls have a song called "Coin-Operated Boy," about a mechanical man who will do anything for his manipulator once he gets his money. As I peeled off my jeans, the song popped into my head and wouldn't go away. I was a Coin-Operated Girl myself in a way: promise me money, drop in the coins, and I would perform. I rolled up my sweater and stuffed it into my bag. Jon had three robes to choose from, lined up on hangers on hooks on the wall: one white terry cloth, one deep red silk, and one in an Asian pattern, sewn with gold dragons. I imagined the women who had worn them before. Had Jon seemed as odd to them as he did to me, more of a dabbler with ready cash than a serious artist? Or were these women used to doing more hardcore work, so that Jon's sleazy yet innocent conception of "sexy" struck them as comparably arty, even romantic? I rejected the garments, pulled on Martin's blue and green plaid flannel robe—the same robe I wore to all my modeling engagements—and came back out.

"I hope you don't mind that I'm just wearing my own robe," I called to where Jon stood, fumbling with the stereo.

"No, that's fine," he replied. "You won't be wearing it in the photos anyway. In fact, would you mind stepping out of it?"

I slipped off the flannel as he slipped a CD into the changer. His small, moist eyes passed over me, from my red-painted toenails all the way up to my neck, then swept down again before coming to rest on my face. The first thirty seconds of nudity are always the worst: sudden and shocking, jumping instead of tiptoeing into a cold sea. Human reactions can be unpredictable, and I knew that Jon could hurt me—physically, and in other ways. I could disappoint him; he could assess me cruelly—make a face, a comment, a gesture that would leave no visible mark, but still come as a terrible shock to my system. I could trust the other artists I worked with to see the beauty in every model, but that wasn't the case with Jon. He was less an artist than a self-styled connoisseur.

"Wonderful," he breathed, looking at me and adjusting the volume.

The voices of the Delfonics began to fill the room, layered with horns and strings, all smooth and soulful: "Didn't I blow your mind this time? Didn't I do it, baby?" No way, I thought. No way, no way. It was like we were in a Tarantino film, without the ironic self-consciousness. I walked my body over to where Jon had set up his equipment. "Ten times or more,

yes, I've walked out that door . . ." My body began to pose, but my mind began to wander, drifting with the music through the studio air.

The first time I ever posed nude for a photographer, there was no music.

I hardly remember now how I found him, and I don't remember his name. I think I saw his ad—a general call for young female models—posted in one of the Boston-area art schools where I posed for paintings, drawings, and sculptures. I do remember how much he paid: fifty dollars an hour. An awful lot of money to twenty-three-year-old me, especially in summer, when my usual gigs were fewer and farther between, with most of the art students out of town and the schools running on skeleton crews. I ripped off one of the name-and-number tabs fringing the bottom of his homemade flier and dialed him up that evening. He wanted to meet within the week.

I showed up to our six o'clock weeknight appointment wearing a loose blue flower-print dress, strappy sandals, and nothing else. My hair was bobby-pinned up with a few escaping flyaways, and I was slightly hot and lightly sweaty, having walked all the way from my apartment in Allston up wide Commonwealth Avenue to Kenmore Square, near Fenway Park. Along the way, I enjoyed the breeze, the freedom, the low-hanging sun, but kept one hand at the hem of my dress to guard against updrafts.

We were meeting across the square from the Panopticon Gallery, founded in the seventies, one of the oldest in the country dedicated solely to photography. The name made me think of Michel Foucault, whom I'd been reading in grad school, and also of how I sort of always felt like I was in a panopticon—how I tended to feel like I was always being observed, whether I really was or not, and how this was probably one of the reasons I was so drawn to modeling. Who was watching? Why? Did they like what they were seeing?

He was a student at NESOP, the New England School of Photography, a busy public place, where I figured I'd be safe. I hadn't realized when we'd made our arrangements that the Red Sox would be away that night. The square was a ghost town. I opened the school's glass door, set into the side of a building shared with retail space—an optician's shop, a bagel joint, a bookstore, and a brick oven pizzeria, all disturbingly empty—and climbed the steep stairs. It had been hot outside, late July, but the classroom where I met him was heavily air-conditioned. Goosebumps sprang up on my skin as we introduced ourselves.

"Goosebumps can ruin a shot," he said. "But don't worry. It's warmer in the studio." I nodded as if I knew just what he meant, as if I'd done this a hundred times before. "I thought I could show you my portfolio to give you some ideas," he added. "Then, if you're comfortable, we can go ahead and get started."

I know I flipped through his images, black and white in plastic sleeves, but I can't remember what a single one looked like. This was not because of any lack of skill on his part, but rather because I was so anxious to get it over with. I couldn't stay focused. His work was typical nude photography, perfectly competent, and it reminded me why I'd been eager to try this in the first place. I'd been posing for artists in other media for over a year, and they seemed to find me pretty, or at least to depict me that way. But I couldn't shake the feeling that they were all taking liberties with artistic license, that I didn't actually look as nice as they—with their charcoal, their oils, their clay—said I did. Photography seemed to me more real, more accurate. I knew that photos could lie as well as, if not better than, any other medium, but I felt that they could somehow give back to me an objective example of how I *really* looked in a way that no artist, no friend, no mirror ever could. I found photography appealing for what I perceived as its oracular honesty, and for that same reason I found it simultaneously powerful and scary.

Also scary? Our trip down to the studio, which felt like a descent into hell. The guy had me walk ahead of him, through labyrinthine corridors, past padlocked boxes and splintery cabinets to the spiral staircase coiling to an unmarked door. Behind it, I imagined, lay a pit, a grave, a place to be dead. I hadn't counted on the studio being set so far from the street, at the end of a hall devoid of other students: a claustrophobic black box, utterly soundproof, in which I was supposed to take off my clothes and pose, to act natural, for the next three hours. No one else knew I was meeting him. No one knew where I was. I easily could have ended up in pieces in a Dumpster somewhere.

It quickly became apparent that I wouldn't. He was a nice enough guy, and just as anxious as I was, if not more so. We both left our shoes outside, so as not to dirty the expensive rented drops he'd laid down. He shut the door, and in that closeness, after I'd shed my dress and he had to get right up next to me to do things with his light meter, I could smell him. He was gently sweaty—a nervous sweat—and a little shaky. This reassured me. As he prepped for the shots, we made small talk about our schools, our families.

But as soon as he began to shoot me, I felt like I was being hunted. Susan Sontag—and lots of other intelligent people who observe such things —has written that the camera can be a stand-in for both a penis and a weapon, specifically a gun. In that instant, as the first barrage of rapid-fire shutter clicks echoed through the studio, radiating out from his instrument and onto my body, I suddenly understood what those people had meant.

You might think I was being paranoid, but you would be incorrect. Death has been a third party present at every photo shoot I've ever done. Photography is inherently colder, more mechanical, than the other arts. The artist could conceivably set his camera on a timer, leave the room, and come back to a made image. None of the photographers I worked with ever did that, but this ability to cut out the middle man, to remove the humanity, is not intrinsic to other media. The camera is an eye, but it is a disembodied zombie eye with no feeling of its own, a chilly little machine I couldn't interact with like I could with a painter. It is unforgiving. It is unsympathetic.

Even under normal circumstances, getting my photo taken always hurts a little, but when somebody does it over and over and over again, it begins to feel like they might want to kill me—that they would not mind having total power over me, that they would not mind making me theirs forever.

Strange superstitions arose in the early days of photography, when the camera instilled terror in the objects of its automatic eye. The commonly held idea was that it could steal a person's soul, or even their life. I had first learned about this fear on a family vacation, the one on which my parents arranged for us to stay in the barracks at Fort Robinson, Nebraska, infamous site of the murder of Crazy Horse.

Throughout his short life, Crazy Horse refused to be photographed. To do so would have been in violation of his beliefs in the preservation of his culture. He never wanted his picture taken, and it never was. He was right, it turned out: white people really did want to kill him. In the end, they did—though not with a camera, but a rusty bayonet.

I learned all this at a time in my life during which I personally would rather have died than have had my photograph taken—and when I was self-absorbed enough to think that I could in any way relate my own suffering to that of Crazy Horse. That was really too bad, because it felt like my picture kept getting taken all the time. I was thirteen and horrible to

behold: skinny, badly dressed, adorned with elaborate orthodontic head-gear, I was a walking Nerdtown, population: me.

I begged my parents to please just take pictures of my adorable younger sisters, of the buffalo roaming and the High Plains' majesty. But no, they said, they loved me and wanted me in the snapshots. On horse-back? I thought I was ugly as the horse-faced horse. On the stagecoach? I felt as though I looked like a varmint. On our Jeep ride through the buttes? Totally uncute. I agreed vehemently with Crazy Horse—getting my photo taken felt like it was killing me, or at the very least, weighing me down, making me feel trapped in a way I did not want to be.

I was obsessed with religion at the time, and with the women in it, and I remembered Simone Weil writing—though I didn't understand her (I sort of still don't)—about how she liked being ugly, and wanted to be recorded as such. "A beautiful woman looking at her image in the mirror may very well believe the image is herself. An ugly woman knows it is not," she said. I understood, vaguely, that her intimations boiled down to what Mom told me all the time: what matters, truly, is inner beauty. But I also knew, or thought I knew, that that is something ugly people say to make themselves feel better. In any event, being photographed felt like it killed my potential, pinned me down as ugly, with no option for beauty. It provided incontro-vertible evidence that I was the way I was, and that way was unattractive.

Time sped by as the photographer photographed me in the NESOP base-ment. The succession of shots was astonishing in its rapidity. As he filled roll after roll of film with images of my nude body, I imagined that I felt a little part of something in me die. Or rather, that I was deliberately killing it off, so the camera couldn't get it.

This impulse of his to take hundreds of photos in the studio was very different from the impulse to take a photo on a family vacation. You do the latter in order to remember, to prove you were there, to fix the people you were with firmly in that particular place and time. But art photogra-phy of the kind in which I was participating seemed an attempt to defeat all of that.

When somebody juggles chainsaws, the reason the trick is cool is that chainsaws are not intended for juggling. If anything, chainsaws almost seem designed specifically *not* to be juggled, and that is where the art comes in. Similarly, in nude art photography, the photographer is trying to wind up with a finished product that is not unique to the situation, not

unique to the person, and that hides the specifics and imperfections of a particular place and time. Art photography uses the camera in a way that seems counterintuitive, if not outright dangerous; at the very least, art photography uses the camera in a way that most people do not use it.

This photographer in the NESOP basement filled all of his film earlier than he'd thought he would. We were done well before our hours were up, but he paid me for all three anyway. He thanked me, shook my hand, took my address, and said he'd send me a couple prints if they turned out all right.

When they arrived in the mail, it turned out they had. I did not look bad. When I described the process to a curious friend, she asked me why I'd done it, why I'd gone through with it, if I disliked being photographed so much, and why on earth I said I planned on doing it again someday. I couldn't explain it very clearly. I'd been reading the philosopher Immanuel Kant for a paper I'd been working on, so I think I answered with some muddled statement about negative pleasure and the sublime—about that sense of relief we feel when we realize that an external threat, a worldly disorder, does not really threaten our life, that while our internal order may have been in danger, it has been somehow spared.

If memory serves, my friend's response was along the lines of "Whatever, you're crazy," and we left it at that. But I disagreed. I did not think I was crazy—though it did occur to me that I should handle the safety issue more deftly in the future. That first shoot, I thought, was a freebie, a chance where things could have gone much worse than they did. I would handle the arrangements differently next time.

Jon began almost immediately to take dozens upon dozens of pictures—three hundred in all, he would tell me at the end of the shoot. Taking my place on the velvety black dropcloth he'd tacked to the wall and spread across the floor, I stretched my arms above my head like a caryatid, arched my back like a cat, coiled like a spring and bent like a bow, as all the while his shutter clicked, clicked, and clicked again—tiny coffin-lids closing in rapid succession. Fittingly, given the lost-in-time bachelor pad surroundings, the shoot itself was unfolding like *Blow-Up*. Standing directly over me, squatting, kneeling, his designer-jeans-clad knees on the floor, next to my hips, my feet, my face, he shot picture after picture punctuated with passionate verbal feedback.

"Yes, yes, bend over. Like that—that's great! That's amazing. Now turn your head this way. Now mess up your hair! OK, lie down and move your

foot to the right. No, no, no! Not that far—back, OK there, there! Great, yes! OK . . ."

By now it was clear that I had nothing to fear from Jon by way of bodily harm. He was less David Hemmings—dashing and menacing—and more Woody Allen—neurotic but harmless. But it still felt so weird that I had to kill some part of my brain, at least temporarily, to get through the shoot. As always, I consoled myself with the knowledge that I was holding something back, that even with three hundred pictures, Jon would never really come close to capturing the Real Me, whoever she was.

There's this scene in *Annie Hall* where Woody Allen's character refuses to let Diane Keaton's character smoke her usual weed before they have sex. The film at that point is double-exposed, so while Alvy and Annie are going through the motions on the bed, we see Annie's detached spirit leave her body, sit on a chair, and watch. Alvy speaks to the spectral Annie and makes love to her body at the same time, frustrated because he cannot possess her entirely. She doesn't understand what the big deal is, and tells him, "You have my body." He says "Yeah, but I want the whole thing." But of course, nobody can ever have the whole thing. That's what it was like. Like I was there, but not there. Like I was watching myself from a cool remove.

I was still civil, though; I was still polite. Whenever Jon needed to change cameras, swap batteries, get a new memory card, or set up the next shot, we'd chat. Why all this interest in the female form? I'd asked him, after so many years as a businessman, after so many years away from "snaps" and the bohemian life? Jon explained that his newfound venture into working with models was all part of a concerted effort to branch out into more "artistic"—and therefore more naked—directions.

As we talked about his plans, his goals for his snaps, he showed almost no interest in me as a person. That was fine. I hadn't come there to share, and I enjoyed studying him. He seemed to like everything the way people who like porn like porn. It pleased him to own cool things, but not to think too hard about, or to really understand, them. His mentality was a collector's mentality: possession, for him, could be a satisfying end in itself. The lifestyle he maintained was kind of a *Joy of Sex* lifestyle. He seemed to believe that there was a way one should live—specifically a way one should live the Good Life—and that there was a technique for achieving it. I imagined him making lists in his head and checking them off.

I could see him eyeing me up—leg, breast, thigh—a bird before the butcher, a cut of meat in a window display. He liked to do body shots:

images that lopped off my head, left out my face, and reduced me to a slice of skin, a slab of ideal flesh. Nipple—check. Eyelash—check. Ear, ankle, butt-cheek—check, check, check. Lots of photographers can do body shots in a way that is beautiful and humanizing, that can make their subject look like more than a Styrofoam tray of tissue wrapped up in a refrigerated grocer's case. Edward Weston, for example, made some of his subjects look like vegetables. He made his sitters look like peppers, or like squash, not to dehumanize them, but to call attention to the splendor of all organic forms: animal, vegetable, mineral, human. Jon was not like Weston. If anything, he seemed to have developed an elaborate and pretentious artistic vocabulary expressly to keep himself from having to think that way.

Halfway through the shoot, he did a sequence of me sprawling on a mattress and draped in sheets that he called "Morning Arising," but that I would have called "Naked Chick Writhes on a Bed."

"OK, now start facedown. Stick your butt up and lay on your stomach," he said. "Now fan your hair out over the pillow. Great! Yes. OK, now twist your hips up, and pull the sheet down. Yes! OK, turn over. All right—wait, do you mind if I touch you? I just want to move your hair. OK," he said, lifting a curl between a pale finger and thumb, and setting it back down, putting the camera right in my face and shoot shoot shooting. "That was beautiful. All right, now raise your arms over your head, like you've just woken up, like you're stretching, you're yawning, yes yes yes!"

I doubted he realized it, but Jon's euphemistic titles placed him in a long line of men who rendered their softcore images of nude women acceptable by giving them "tasteful" names. That statue attached to that building is not just a cheap excuse for some T and A—she's the embodiment of Victory! That frieze of cavorting bare-breasted shepherdesses winding around the ceiling of the theater isn't an orgy—it represents Plenty! I'd read about Apollonie Sabatier, a Parisian widow, opera extra, and high-class kept woman, who had posed for Clésinger in the 1800s. His sculpture was a life-sized nude of a voluptuous woman twisting atop a bed of flowers—head tossed, back arched—looking for all the world like she was having an orgasm. Such a frank depiction of sexual passion wouldn't have been permissible at the salon of 1847, though, so he wound a tiny bronze snake around her left ankle and called the whole thing *Woman Bitten by a Snake*. So Apollonie wasn't *coming*, she was *dying*; this wasn't *pornography*, it was *tragedy*. The high-minded piece was a huge success, and continues to be popular, even though the serpent itself has been lost to the ages.

"Hang on," Jon said, after I thought the series was done and I had fully arisen. "Don't move. I want to basically do that all again, but in black and white this time. This one's going to be really beautiful, really arty."

I flipped myself over, a piece of meat on a grill, and we did the whole thing again, even classier this time.

Some of the best photo shoots I've ever done were ones where there was no pretension toward artiness: shoots for stock photography, attractive yet generic images made with the intention of being used not as art objects, but rather as a means to sell a product or a service. I always found the honesty of stock photographers refreshing.

Mark was the first stock photographer I worked with, and I suppose he was my favorite. I'd been introduced to him by my friend Adrienne, a member of a small, all-women drawing group I'd been posing for in Allston and Cambridge. She thought I might be what he was "looking for," so we e-mailed a bit. He looked at my head and body shots and decided she was right. We set up a date.

In his forties, with floppy brown hair and sexy age lines, Mark met me at the South Station subway stop on a bright late-winter weekday in mid-March. He offered to carry my bag; I accepted. From there, we walked the few snowy blocks together to his workspace in South Boston. I knew I liked him right away. He was candid and forthcoming, and he seemed to have no illusions about his career as an artist.

"I'm a fine arts painter, but I make my living painting backdrops," he explained. "Stuff for other photographers and agencies to use. But I like to take photos myself, so I figured, why not do a little stock photography on the side? It helps pay the bills."

I liked what I saw as our harmonious purity of purpose: we were both there to get paid, me for posing that day, and him eventually, when he sold the images for ads, brochures, displays, and Web sites.

"Sorry, there's no elevator," he said when we arrived at the long white warehouse on the icy waterfront where he rented space.

"No problem," I replied as I followed him up.

He was quick and light, and breathing without difficulty when we arrived at the top floor, the fourth, and the door to his studio. We opened the metal portal and walked inside. The tour was quick, since it was all one enormous room: a loft, with only a few thin drywall partitions to separate one section from the next, a nook for his desk and a tiny kitchenette

with a coffee maker and an electric teakettle off to one side. It smelled lightly of sawdust and heavily of fresh paint and recently oiled canvas. Books of backdrop samples lay open on a plump navy-blue sofa, itself facing the shooting space, which was hung with example after deftly-painted example of the real thing. Mark outlined the plan for the next two hours, leaving no time for awkward chitchat.

"I thought we could start with some clothed shots, then move to underwear, and then do some action stills. If there's any time left at the end, maybe we could go next door and do a few nudes. They won't be for stock, just for my own portfolio. Whaddya say?"

"Sounds like a plan," I said.

"Great. All right—let's see what you brought."

I dumped out my bag of outfits onto one of the white dropcloths spread across the concrete floor: dresses, stockings, bras, shirts, and jeans, all without labels or brand logos—no Victoria's Secret underpants even, because such lettering would all show up in the photographs and ruin the images' viability as a means to sell other products. There was underwear aplenty, underwear galore, but none on me at the moment.

"We'll start with the dresses," he said, "and move to the panties."

I've always hated the word *panties*—girlie and infantilizing—but I agreed. I trusted Mark. I admired his professionalism, and I wanted to please him.

We began with me in a succession of dresses. Mark wanted some happy shots, some shots that said "joy," and he thought the best way to express this would be through my kicking off my shoes and jumping in the air. So there I bounced, at the center of the shooting space, a swiftly changing array of backdrops behind me: sometimes canvas, sometimes muslin. Sometimes the blue of a tranquil ocean or a cloud-pocked sky, sometimes green like the inside of a honeydew. Sometimes a vibrant slash of color like a crayon scribble or the iridescent bubbles of a champagne ballroom. I thought of Lawrence Welk, I thought of being outside, I thought of how hard it was to keep hopping higher and higher, as high as I could, in just my two bare feet with their red-painted toenails on the cold concrete. As if reading my mind, Mark stopped and rolled out a mini-trampoline so I could get more air, and I jumped some more, my head thrown back and my dark hair flying.

My toes met the springy black material again and again, and I hoped I looked happy enough. Then I realized that, improbably, I really was

almost happy. I was usually tense during photo shoots, on guard, never as peaceful as I was when a painter sketched me. Perversely, posing for photography—inherently faster and requiring more movement, simply because of the speed of the technology—often made me feel more dead, even though the sessions themselves were more active, while the slow static poses required for painting and sculpture generally made me feel more alive. And yet here I was, everything happening so fast, actually having a good time.

I spun around on the trampoline and faced the other way, my gaze pointing out the high windows, streaked with dust and spotted with paint. I could not see any people, but I could see the bay.

"That's lovely," said Mark. "The light is great. Keep jumping that way."

Once, in a museum, I had seen the first permanent photograph ever made, a simple landscape of a town in France by the inventor Joseph Nicéphore Niépce. He pointed his camera obscura out the window of his workshop, took off the lens cap, and left the exposure for a full eight hours. It was years before his collaborator, Louis Daguerre, perfected the method to the point where it could be used on people, and even then sitters had to remain perfectly motionless, still as statues, for many minutes before their portraits were properly recorded by the machine. Moving objects—like me—became invisible during the lengthy exposures. Samuel Morse, a famous Bostonian, who perhaps had gazed out at the same bay I did as I bounced high on my trampoline, had seen an early Daguerreotype of a Paris street scene and marveled aloud that there were no people. It had to be explained that yes, there had been people, lots and lots of them, but you simply could not see them, since they'd been in motion.

"All right, Kathy, I think I've got enough," Mark said, changing cameras. "Let's move to the panties."

"What's my motivation?" I asked, stepping down from the trampoline to change, half joking but half serious.

"You're a young woman, sort of lounging around," Mark said, smile lines crinkling at the edges of his eyes. "I'm not sure what these will be for. We'll just do a variety."

We did a series of quieter poses as the backdrops changed like a mood ring behind me: gray and cloudy like a smoke-filled bar for one sequence, pink as a little girl's bedroom for the next. In these, I was not necessarily to embody "happy," but simply to sell, to be an ideal and appealing body.

Mark had me pose in classic pinup girl style, flat on my back, one leg straight up, the other bent out at the knee. I imagined my body a crumpled k when seen from the side. He dragged over the sofa and had me pose on that, had me do all sorts of generic young woman activities: me looking in a mirror, me putting on lipstick, me pretending to be on the phone, pretending to be reading, pretending to be writing, even one of me pretending to be doing a breast self-exam.

"Medical brochures are kind of my bread and butter," Mark explained.

These poses were not bad, and Mark was far from creepy, but I began to feel dead again, to long for the other kinds of posing—slow and steady and organic, as opposed to photography, so quick and jumpy. Sunlight poured in from the airy windows; we were so high up, there was no call for curtains. No one could see in, though I could see out toward the raggedy waterfront: the heavy industry and trade, the cranes and the boxcars, the pallets and the engines, the winches and pulleys. I could not see them, but there were men out there working, using their bodies to make a living. I identified with them, if only slightly, and allowed myself to be grateful for the natural light.

It's hard to look good in photographs. A lot of people are bad at it, especially in the artificiality of typical studio lighting—the umbrellas, the flashes, and the garish props: the four-foot posing ladders, the fake roses, and the faux Roman columns. Accustomed as I was to having my image made, I could still be disconcerted by the process when it happened in non-professional—which is to say, non-nude—contexts, or contexts in which I was paying to have my photo taken, instead of the other way around.

Recently, I'd had to get a visa photograph made—two-by-two, full-color, front-facing against a plain white wall—in short, one of the single most unflattering setups ever. The clerk at the UPS Store where I had it done (they were cheapest), a young man labeled TEDDY by his plastic nametag, immediately began flirting with me. His female coworker rolled her eyes; I smiled at her and she smiled back. "Hey, have you ever had a mug shot taken?" he asked, setting up the camera. "No? Because you look like trouble. I think maybe you robbed my house last week; I'm missing my heart."

They really did look like mugshots.

Given the official function of the photographs, I had not been permitted to smile, tilt my head, to make only one ear visible, or use any of the

other tricks I'd picked up. As a result, even after having spent the last ten minutes getting hit on, I felt ugly, as if those Polaroids sitting there damp on the counter were somehow revelatory of the Real Me. Never mind every other photograph of myself I had ever seen; they were all negated by this most recent image, which provided inarguable proof that I looked tired, washed out, and vaguely rodent-like.

This and other chance encounters with my own unphotogenicity arrested me, preying upon and adding to one of my deepest anxieties, an anxiety of perception: You think that you are X, but find out that some perceive you as Y. How do you know who you really are? How does anyone?

Hundreds of images later, Mark wrapped up the formal part of the shoot, I wrapped myself in a robe, and we ventured through the hallway to the other half of his floor, occupied by an unfinished and expansive room, left essentially as it had been when the building had ceased to be a warehouse. The yellowed paint was peeling and pipes protruded from the ceiling; cobwebs dangled from columns and support beams. We did a few nude shots. In some of them, Mark wanted action, movement—what he called "obvious visual interest." In these, I writhed around like the female lead in a hair-band video from the eighties. In others, he let me have stillness. I was quieter—not unlike, I hoped, a figure in self-taught photographer Harry Callahan's photographs: gazing out the window, leaning against a post among the nails and paint chips, facing away with my hands resting lightly on a rough, broken radiator.

The session ended in calm, and I felt more relaxed than I generally did after a photo shoot. I put my clothes back on, adding underwear this time, and Mark handed me my envelope full of cash. He walked me back to South Station, and we said our goodbyes. When he e-mailed me a few images later that week, I was pleased to see that none of them struck me as particularly cheesy. They were not great, but they seemed perfectly salable.

Jon never necessarily intended to share his "snaps" with anyone, and he certainly didn't plan to sell them for public consumption. At the beginning of the shoot, I had signed, as I always did, a release, permitting him to use the photos for private purposes—personal portfolios and gallery showings —but never for general posting. I was pretty laid back, but I did hope one day to have a respectable career, and I didn't want to find out what that

would be like while trying to suppress naked images of myself that had found their way onto, say, the Internet. But while this contract was practical in its post-shoot restrictions, it did not occur to me that it also meant that Jon could get as weird as he wanted during the shoot itself.

It did not occur to me, that is, until he told me, seemingly apropos of nothing: "I collect miniature crystal figurines. Murano glass from Italy. I've never been there, but my wife has."

Since he was not trying to cater to a broad audience with his snaps, Jon could indulge his quirks to his kinky heart's content, and that is what it appeared we were about to do. With fifteen minutes left on the clock, he brought out a shining, cool, circular mirror-tray full of spindly giraffes and stocky elephants, a green caterpillar, a red heart, a swirled piece of candy and a waddling penguin.

"I've just started this project on the body as geography," he explained, "and these little guys like to explore the female anatomy, especially butts and breasts. So it's not me, really. It's them."

I tried to laugh. "Ha ha," I said.

I leaned against a black backdrop and a stack of pillows. A purple glass horse galloped across the pale and rippling plains of my ribs before scaling the small peak of my breast, coming to rest near my nipple. Jon moved the animal, paused and took a snap every step of its journey, the way I imagined those spooky stop-motion holiday specials were shot.

Jon took picture after picture of the sparkling pony next to my nipple, then decided, while the shot was set up, to swap out the steed and put in a different creature. The caterpillar, he tried? No, too icky. The honey bee? No, no insects. The heart? Too silly. And then it came to him—the candy!

I felt like candy myself for a second, like he wanted to devour me. I imagined him wolfish, drooling. I looked again at his jeans, ragged and ripped in just the right places. I wondered if there was a boner in there. All the more reason to absent my mind without leave, to become as vacant as the dolls strewn around the room, looking on flatly without surprise from the perimeter. But I couldn't. It was too engrossing.

He set the cold glass candy where the horse had recently been, on my right breast, to the left of the nipple.

"To make some kind of statement, you know," he said.

"What kind of statement?" I asked.

"Oh, uh, something about, you know, consumption. Like the consumption of women, right?"

It struck me that Jon had once been cool, long ago, but had not really progressed. He liked cool things, but in a somewhat robotic and uncool way. Instead of enthusiasm, he had taste, but it was not good taste.

"Hey, can you make that nipple a little perkier?" Jon added, then stammered, "That's only, like, the second time I've ever said that. It's still weird. I mean, they're already pretty perky."

As usual, I'd come to this job with the intention, more or less, of "being a part of art." Yet unlike most other sessions, I couldn't shake the feeling that I was sort of becoming a part of some dilettante's collection of glorified spank material. Or maybe not; maybe this really was just his idea of pretty. In spite of myself, I was hoping that I'd look nice either way, that I'd look attractive regardless of what use to which the images might be put.

I sometimes wondered: would the sum of my work add up to an estimable track record in service to art, or would the total be tallied as just so many nudie pics? If perceived as the latter, the countless paintings, drawings, and photographs could conceivably come home to roost heavily on my reputation, my future, my character—filthy birds whose collective weight could collapse all three. I wondered, too, whether it was beneficial or detrimental, psychologically, for me to be seen and seen and seen—made over and over and over—in this way. Did it make me more or less confident, more or less vain? My mother (who had no idea I was doing this) would have said that it made me more vain, and that I should probably be ashamed.

Jon photographed the boob candy for so long and from so many angles that if it had been real, it would have been melting from prolonged exposure to my warm skin.

"OK, now let's have you flip over," Jon said. He sent another few rounds of brave animal explorers out on expeditions over my thighs, my waist, my neck, my shoulder blades.

A green glass elephant explored my backside, scaling it like a crevasse. I imagined my ass as it would appear to a beast of the elephant's size: huge and alien as the North Pole, white and looming as a lunar landscape. Jon snapped away as I pictured the pachyderm planting a flag with its delicate trunk, trumpeting loudly, claiming it for Italy.

At last, Jon returned the elephant to its silver tray and set the intrepid menagerie aside. I thought we were done. I'd begun to get up, when he asked me to turn around just one last time.

"I want to get a few more shots from behind," he said. "You have a great butt. It may be your best feature."

A famous poet once told me that a poem of mine was comprised entirely of clichés—that it was completely devoid of any imagination whatsoever. I cried quietly in front of everyone in class for the remaining hour-and-fifteen-minute duration of the workshop. I couldn't stop, and I couldn't bring myself to leave. I respected and admired him so much that it was most hurtful criticism I had ever received.

Jon's praise felt not unlike that in reverse. Because no matter how many times people compliment me on how I look, I still try to consider my imagination my best feature, or at least the one most worth cultivating long-term.

Jon snapped away behind me, really getting into it. He was treating my butt like a supermodel, giving it the star treatment. The irony was, no one would ever be able to tell for sure the ass was mine. My head was cut off, and all identifying characteristics that connected it to me were detached, erased.

Nude and more or less anonymous, more or less objectified, I accrued a curious authority. And even though I was undressed (theoretically exposed, vulnerable) and the photographer remained clothed (theoretically dominant, invincible) I frequently felt as though I was the one in control. Thinking this way, I could almost enjoy myself. Eventually, though, enough is enough, and all things—good, bad, bizarre, or otherwise—must end.

"Oh wow, look at the time," I said, automatically glancing at my wrist, though I'd had to remove my watch. "We'd better get going, or Martin'll wonder where I am."

"Yeah," said Jon. "Man, I just get so carried away when I'm having a good shoot, you know? That was amazing. You were amazing."

I thanked him from behind the screen where I'd returned to change, shucking off the plaid robe and sliding my legs first into my undies and then my jeans, adding a bra and socks to my ensemble now that I was free.

"We'll have to do this again sometime," he called loudly, overcompensating in volume because he couldn't, at the moment, see me.

"Oh, totally," I said, fully dressed and re-emerging. "Sure. You have my e-mail address, right? When you send me the pics, just let me know."

But as we moved to the door and down the stairs, I knew that I would never see Jon again, at least not in that context. We might run into each

other on the street, or maybe at a rock show, but he was done with me as a subject. He was not a serious fine arts photographer interested in cultivating a collaborative artist-model relationship; he was an upper-middle-class amateur with money to burn, interested in burning it by taking as many nude photographs of as many young women as possible. Next weekend, he'd move on to some other girl, some other lightly naughty shoot. As we drove in the Volvo to the Starbucks to get Martin, I felt a little sentimental—I'd never have the view from this passenger-side window again—but I also felt relieved. Wham, bam, thank you ma'am: this lack of sustained relationships was another reason I disliked photography modeling in general, yet so, too, was it one of the reasons I liked it sometimes. Compared to any other medium, it was quick and dirty. It was in, it was out, it was over, and we never had to talk to each other again.

Jon had gotten what he wanted: a slightly risqué Saturday morning, a large new set of snaps to play with, to Photoshop and color-correct, to montage, if he wanted, with his other snaps. He got off, I could tell, on being able to shell out a cool two hundred for my services without batting an eye. And I couldn't lie: I got off on earning it. I was two hundred dollars richer than I'd woken up that morning, and it was barely noon. And I suppose I'd gotten other things I needed as well: confirmation that I was, for whatever such judgment was worth, young, skinny, "pretty." But more than that, I'd taken a risk and gotten away without a scratch.

We passed a motorcyclist—speeding and breakneck, in spite of the rain—and it crossed my mind that posing for photography was the daredevil event in the sport of art modeling, and that my mindset in doing it was sort of Evel Knievel. Nobody *has to* rev up his bike and attempt, at great and perilous threat to life and limb, to clear thirty barrels, a pit of vipers or tigers, or the whole Snake River Canyon. I didn't *have to* sign up to pose in nothing but my lipstick for total strangers with expensive cameras. But some people are compelled. It was dangerous, maybe, but in the end, it was a rush. It was a little sleazy sometimes, but the high on the other side was sharp and clean.

Martin was standing in front of the Starbucks when we pulled up, beneath the deep green awning to avoid the rain. When he climbed into the Volvo behind me, Jon greeted him like an old friend.

"Hey man, how you been? Thanks for waiting."

"No problem. How'd it go?"

Jon went on and on again about beauty and eroticism and how happy he was with the project. Martin rolled his eyes at his me, his "hot" fiancée.

"Hey man," Jon said to Martin, earnest, avuncular. "You like Steve Earle?"

"Yeah, man," said Martin.

"Well, you gotta hear this new album I've got. Emmylou Harris is on it, too, and she's really fantastic," he raved, putting a CD in the car stereo.

Jon and Martin conversed about Steve Earle and Nashville and the rise of alt-country, Jon rambling on like some kind of aging older brother, trying to stay hip to what the kids were into. Then Jon stopped himself short and remembered:

"Hey, I need to pay you!"

"Yes," I said. "You certainly do."

Paused at a stoplight, he reached into the front pocket of his ancient leather jacket. He handed me an envelope. He had misspelled my name, writing "Cathleen" with a C in black grease pencil, but I didn't mind too much. I pulled the money out of the envelope to make sure it was all there. It was. Inside were four fifties, Ulysses S. Grant, bearded and baggy-eyed, gazing up from the obverse.

I remembered reading that the portrait of Grant was done by the Civil War photographer Matthew Brady—or maybe some other guy—and I wondered how Grant had felt that day when he'd sat down to pose for it, whether he'd been worried about looking all right, whether he'd had any idea where the image might one day end up. And I wondered about Brady. When the government had refused to buy his war photos following Lee's surrender to Grant, he'd been forced into bankruptcy. He had died in obscurity, a lonely alcoholic. Grant, too, after the presidency, had gone bankrupt. He died of throat cancer, penniless but famous, just days after completing his memoirs, which ended up earning his bereaved family a small fortune.

I wondered how I would die, and whether I would have any money when I did. And I wondered how Jon would die, and when. My friend Robin, a painter, always says that men of a certain age who take up, or become obsessed with, drawing or photographing nudes are inevitably grappling with issues of sex and death—with their own desire and mortality.

Today had been about both. Nobody had gotten hurt, and nobody'd had sex, but I still couldn't help feeling just a tiny bit like a call girl. I was glad it was over, glad to be going home, done with it all. Until the next time. I thought of the sublime, of negative pleasure, of my thrill-seeking friends who compulsively put themselves at risk again and again. We were all still alive. We were not dead. Not yet.

chapter five

What It Feels Like for a Girl

When I was twenty-three, one of my multiple simultaneous summer jobs in addition to modeling was being a sales associate in the cavernous flagship Guess store on Newbury Street in Boston. Working in the men's department one muggy afternoon in late August, I saw this creep shuffle in off the street with the sweaty, furtive urgency of a consummate perv. This set my intuition a-tingling, although he was such a transparent sicko—beads of moisture on his long, hairless upper lip, eyes wet, flush creeping from under his unbuttoned collar—that anyone's would've been. Still, what else could I do but serve him?

He rushed through the racks collecting half a dozen pairs of jeans, heedless of size or wash, denim streaming behind him as he entered the fitting room I had unlocked. A moment passed, then, "Miss!" he practically screamed. As he opened the door, I prepared as best I could for the worst, and there it was: his dick, erect, poking through the fly of his ill-sized jeans, its fleshy hue stark against the blue cotton, bobbing like a rubber duck in a kiddie pool.

I quit within the month—not just because of that, or really because of that at all, but rather because I'd been planning to quit essentially since I got the stupid job, which was soul-crushingly sucky in a thousand petty ways too boring and grim to get into here.

Turns out, I much prefer a job where I have some semblance of power and agency, and where nobody but me feels compelled, or has the wherewithal, to expose themselves.

Because that's the peculiar thing (OK, one of the many peculiar things) about my encounter with the denim dick man. Nakedness is usually to be

taken as a sign of weakness or vulnerability, but not in this instance. Even though he was the one who was exposed, so too was he the one making me uncomfortable; he was the one with the power, which at first glance is not what you might assume should be the case.

Mark Twain said, "Clothes make the man. Naked people have little or no influence on society." That year, the year containing my encounter with the Bostonian flasher, I had been informally testing the truth of Twain's formula by placing myself on both sides of the equation, pushing the boundaries of my influence both clothed and nude.

The groundwork for my clothing retail job in Boston had been laid the previous summer in Washington, D. C. Because the money from art modeling is decent, but inconsistent, I had applied for and—to my surprise, because it was nowhere I'd ever shopped, nowhere I'd ever even walked into—gotten job at a high-end boutique on M Street in Georgetown. This new job was not easy to land; to keep it, I needed to look my best every day, and to get very good at earning commission.

We were snotty, my coworkers and I. We were catty. We were mean. My supervisor, Kassech, was from Ethiopia, lean and striking, with eyes like an icon. She and I made jokes to pass the time. Whenever a chubby customer beseeched us, "Do these jeans make my butt look fat?" one of us—whichever one was hustling for that commission—replied, "Oh no, no way. These are very flattering," or "They're made with spandex—elastic is the best thing to happen to jeans in years," or "They'll stretch when you wear them—you wouldn't want to put designer jeans in the dryer anyway." But whatever we said, we avoided making eye contact with each other, because the customer had given us the set-up for our favorite punchline: "Honey, those jeans don't make your butt look fat—your butt makes your butt look fat!"

I was dressing better than I ever had, thanks to the employee discount. I was growing out my hair, wearing more makeup, ditching my glasses for contacts, and being rewarded for looking more pretty, more feminine, every step of the way.

That fall, I moved to Boston. The area was lousy with colleges, and before long, I was taking my clothes off for art classes at half a dozen of them. As in D. C., none of these schools had any body-type guidelines; they craved variety and they craved diversity. The students needed to learn to draw people of all shapes and sizes.

Soon I was finding myself with more offers for work than I knew what to do with. Part of this was because I was an excellent employee: enthusiastic, accommodating, always on time. I did not disappear for longer than my allotted five minutes between twenty-minute poses. I never showed up drunk or high, and I never complained or fell asleep on the stand. But I was meeting a fair number of models to whom all those criticisms did sometimes apply, and they had to struggle more than I did to make ends meet. While it would be sweet to think I was being asked back and back and back again simply because of my winning personality and finely honed work ethic, I knew it didn't hurt that I was slim and feminine, a fairly close approximation of generally held ideals of what it means to be an attractive woman. And I didn't kid myself that I didn't like this, that I didn't like hearing a student in a drawing class at Boston University, for instance, say, "Oh, it's you—yay! I'm glad you're not that fat old guy we had last week." I was glad I was not that fat old guy, as well.

But I was troubled, too, to consider that perhaps I was objectifying myself. My inclination was to think that I liked who I was, how I felt, and how I acted more in my job as a nude art model than as a bitchy store clerk. No wonder, then, that I've never been able to get that old public speaking suggestion about picturing everyone else in the room naked to work for me. I know it has something to do with authority, and how if you're clothed and your audience isn't, then you have more, but that notion of clothing as a symbol of supremacy doesn't strike me as necessarily true. Naked people can be intimidating. Once her clothes are off, and other people's eyes are on, the naked person has nothing to hide and nothing to lose. Were I ever charged with the task of addressing this mythical unclothed audience, I suspect I'd just stand there at the podium thinking, *Wow, these people are confident enough to be naked.* In the face of their monumental self-assuredness, I'd be struck speechless.

But some of my feminist friends and fellow grad students accused me of self-deception—of telling myself that my job as an art model was empowering, honest, liberating, when really it just perpetuated stereotypes about how women should look and act.

Taking advantage of the library at my new alma mater, I checked out a copy of *The Object Stares Back*. In it, art historian James Elkins seems inclined to agree with Twain about the lack of influence the naked have in society. He observes that in the majority of situations in which one person is clothed and another naked, the balance of power tends to be in favor of

the clad person. He goes on to cite examples of situations in which this is the case, including hospitals, the porn industry, and especially prisons—with their strip-searches and uses of nudity as punishment—before concluding, "There is humiliation in all three settings, and people are coerced in each of them."

Elkins's analysis, though perceptive, struck me as incomplete. In the situations he describes, the naked people are not disempowered because they are naked; rather they are naked because they are disempowered (although I suppose one could debate the disempowerment of porn actors). Clothed or not, convicts and sick people are sort of down for the count anyway in terms of their influence over society. So, to me, Elkins's equation: $N = S$, where N stands for nakedness and S for subjugation, didn't add up.

Throughout my life, I've been more disturbed by what I perceive as the more significant disparities among people who are clothed and ostensibly equal. I won't dispute being a nude model sounds saucier than, say, being a salesgirl or a secretary, both of which are low-level jobs I've held and hated. And much of this purported sexiness stems from the risk and thrill of my being nude in front of others who are not. But here's the thing: in those other, clothed jobs, I was looked at, and even touched, by my male colleagues and customers, and there was little I could really do about it. In modeling, I am the one in charge of who gets to look and when, and in most cases I get paid over twice as much as I would in those jobs where I had less control over such matters.

As a model, I have more power on the stand than might be apparent at first. I have the power to get to know the artists for whom I pose in a way I might never get to otherwise, to see inside their private lives, and to appreciate them as people. They don't all always appreciate me back in the same way, but even that is fascinating.

Somebody—Freud?—once said, "Everything is about sex, except sex, which is about power." This may or may not be true, but I like to contemplate how it does or does not apply when I am posing for women versus when I am posing for men. Technically, I will never be the most powerful person in the room when I am up on the model stand, for I will always be the one getting paid, and the person or people in the room will have the edge of paying me. But even though my artists and I are never perfectly equal, there are times when it does feel like we are just a couple of individuals working together, doing our respective jobs. I tend always to feel at

least equal to my artists, more like a collaborator than a hollow dummy—cultivating this feeling is necessary to do what I do—but I can tell that my artists do not always agree. My female artists tend to display a curiosity about me as a complete person, not just an object for the drawing, and so do most of my male ones. But there have been times that men I have worked for have made it clear that they are the aggressive ones, the visionary ones, the ones in control, and I am just there as a means to their ends.

It is very late summer of in 2005, and I am riding the air-conditioned commuter train up the rocky coast from Boston to Cape Ann. Although it is mid-morning, well past rush hour, the train is still crowded, not with working people on their way to or from jobs, but with beachgoers: young couples of high school and college age toting picnic baskets and big plush towels, mothers with small children in colorful bathing suits, their tiny snub noses slathered in zinc oxide. It is September, the time of year when the air is beginning to grow colder, but the water is at its warmest and most pleasant point, having been heated through the summer months by the sun. The Rockport line leaves Boston once every hour, and drops me off in the small seaside town of Gloucester about one hour later. This is on top of the forty-five minutes it takes to get from my apartment in Allston, on the west side of the city, to North Station in the first place.

Once I arrive up the cape, Robin, the artist I have come all this way to see, will pick me up in her car at the station in front of one of the area's ubiquitous pink and orange Dunkin Donuts shops. She will drive us the rest of the way to her studio. She will probably have a tape of indigenous music from Oaxaca in her tape deck, because she has been traveling to Mexico whenever she can, to work on portraits of the people there: charcoal drawings of women and girls, lucid watercolors in which the clothing of the sitters is rendered in as much detail as their glossy black hair and broad tan faces, reflecting the textile production by which these women make their livelihoods. Robin adores the village she paints in, and feels that the hospitality the women there show her stems partly from their shared interest in the arts. She considers their rug-weaving a creative endeavor on par with her own work as a painter. She feels deep gratitude for their willingness to pose for her. She only depicts the women; never the men.

Normally I'd decline to travel so far, miles and miles up the North Shore, for what often amounts to just three hours of work. Yet I've been

making this trip with semi-regularity for the past year and a half. Robin pays generously, sure, so it is well worth my while, but beyond that she is a compelling person with whom to spend time. A strawberry blonde of middle age with innumerable freckles and a slow, serious smile, she was raised in Kenya and in the UK, has a lovely accent, and always looks as though she is thinking of some distant, mysterious, and rather sad secret. Her life story—parts of which I have been able to piece together from our work over the past few months—is epic and captivating: itinerant parents, moody half-siblings, romantic affairs gone awry, and a tragically lost first husband.

Every time I embark on this lengthy train ride up to Cape Ann, I feel less like a commuter on her way to a paid gig than a lucky kid on a long-anticipated field trip. Even riding the train to see her seems magical, like it's not only a method of transportation, but a ride—a ride for fun, like at Disney World or at a funfair—an amusement in and of itself. She has had two studios since I've started working with her, the first in Beverly, and now this one in Gloucester. Both were nice, but I feel this one best suits her: three pretty rooms in a still-functioning leather goods factory, a rarity in the desolate New England landscape of the defunct and the gentrified: once booming and lucrative sites of industry now vacant or converted into lofts, condos, studios, places for people priced out of Boston proper.

Sometimes on the ride, I read a book of poetry—an assignment for grad school, or from a small magazine for which I'm writing a review. A lot of the time, I end up staring out the window. The towns on the Rockport line slide by beyond the glass: Chelsea, just across the Mystic River; Lynn, an old mill town, now home to a Garelick Farms creamery and to the company responsible for Marshmallow Fluff; Salem, site of Nathaniel Hawthorne's House of the Seven Gables and the infamous Witch Trials, always Halloweenish, even in summer. Just as she appreciates that the Oaxacan women are artists, not just faces to be spun into profitable paintings, Robin takes an interest in the fact that I am a writer, an artist too in her eyes, an equal producer.

Linguists have found that if you want a statement to sound automatically smart and superior, no matter what its content, then you should get somebody to say it in an English accent. I thought of this the first time I heard Robin speak in a watercolor class at the School of the Museum of Fine Arts in Boston. She was talking about the difficulty of painting hands and feet, and how just because you might have skill at portraying human faces didn't mean you could get away with giving "short shrift to the

equally expressive extremities." Her content was as impeccable as her enunciation, and I enjoyed that first session in large part because her lectures —on everything from art history to technique—were like music.

Robin had the reputation of being an exacting instructor, not just to her students, but to her models as well. That is why I felt so beamed upon, so radiantly selected, when after that first class she complimented me on my skill and asked if I ever posed for groups outside the art schools.

That is how I ended up posing for a watercolor workshop—or watercolour, as Robin would spell it—in Beverly, at the house of a wealthy patroness of hers. The house was less house, more mansion, and as I walked in, I saw above the sweeping grand staircase in the foyer a life-sized oil portrait Robin had painted of the woman's family, flattering but accurate. Robin had a knack for hobnobbing with the well-heeled and semi-famous, and she was happy, over that year and a half, to Robin Hood some of that lucre down the line to me. I earned a hundred dollars for that session, a ridiculously high amount for just two hours of non-photographic work, plus a catered gourmet lunch, train fare, and a captivating glimpse at how the other half lives (with organic crudités, ocean views, trust funds, and balconies).

On my way to that sweetheart deal, Robin met me at the train station and drove me to the mansion. Beverly, where we were, was a fine town, but she wanted to relocate to a studio in Gloucester.

"The light there is magical," she said, "absolutely legendary."

"Do you have somewhere in mind specifically?" I asked.

"Fitz Henry Lane—he's one of the painters who pioneered Luminism— his home still stands on the waterfront there. William Morris Hunt painted in Gloucester. Winslow Homer, Childe Hassam, John Twachtman, Mark Rothko, Milton Avery. Oh, who else? Marsden Hartley. Edward Hopper, John Sloan, those Ashcan School gentlemen. Robert Henri, Maurice Prendergast."

"Wow," I said, then wished immediately for something more intelligent to add.

"If it was good enough for them, then I'm sure that almost anywhere there will be good enough for me. I'm not picky."

After that class, before she drove me back to the station, she took me aside and asked if I ever posed privately, for individual artists. I did, I said, and she told me where she lived, also in Beverly, and that is how I ended up taking the first of many such train rides to see her exclusively.

That first time up, I felt giddy, plucked from Museum School obscurity: Lana Turner at Schwab's Drug Store, or, to use an English example, Kate Moss at JFK International Airport. I was also fired up by the situation's rarity. This was an adventure, and an answer to a question I hadn't really realized I'd had: what would it be like to pose for a female artist? I found myself posing for small groups of women with some regularity, but only rarely was it just me and a solitary female. Strange, since I ended up one-on-one with men all the time.

I discovered, with Robin, that posing for a lone female was an experience best defined by a single word: sympathy. Robin had worked as a model herself when she was in art school in Edinburgh, so she and I shared a point of comparison I had never been able to enjoy with the male artists for whom I posed, and seldom enjoyed with other female ones.

I also discovered in Robin—though I never told her—a role model. From the start—when she began the first of many full-sized, fully clothed portraits of me she would do over the next year and a half—my relationship with Robin was almost equal. She actually read poetry for fun, and she respected the fact that I was a writer. When my first nonfiction book came out in early 2005, she braved the snowy drive down the coast to the city to hear me read.

The thing that kept our collaboration from being totally equal—aside from her paying me—was the fact that on my end, our relationship was aspirational. I didn't want to be Robin, but I did want to be like her: to have her grace and poise, her wisdom and beauty. She looked her age, but lovely and dignified. She was one of the most confident yet modest women I have ever spent time with: long hair, minimal makeup, well-designed clothes worn well, with pride but without vanity. I wanted to be like her when I grew up. I approached Robin with a sense of deference because she was older and had more life experience and sound judgment, not because I was naked. Because most of the time, I wasn't.

I arrive for what will be our last session working together in the leather goods factory wearing the same hairstyle and dress I wore months ago, my first time there, back in May: a bobby-pinned crown of several twists and a dark blue vintage Betsey Johnson dress I'd found at a store in Portland, Maine, embroidered all over with blue and pink and green creeping vines and flowers, and edged at the hem with pink glass beads that clattered like a curtain from the sixties whenever I moved. I had done a mini–fashion

show for Robin that day in spring when we had begun the pose, and that was the dress she had selected, partly for its visual interest and partly for its difficulty. The whimsical colors and elaborate needlework reminded her just slightly of the women in Oaxaca.

As we've done every other time I've been here, Robin and I walk up the stairs together before parting ways at the top landing. She heads through a series of flimsy wooden doors to ready her studio, and I duck into the restroom to make sure everything about my appearance is in order. Also, after such a long trip, I need to pee.

The leather goods factory echoes with clanging machinery, yelling, and laughter, and as I arrange my hair, factory ladies share the bathroom with me, joking, cursing, talking about the footwear they need to not hurt like hell by the end of the day. They are friendly, worn and smiling, with terrible teeth. They wear orthopedic shoes, along with gloves and hairnets, and one of them always tells me that she likes my dress.

When I enter the furthest back of Robin's three small rooms, the one with the best light and the chair in which I've been posing for the last few months, I rummage in my bag and pull out a slim monograph on the Welsh artist Gwen John.

"Here," I say to Robin, handing it to her. "I almost forgot. I was already waiting for the T when I remembered I hadn't grabbed it, so I ran back up to my apartment. I hate it when people don't return books."

"Oh, thank you! I'd almost forgotten I'd loaned you that. How did you like it?" Robin asks.

I answer truthfully that I liked it a great deal.

Robin wrote a thesis on Gwen John. At an earlier session, we'd gotten to talking about her—how she was a gifted artist, but remained most known for her relationships with the men in her life: her brother Augustus, a painter as acclaimed as he was randy, and Auguste Rodin, the sculptor for whom she began posing in 1906, before going on to become his mistress.

My muscle memory has grown accurate from my years as a model, and I sink into the chair, settling back into the pose without needing to consult the canvas.

"Could you move your hand just a little to the left, farther back from your knee?" is the only direction Robin has to give me, and then we're off, she trying to finish the portrait today at long last—since this is her final chance—and I into my usual quiet reverie.

It is fitting, I am thinking, that another female artist from the UK introduced me to the life and work of Gwen John. I am thinking how, like Gwen—who had to pose for a living in order to finance her own painting—Robin knows well this difficulty of walking the line between creation for oneself and inspiration for others.

Working with Robin, it is easy to imagine why Gwen John preferred to pose for female artists—for several who became her friends, among them Mary Constance Lloyd, Isabel Bowser, Maude Boughton-Leigh, and Hilda Flodin, as well as for others who didn't, including "Séraphin Soudbinine, the Swiss 'man-woman' Ottilie Roederstein, the American Anne Wood-Brown, a Miss Hart, a Miss Ludlow, a M. Jacques, Huala O'Donel, a Miss Gerhardi, and a Madame Smidt," as the books Robin showed me about her said.

During her turn-of-the-century years of what appears to have been near-constant modeling (it's a wonder that she was ever able to get any of her own work done), Gwen wrote: "*Quand je pose pour mes dames clients le travail n'est pa si pénible, et je peux diriger mes pensées*"— "When I pose for my women clients, the work is not very hard, and I can direct my own thoughts."

Because I am modeling almost one hundred years after Gwen, I feel as though I can direct my own thoughts regardless of the gender of the person or people for whom I am posing. I have become friends with both the men and the women with whom I have worked to make art. But Gwen is right: the gender of the artist for whom you've stripped naked certainly influences the directions those thoughts are inclined to take. When I pose for women, the entire proceeding tends to feel more relaxed, almost sisterly, even. I do not want to come across as blindly heteronormative by suggesting that this is the way it feels for all models—just that this is the way it feels for me. With men, the artist-model relationships I have experienced have often been tinged with a hint of the erotic, no matter how quickly that may dissipate, but with women, that frisson tends not to be present.

I have this friend, Amanda Tétrault, a Canadian photographer I met at the Fine Arts Work Center in Provincetown. We were gym buddies and ice sisters (long story), and while we never worked together, I had the chance to talk to her about her own experiences with life studies. Like Robin, Amanda has worked on both sides of the lens, and like Robin she expressed an awareness of the delicacy of the balance of power in a situation in which one person is clothed and the other is not.

Amanda used her friends and family as models, she explained, "people who would be really comfortable with me. And it wasn't commercial, so I wasn't paying someone to do it. So that changed it, too. The women who did it for me were completely comfortable with me. We were like sisters or something—like we might be naked together anyway. So that's what I needed at that point. And whoever I have shot naked since, there's that feeling, like it's friends. I wouldn't want someone to take off their clothes if they didn't want it."

I like her application of the term "like sisters," since some of my favorite groups of women to pose for have that atmosphere as well. Three women I came to know through a continuing education class at the Museum School—Jan, Adrienne, and Meg—hire me privately on a regular basis to come to either Jan's or Adrienne's studio, the former in Cambridge, the latter in Allston. I look forward to these dates, and so do they. The sessions feel something like a book club and a birthday party and a drawing group combined. Middle-aged and vital with a wide range of interests, Jan, Adrienne, and Meg are serious artists—gifted at and committed to what they do creatively—but so, too, are they committed to having fun, and to making sure the model does, too. There is often cake for special occasions, and no matter the day, there are always treats and hors d'oeuvres—plus, if one of them has placed a piece in a gallery or sold a painting, champagne or sparkling wine. On these days in particular I feel absurdly pampered, a member of some harem, as I recline nude in my cushy chair, holding perfectly still except for the periodic raising to my lips of a plastic cup of Dom Pérignon. Really, the only thing missing is fans of fronds (though often there are grapes).

Another group of women for whom I pose privately is led by Suzanne from the Pine Manor Sketch group. Her spin-off sessions consist of older women, in their sixties and early seventies, many of them recently retired, who convene in Suzanne's immaculate Cambridge living room when they feel the need for more practice than the Pine Manor group, which meets once a week on Saturday mornings, affords them. Unlike the male artists for whom I pose, and who rarely ask me to appear before them dressed, Suzanne and her cohorts love to make me over in gowns and wraps like a vintage Barbie.

Whenever I hop on the bus to Cambridge for a rendezvous, I take half a dozen dresses along for the ride, and even then the odds are good that once I arrive, my Cambridge ladies will dig arms-deep into their own stores of garments, bring out shawls and stoles they haven't sported in

years, pile them on me and set me on a chaise, so I look like I'm not remotely from the twenty-first century. Again, the work they do is serious, skillful, but the aura of the session is that of a game of dress-up, a sensation I've never gotten when posing for a man.

The women are on average more solicitous, more sympathetic to my needs as a model. Not to say that the men are in any way abusive; it's more that these kinds of concerns appear not to cross their minds, or at least that they seem less inclined to bring them up. Delacroix reported that he "'suffered for the model,' by identifying with it and also by giving himself, body and soul, to his painting." Most of the men I have worked for and asked about this did not voluntarily express such commiseration. They copped to their own pleasure in drawing from the model, but not to worrying about the model's possible pain or discomfort.

"It's been half an hour already!" Robin says. "Would you like a break?"

Swept along by the direction of my thoughts, I haven't noticed how much time has passed. I haven't felt any numbness or fatigue, since it is a straightforward pose. But this is one of the things I like about Robin and my female artists: their concern.

"Yes," I say, not so much because I need the break, though it always feels good to stretch, but more because I like the chance to talk with Robin.

I do a couple basic yoga moves—standing forward bend, rag doll, monkey pose—and Robin smiles. She practices yoga, too.

"Oh, Kathy," she says. "I haven't shown you those photos from June, have I?"

She is referring to photographs she shot several sessions ago, so she could work on the composition of the portrait while I'm not around, which is most of the time.

"No," I say. "You haven't. I'm almost afraid to look."

At the time of those snapshots, I had just recovered from a vicious bout of food poisoning. After posing for Doug the sculptor's summer session class one Monday night, he and I decided to get dinner. His restaurant of choice—since he was driving—was a steakhouse on the edge of Watertown, a Boston suburb. Many lessons were learned that night, but chief among them: never, ever trust the veggie burger at an eatery called "The Stockyard."

I was sick for days, thinking I would surely get better on my own. Martin, my fiancé, was afraid I'd seriously damage myself from the dehy-

dration. He drove me to the emergency room late Friday night, when all the doctors' offices were closed. When the doctor finally saw me, he was shocked at how ill I was, and ordered saline IVs to rehydrate me and Cipro to kill whatever nasty thing had made me so sick. He asked if I wanted him to do a test to see what germ might be responsible. I asked him if that would change the course of treatment, or just end up costing more. The latter, he said. No thanks, I said. Art modeling is great fun, but it doesn't come with benefits, and I was fairly sure my limited student health insurance couldn't handle the blow of yet another expense.

In the week or so that it took, from start to finish, for me to recover, I had to cancel a couple sessions with Doug because I was too weak to pose. I also had to cut short a session with Jeremy the following week because I wasn't feeling as well as I thought I would be.

When I took the train up to pose for Robin about two weeks after I had been able to start eating again, she was stunned at how thin I had become: my eyes still a little hollow, my cheeks still a little sunken, and the dress noticeably looser than it had been the last time she'd seen me. I'm skinny to begin with, and not being able to keep anything down for days on end couldn't help but take a toll.

"My god," she said, when I took off my sweater and resumed the pose. "You could have cancelled if you needed to."

"I didn't want to," I said. "I was looking forward to seeing you."

"You can eat now, right? Let's go get you a sandwich."

She locked up the studio and drove us down the road to a general store with a deli in front, where she bought us both lunch that we took to the beach to eat. Only after she was satisfied that she'd done her part to help me get my strength back did we return to the factory and get to work.

Meanwhile, Doug and Jeremy, both of whom I loved, in a way, and considered friends were a) unaware that I needed to, or b) annoyed when I had to go home and rest from class or a session, more vexed by the inconvenience to themselves and/or their students than they were about me. They weren't mean; they just didn't get it.

Now, Robin is spreading the three-by-five color prints across the table, next to her easel, showing me how unwell I had looked, telling me how glad she had been to see me looking so much better the next time, and warning me to please be careful and not do that again.

"I definitely don't plan on it," I say, as I return to my chair and resume the pose.

As I do, I think about how Robin acts, in many ways, like a big sister to me, and how much, as the oldest of three sisters, I enjoy that. And it makes me compare, for just a moment, Amanda's sisterly remark to one made by an artist whom I'll leave anonymous, for reasons that will soon become obvious.

I was posing at MassArt for a Saturday morning sculpture class led by a male artist with whom I'd worked in the past, and with whom I'd work more in the future. The students were doing sketches in clay, quick gray sculptures of me doing five- and ten-minute gestures as they rotated around the model stand, kneading their damp clay. The professor circulated among them, answering their questions.

"What do you usually look for in a model?" one of the students asked. "Like when we're not in class anymore, and we're on our own, what should we try to find?"

"Great question," he said. "I like working with people who are low-maintenance. Like Kathy here. She's a great example. I think of them as being docile. I really don't like finicky models that have a lot of issues and bring a lot of stuff to the situation."

The student nodded. "I see," she said, satisfied. But the professor went on.

"I think of it as, like, if you're working with dogs. I wouldn't want a Papillon or something, I'd want a Golden Retriever."

"Oh," the student said, squirming a little.

The other students looked up at me, then at the professor, then down at their work. On the next break, the student who had done the asking came over to where I was reading my book and apologized.

"I'm really sorry," she said. "I didn't think he would answer that way. I mean, what a weird answer."

"No problem," I said. "It's all right."

And it was, basically. I should qualify this by saying that this is a guy with whom I worked for many years, in numerous situations. He never did anything that made me feel canine, or even that made me feel he didn't respect me—it was more that he didn't really care how I felt up there on the dais. I was just a thing, or maybe a creature of a slightly lower order that he needed to show up and behave so he could get his work done. I don't think he meant the dog comment to be rude; I think he wasn't thinking about what he was saying, which is sort of the whole point. Also, this artist's comment is not without precedent. Degas, I read somewhere, was

said to denote the qualities of his models in his personal notebooks, sizing them up like racehorses.

Clearly I prefer to pose for people—like Jeremy, Jan, David, Doug, Robin, and Hilary—who are interested in me as a person, and who don't mind or who even welcome my reciprocal interest in them. Equally as clear, though, is the fact that this traditionally has not been the way the artist-model relationship has worked. As Francine Prose notes, "That so many of the muses seemed to have functioned as nearly blank scrims for their artists to project on points to yet another reason for the rarity of male muses. Though one hesitates to generalize, women seem less inclined to idealize men to the point of featureless abstraction. Perhaps for reasons connected with the survival of the species, women are trained to pay close attention to the particular needs, the specific qualities of an *individual* man, while men often find it more useful for the purposes of art to worship a muse who fulfills a generic role."

Even in more contemporary situations than the ones about which Prose writes, artist and writer Paul Karlstrom suggests that "the key here may be that more women seek in their models connection with an entire person than do most men, many of who seem to be able to separate mind (and evidence of individual experience) from body."

Robin calls for another break.

"Excuse me for a moment," she says. "Off to powder my nose."

While she is in the bathroom, I stay in the studio, sipping my water, stretching, and looking out the window. The winding streets of the town are lined with trees. A few of the leaves are just beginning to change, and the curving road that the factory sits on is punctuated by the white, emphatic steeples of small old churches. I slip my shoes back on—Robin lets me pose barefoot even though it's a clothed pose; it's more comfortable that way—and amble to the opposite side of the canvas to study Robin's progress.

The painting, which she has allowed for months to be fluid, organic, free and ever-changing, has begun to lock itself into place. She has made decisions and stuck to them. The eye that she kept moving ever-so-slightly up and down has come to rest at what appears to be an accurate point, and the nose, which has been giving her trouble from the very first sitting, has resolved itself into a spot-on depiction of my own aquiline one. The hair, which for weeks has been a dark abstract mass, today has distinctive strands and shines where the light hits it, looking as mine does, pulled back

in a many-pinned and twisted crown. In short, today is the day the paint-
ing has truly come to be of me.

"What do you think?" Robin asks, and I jump.

She is standing in the doorway. On my breaks, whether I am posing in
a school or a private home, I can never resist sneaking peeks at the artists'
progress. I am obsessed with the way a roomful or a succession of individ-
uals can perceive the same person or thing in an endless number of ways.
Yet I never offer my opinion of people's depictions of me unless they ask,
and even then I hesitate. I am not an artist myself, and so feel unqualified
to speak with authority on the quality of a trained professional's compo-
sitional decisions. And I don't want to risk seeming vain, don't want to
seem as though I like a painting just because it makes me look pretty, or
that I dislike a painting because it does not.

"It looks like me," I say. "It looks like it's been worth it for us to work
together all summer."

"Oh, absolutely," says Robin. "I'm still not satisfied that I've got you
quite right, but it's been very necessary to have you up here. It's been
lovely. I obviously couldn't have done it without you."

"You've heard of the model Kiki of Montparnasse, haven't you?" I
ask.

"Yes, the one who posed for Parisian artists in the teens and twenties."

"Right," I say. "When I came around to take a look, I was thinking of
her. I've been reading her diaries, and she tells this story about posing for
Maurice Utrillo. She said that after hours on end of her standing there
naked, and him standing there drawing, she put on her clothes and took a
peek at the canvas. She discovered that all he'd been doing that whole time
was this quaint pastoral scene of a little country house. 'I was knocked off
my pins'—that's what she said."

"Well, whatever we end up with might knock you off your pins,
because I still have time to ruin it," Robin laughs. "But I swear I'm at least
trying to make it look just like you."

As I kick off my sandals and position myself in the chair, I consider
how many artists don't try to make their work look just like me. Nobody's
ever been quite as dramatic in their disinterest in depicting me as Utrillo
was with Kiki, but I have seen someone—a sculpture professor from BU
named Chris Untalan—come close.

I first encountered Chris when I was posing for the life-sized sculpture in
Isabel's class at the university. The art department there was in the middle of

a search, and Chris was one of the finalists. As one of the last steps of the candidate screening process, Isabel brought each of the three finalists into our sessions to have him—and they were, for whatever reason, all hims—practice interacting with the students. Chris was the third one to put in his appearance. The preceding two candidates had had big personalities —had talked, had laughed, had introduced themselves to me, as well as to the students—and even though they were being friendly, I had felt weird, slightly, at having these two strange new men suddenly see me nude. The sensation wasn't sinister, but it woke me up and made me alert, made me prepare my own personality to react to theirs. Chris, on the other hand, was so subdued, so professional and detached, that I felt nothing when he looked at me, even when he held a plumb bob up to my knee to help one of the junior sculptors tackle a finicky angle. With the preceding two candidates, I could imagine having a conversation with them when I put on my robe and hopped off the stand. Chris seemed like the most words he'd likely say to a model would be when, where, and how long to stand. Chris got the job.

That following fall, when he was responsible for his own classes, I found myself working quite a bit for Chris, or "Untie" as the students called him—never to his face, as he was not a nickname kind of guy, but behind his back; not meaning any disrespect, but more in an ironic acknowledgement of how remote and businesslike he was.

In keeping with BU's classical approach to the figure, the nude had been central to Chris's own work for years. Also in keeping with classicism, his approach to the nude was perfecting, not individualizing. I posed most often for his anatomy classes. Chris was a master of anatomy and could create a sketch of a flayed human body—the skin peeled off, the muscles rolled back and the bones exposed with scientific accuracy—in a way that was truly Leonardoesque. He requested explicitly that the model coordinator hire me for these sessions, but that was only because I was skinny, and therefore the novice students could articulate my subcutaneous structures with ease. His requests had nothing to do with him liking me. In one such session, an evening class, he roamed among the easels, doing impromptu critiques as the students sketched my torso from throat to pubic bone.

"What is that?" he asked a girl all dressed in black with Cleopatra eyeliner curving from her half-lowered lids. He tapped at her newsprint with his charcoal pencil.

"A scar, I guess," she said. "See? It's right there."

He strode to the model stand and pointed at me, at the small two-inch scar from an incision on my lower abdomen. "Right here?"

"Yes," she said. "I'm trying to be accurate, like you told us."

"It's from when I got my appendix out," I offered.

"There's a difference," Chris declared, addressing the whole class now, "between being accurate and being individual. We are not here to portray the model as she appears individually. We do not care what happened to her appendix—no offense, Kathy. We are just trying to see how these features—features all humans have—come together in the body and how we can draw them.

"For example, the sculpture I make is always based on an idea," he said. "I try to be responsible for the production of as much of the form as possible. So in a sense I am making up the figure in the sculpture. To do this, and to avoid making the idiosyncrasies of one person, I try to work from more than one model. So I guess you could say that model is just a figure for me."

A series of nods ran around the room, like the wave at a sporting event, as everyone got back to business.

If this makes it sound like working with him one-on-one might be a cool and distant experience, then I've gotten the details right. I liked working with Chris, but this like was disconnected and clinical compared to the gratification I derive from working with artists whose friendliness and passion run closer to the surface. Chris can be friendly, and Chris can be passionate, but as far as I can tell, he keeps these qualities in check as he works.

Still, despite what seemed like a lack of any outward signs that he especially liked working with me, he chose me to pose as one of the models for a larger-than-life sculpture of Lot's wife at the moment she begins to turn into a pillar of salt. His personal studio at BU hadn't been set up yet, so instead, we worked in a spare bedroom of his house that he'd converted to a studio. There I posed, drank tea with him and his graphic-designer wife, saw their other work, listened to music on their iPod, and met their scene-stealing cats who liked to climb up on the stand with me.

Yet I still don't feel like I learned all that much about him. He didn't like to share, and he didn't like to chat. Details most other artists would have divulged to me he kept to himself. I didn't know his wife was pregnant with their first kid, for example, until I showed up one day having not

posed at his home for months and saw that her belly was enormous. Chris keeps himself hidden. And in his sculptures, I am hidden. When they are finished, you'd be hard-pressed to tell that I had any part in their creation. All my hours spent standing atop the rotating gray stand, little pink foam-core wedges shoved beneath my bare feet to make the pose appear more agonized, more pillaresque, ended up transformed into a statue that looked exactly like Chris imagined Lot's wife would look, and nothing whatsoever like one Kathleen Rooney.

The spring after he finished Lot's wife, Chris hired me again, this time to pose for a nymph-like set of figures representing Spring and Autumn. As I knelt on the stand in his new studio at BU in what I strove to make an autumnal attitude, another of his works-in-progress caught my eye: a quarter-scale sculpture of an enormously fat woman planted atop a stool that looked ready to crack under her weight.

Curious, I asked him about it—who she was, what she represented. She was an amateur volunteer he found on Craigslist. She'd never done anything like this before, but he needed an extremely heavy model, because that was what he felt like sculpting. She was over three hundred pounds and willing, so there you had it. He wanted to be a bit perverse with the sculpture; to make beautiful something that most viewers would presume automatically must be ugly. For a split second, I was jealous of the elephantine woman. Not of her appearance, but of how Chris had made her appear. He'd sculpted her fat as handsome, majestic, though in the photographs her excess flesh sagged down her torso, cellulite dimpling sadly along all of her limbs. Her expression, on the sculpture, was blissful, beatific. Chris had made her look simultaneously like herself and better than herself. I knew that my face would not grace either of the two seasonal figures—I'd be lost in their ideal form as usual. But there the fat woman's face was, looking happy, radiant, and exactly as it did in the preliminary photographs.

Envious though I was, the more I think about it, the more I suspect that Chris never could have represented me fully as an individual, even if he had tried. He was too much of an idealizer, rendering people, for the most part, how he wanted them to be, not how they were.

Put another way, I thought, as I watched Robin watch and paint me, Robin was doing portraits, while Chris was doing allegories. Back then, when I was posing for Chris and looking—because of the way the stand was rotated—at his quarter-scale sculpture of the enormously fat woman,

I thought of a story I might have told him out loud if we'd been on those kinds of terms, if I thought he might like hearing such a story from someone such as me.

The sculpture he'd made of the woman counterintuitively interpreted our broad cultural ideas about what constitutes beauty. He had taken the enormously fat woman—by society's standards, an anti-ideal—and made her into an object of admiration. In doing so, he had shown how in some ways, an anti-ideal stands to reveal just as much as an ideal does. A grotesque can show us, as we often expect art to do, a version of reality that is somehow realer than real. Galleries the world over are full of examples, but I was remembering one that hangs in the Art Institute of Chicago.

The title of the painting is *Into the World There Came a Soul Called Ida*. In it, Ivan Albright depicts a corpulent, sagging old woman of sixty or so slumped in a chair before a ramshackle vanity. Her lumpy flesh wilts, gray and dimpled, from her limbs, and a forlorn mirror dangles from her right hand as she presses a pathetic powder-puff to her drooping bosom with her left. The sitter was a woman named—no surprise—Ida Rogers. The sitter—surprise!—was only eighteen years old at the time. To imagine Albright's skill, it helps to know that he was later commissioned by Metro-Goldwyn-Mayer on the basis of this painting to do the putrefying portrait of Dorian Gray for the 1937 film.

Preferring amateur models to professionals, Albright hired Ida—a new bride, married to a truck driver she'd met at the roller rink when she was sixteen—after she responded to an ad he'd placed in the newspaper, not unlike Chris and his enormously fat woman. He bought her a monthly train pass that she used day in and day out in 1929 and 1930 to ride the Aurora-Elgin line from Downers Grove, Illinois (the town in which, almost seventy years later, I'd graduate from high school), to his studio in Warrenville. With the exception of a short trip to California, Ida posed each day for an hour and a half, for the generous rate of ten dollars an hour. A painstaking worker, sometimes using a brush with only three hairs for the finest detail, Albright slaved over the painting for a solid two years, bringing peanuts for Ida to eat and milk for her to drink while she sat. This hospitality is alluded to by the peanut shell that appears on the floor in the painting.

Also alluded to is Albright's unrequited attachment to his youthful sitter. A crumpled piece of paper resting near the aged Ida's chair is believed to represent either a poem the painter "scribbled. [. . .] on the back of an

envelope and gave [. . .] to her" or "a sheet covered with dozens of poems," which he then tore into tiny pieces after she giggled with embarrassment. Critic Henry Adams speculates that, "the act of portraying Rogers as repugnant was perhaps Albright's way of controlling his strong feelings for her."

Perhaps it was also the best way he knew to create something beautiful, at least in the Baconian sense, that "There is no excellent beauty that hath not some strangeness in the proportion." In any event, the strangeness of the proportion of Albright's image of Dorian Gray helped the artist achieve celebrity status. Meanwhile, though she did go on to work as a hat model for S. S. Milliner of Chicago, Ida never again posed for another artist. Maybe Chris's fat woman will never pose for another artist either, or maybe she liked working with him so much that she'll go on to do it all the time. Chris being Chris, he'll probably never know, and neither will I. Anyway, if Chris had been more inclined to take an interest in those kinds of stories, I might have told him that one, and suggested that he check Albright's painting out if ever found himself in Illinois.

Unlike Chris, or even Albright, Robin is painting me today as I appear. She is painting me as I have appeared each time I've seen her for the past five months. Although today, in our last twenty minutes before we will knock off, she is painting one new detail that was not there the last time I saw her: a silver wedding band on my left ring finger. I got married to Martin in Brazil in August, and that is part of the reason this will be the last time Robin and I work together. Martin has been accepted as a fiction fellow at the Fine Arts Work Center, an artists' colony in Provincetown, on the tip of Cape Cod. He will move there in October and I will join him in December, after my semester of teaching is over. Robin, for her part, is about to leave for Paris, where she will remain until December as well, so we will just miss each other: no more opportunities for me to come all the way up her cape, Cape Ann, ever again.

The timer of my cell phone goes off, signaling the end of the session. Robin takes another series of photographs to help her complete the painting at some future date; the artists I pose for privately are rarely ever "done" with a piece by the time I am done posing.

Neither Robin nor I can believe that I am done posing with her, but it seems to be the case. I pack up my bag, and Robin drives us down the road to the general store with the deli where we buy a pair of sandwiches one

last time and take them to the beach: our goodbye lunch. We see a woman, tan and middle-aged, standing in the waves, pressing her phone to her ear, struggling to hear the person on the other end of the line over the surf. This cracks us up. Later, I will go online to visit Robin's Web site, and I will see that she has made a painting of this woman.

We sit on the sand and talk as usual. One of my favorite subjects to discuss with Robin is her liaison with Robert, a godfather of conceptual photography whom she'd met while getting her master's. He was a visiting artist at the time, who admired her work and who shared a similar, slightly dim view of the school. He was a brilliant photographer, but with a haunted past: a recovering alcoholic and agoraphobe, a recluse and a crowd-hater who'd retreat from his problems by getting in bed by seven in the evening to watch television.

"So Robert's invited me to come out to his studio near Northampton to pose for him," Robin says.

"But you're still with Richard, right?" I say, asking about her boyfriend.

"Oh yes. I'm not interested in rekindling an old flame, but I wonder whether Robert might be," she says.

"What gives you that idea?"

"Well, I knew I should be suspicious when he told me to bring up some stockings and heels," she replies. I can't tell if she's joking. I don't think she is.

Robert has recently gotten into a life drawing kick, and is now on the prowl for models. Life drawing, Robin says, is easy to become obsessed with, but not necessarily good for one's career, since nudes are generally not salable. They make people nervous.

Robin says that she thinks Robert, like so many men his age, has taken up life drawing to grapple with his own issues regarding sex and death. "It's absolutely something to do with their own desire and mortality," she says.

I tell her about the only time I've ever been the object of an overtly sexual (and not remotely threatening) demand: one night at the Malden Sketch Group in Malden, Massachusetts. The group meets at Malden Community Center (which, the last time I was there, was fighting not to become yet another Dunkin Donuts) near the Oak Grove T stop on the orange line north of Boston. The place feels like a secret high school party in somebody's parents' basement: orange-carpeted, wood-paneled, damp, fluorescently lit, and set to a classic rock radio soundtrack, like a retro rec room.

The setting aside, the group members are serious as a heart attack about their sessions. Hard and fast rules govern the two and a half hours between seven and nine thirty each Monday night: no lateness, no food, no phone calls, and no socializing when you're supposed to be drawing the figure. All that stuff can be saved for when you go out for beers afterward.

The proceedings are governed by Nina, a trained artist and a mother-hen/den-mother with a thick New England accent and an iron fist, a soprano voice tuned alto by years of smoking. "Model's posing!" she hollers when it's time for me to work, whether I'm actually posing or still lounging in my robe. That way everyone else knows it's time to get their butts back to business. I know they've hired people to sit for portraits or as subject paintings—one of the member's teenaged sons, for instance, or a woman they know who works as a clown—but they typically prefer to have me sit nude, which is fine with me, as nothing could be simpler.

One night last winter, though, they decided they wanted to use props. Van Morrison crooned to his "Brown-Eyed Girl" in the background as Nina announced they'd like to try something different for a change.

"Here," she said, "you can wear these." She rooted through her bag, reeled out a pair of thigh-high black stockings, and thrust them toward me.

I'd posed as an Egon Schiele-style stockinged sylph before, so I didn't bat an eyelash—until she added, brow cocked, "These are my sex things. Don't worry, they're clean."

The room shook with laughter above Van Morrison's *sha-la-las,* and after a startled skipped beat, I added my forced chuckle to the chorus. Within thirty seconds we'd settled down to business; I'd quit staring at the nylons in my hand as though they were coiled black snakes, and put them on. The rest of the evening proceeded without incident. Not that the joke had been what I'd consider an incident in the first place; Nina is salty, and a terrific smart-ass, and I love that about her. She hadn't meant anything by the remark, and I wasn't about to dwell on it. But in that instant, I'd been reminded that as much as posing for the group made me feel like the member of some special, secret club, I wasn't really. I was different, and I wasn't equal. I was an employee, and therefore paid to do what she said.

"Oh, that's wonderful," Robin says, rolling her eyes. "Her sex things."

"Yeah, but I've got nothing on your girl Gwen John," I say. "That part in her biography about the kinky things her employers had her do when she was modeling? Yikes. That woman who paid her to hold a nude

pose while she had sex with some man in the next room? They treated her like a puppet."

"You're nobody's puppet, Kathleen," Robin says. Then she smiles her sad smile. "We'd best get you to the train."

Nobody's puppet. I can't help but like that. I do my best not to be, both when I'm posing and in real life. I hope I succeed.

I have seen the ways that artists invent their own ideal images by disregarding physical constraints. By ignoring realities. Robin, in the end, had more power over me than I expected, just by treating me as an equal. She did not idealize me, but by treating me as she did, she made me want to idealize her.

I have read that Ingres added an extra vertebra to the neck of his Odalisque. Picasso scrambled his loved ones' features. Modigliani made their faces in almond shapes. Giacometti melted his people into metallic wires. Such are the things we do for our visions. Such are the things we do to create things we love.

chapter six

The Lie That Tells the Truth

 When I was posing for Isabel's life-sized sculpture class at Boston University, Kalman, one of the student sculptors, a tall, broad-shouldered, strong-jawed sophomore, had a difficult time making me look like me.

He tended to veer away from what he saw and into what he knew. Unable to capture more feminine forms, he drifted into masculine ones, solid shapes with which he was more familiar and could therefore infer. By the end of each session, Kalman had made my body look strapping, had made my narrow face manly. Isabel would have to come around during critique and remind him to slenderize my shoulders and hone my facial features back to their natural delicacy.

Kalman was not possessed of an inordinate amount of self-love. His brain and his hands were simply doing the best they could to create a life-like image, and they instinctively kept returning to the forms that were to them most lifelike. Even if he had been acting out of a deliberate fondness for his own appearance, Kalman would have been in good company, considering the rumors that Leonardo himself used his own features as the basis of his *Mona Lisa*.

Besides, as Doug the sculpture professor warned on more than one occasion, almost every artist, especially when they are just beginning, must struggle with the proclivity to make all of their portraits look like themselves. Our own faces are the ones with which we identify most strongly, and with which we have the most sympathy. From Plato on up, many a critic has pointed out that art acts as a mirror: even when we are not, like Kalman, sculpting our own features onto it, we are seeing ourselves in it.

The word *person* comes from the Etruscan *phersu*, which means *mask*. The word *monster* comes from the Latin *to show*.

Posing is a kind of mask. So is this chapter.

Art historian Kenneth Clark points out that one person's god is another person's monster: "many of Michelangelo's figures, if they came to life, would be monsters and would shock us."

My husband has just finished writing a novel about Venice. As such, I have become a repository of trivia about all things Venetian. Favorite Historic Venetian Fact Number One? The *baute*. The masks. Tragic. Comic. Demonic. Angelic. Masks not just for Carnevale, but for all the year round. In the 1700s, the facially disguised zenith of the Venetian mask craze, residents of the sinking city took to wearing them day in and day out, all twelve months of the year. You could be anyone or no one; you could escape from your identity and therefore from your (social, economic, sexual) reality.

This escape takes place in the art studio, as well. As a model, I reveal all of my body, but only a fraction of my self; I have my clothes off, but the mask of my professionalism as an artist's model on. Meanwhile, the artist reveals something about him- or herself through the work being created, but as they work from my body, they too wear a mask.

Favorite Historic Venetian Fact Number Two? Extended adolescence. In Renaissance Venice, it lasted until you were twenty-seven. This staving off of time takes place during posing, too. Paintings and sculptures produced from the live model are not adolescent; they're timeless and permanent, or least we wish for them to be. We hope that our art can preserve or outlast the person, place, or thing that provided its image.

Yet art modeling itself, in a way, is an adolescent pastime: you are frozen forever in the process of becoming. You are never fully formed. Each session presents the opportunity to adopt a daring new identity for a finite time; then you cast it aside like last month's trend before trying on a new one—like being a jock your freshman year, a Goth your sophomore year, a drama queen when you're a junior, and a prep when you're a senior. Then maybe you go off to college to prolong the experimentation. That is how you can choose, if it suits you, to become a totally different person from painting to painting, artist to artist.

Fantasies and daydreams. Dazed from standing still, gazing out the window thinking, *I am a princess. I am a chorus girl. I am the mother of the world*, as the situation requires. Because all of these things are you, and

none of them are. The reality of the so-called real you is that there is no single real you.

In her book *Rollover Mona Lisa!*, model Theresa M. Danna includes a well-intentioned section titled "Answers to Uncommon Questions." In it, she answers the uncommon question, "Who models?" by writing, "If you are comfortable having people look at you, can sit still for 20–30 minutes at a time and have some interest in the creative process, then you can model. You don't have to fit into society's standard of what is attractive. If you reflect a peaceful or integrated frame of mind, then you are beautiful. Just be yourself and feel good about it." Sensible advice all around, up until the "Just be yourself" bit.

Whenever anyone says "Just be yourself," they are presupposing—and asking you to presuppose—the existence of a single self you can just go ahead and *be*. Not only that, but said self is supposed to be so perfect, so pure and unified, that it will be suitable for every occasion. Most people do not—cannot—operate with this one-self-fits-all mindset. One of the reasons I'm drawn to modeling, I think, is because the artist-model transaction points up this fact. The best models have a sense of the dramatic, an ability to lose themselves or to take on new selves as the project necessitates.

This idea of becoming someone I am not pleases me. You can be something, like it, revel in it, stop, and it never gets boring. Or be something else, hate it, and know it won't last and you don't have to do it again. Like babysitting or dog-sitting, sort of. Getting the experience, but not being saddled with the actual responsibility.

French artist's models were occasionally referred to as *poseuses*. Literally, a *poseur* was a mason or bricklayer, but colloquially, then as now, the word implied that the *poseur* in question was attempting to project a false identity. Susan Waller notes that the word "*Poser*, to pose, had become a common slang usage after 1840 [. . .] used outside of studios to refer to the identities assumed in public, personas one might counterfeit but could not legitimately claim." I like this application of the term *poseuse* to models, the way it adds insight into what models do, the fakery, the theater, the artificiality, the constructed and orchestrated drama of the creation of an image.

I often have the most fun posing when I am immersed fully in this fakery, when I am deliberately instructed to be something more than myself: posing as Madame X for a painting class in Newton, posing as the Rodinesque eternal feminine for a sculpture for Doug, posing as the

allegorical manifestation of erotic love for Ed Stitt's triptych of Eros, Philia, and Agape.

The chameleonic behavior of art models dramatizes the shifts in self each of us runs through on any given day. Philosopher Thomas Nagel argues that "The distinction between what an individual exposes to public view and what he conceals or exposes only to intimates is essential to permit creatures as complex as ourselves to interact without constant social breakdown." Nagel insists on using only the masculine pronoun, but otherwise this is wise. I hide my true self whenever I'm posing, but I—and everyone else—also engage in this type of concealment almost all the time.

When we do, we are rewarded. When we don't, the wheels can fall off. For as Nagel continues:

> Each of our inner lives is such a jungle of thoughts, feelings, fantasies, and impulses that civilization would be impossible if we expressed them all or if we could all read each other's minds. The formation of a civilized adult requires a learned capacity to limit expression to what is acceptable in the relevant public forum and the development of a distinct inner and private life that can be much more uninhibited, under the protection of the public surface.

Posing nude for artists gives me the chance to expand my expression slightly beyond what is typically acceptable. Posing nude for artists lets me mess with the borders between public and private. Posing nude lets me consider my desire for a certain kind of attention. And it lets me confront the idea of why I want that attention, why I have this impulse to be noticed and acknowledged, which maybe is, at its root, related to or the same as my impulse to write books like this one, why I want not just to wear a certain kind of mask, but also to be looked at with a certain kind of interest.

And even though I can never be sure what kind of attention I really want, or whether I will ever get it, art modeling and writing both make me feel like at least I am trying.

There is an episode in Oscar Wilde's *Picture of Dorian Gray* when the artist Basil Hallward says to Dorian the words every model might thrill to hear: "Dorian, from the moment I met you, your personality had the most

extraordinary influence on me. I was dominated, soul, brain, and power by you. You became to me the visible incarnation of an unseen ideal whose memory haunts us artists like an exquisite dream. I worshipped you. I grew jealous of every one to whom you spoke. I wanted to have you all to myself. I was only happy when I was with you. When you were away from me you were still present in my art."

No one has ever been quite that florid with me—nor have I ever expected them to be—but even if, as an artist's model, you don't get that kind of reaction, you will still get something.

And even if a portrait or project is ostensibly supposed to be of or about you, it often isn't, or at least isn't entirely. Early on in Wilde's novel, Basil observes that "every portrait that is painted with feeling is a portrait of the artist, not of the sitter" and that the "sitter is merely the accident, the occasion."

This isn't a big revelation for Basil, just as wasn't for me. It wasn't something it took me years of posing and hundreds of portraits to find out. Rather it's something I have known throughout my career, even from the beginning, that very first January day back at the Corcoran in Washington, D. C.

Just as people want to know why I pose in the first place, so too do many of them wonder what I've learned as a result of doing it. And I know they don't exactly mean little discoveries like the ones I've been writing about for the last two hundred or so pages; rather, they are looking for an epiphany, a climax, a life lesson learned. I often find myself unable to deliver a satisfactory response. I don't know what I've learned. I haven't made any single Big Self-Discovery or arrived at any exclusive Life-Changing Knowledge over the course of my art modeling career, nor am I probably done with posing. So I don't know how good of a story my experiences make, lacking, as they do, both a clear climax and a natural endpoint.

I want to tell these people who ask me that what I've learned this: this is not now, nor has it ever been, a journey of self-discovery. At best, it has been, like some sculpture, a subtractive process, a process of reasoning to come to an answer to the question: why do I behave the way that I do? And that answer has something to do with repetition, compulsion, and the fact that some truths need to be proven not once, but over and over, many times in a row.

When I teach my university first-year writing class entitled "On Beauty," I like to wrap the semester up with Greek philosophers. My students go crazy for Plotinus, because he is so big-hearted, so optimistic, so easy to understand. In the *Enneads*, he writes:

> Withdraw into yourself and look. And if you do not find yourself beautiful yet, act as does the creator of a statue that is to be made beautiful: he cuts away here, he smoothes there, he makes this line lighter, this other purer, until a lovely face has grown upon his work. So do you also: cut away all that is excessive, straighten all that is crooked, bring light to all that is overcast, labour to make all one glow of beauty and never cease chiseling your statue, until there shall shine out on you from it the godlike splendour of virtue, until you shall see the perfect goodness established in the stainless shine.

We read this aloud together, and we discuss it. My students like to hear it again and again. They like to read it back to me and quote it in their final papers; Plotinus's words apply to how they feel about their bodies, how they feel about how they feel about their bodies, and how they feel about the very process of writing itself.

When I first started modeling, I thought it was empowering, liberating. And I wasn't wrong. I thought it taught me to like my body better than I had before, to appreciate all the things it can do, and to push it to do new ones. And it did. Where I *was* wrong, though, was in thinking that if you learn something once, you've learned it forever. My students have taught me that there are different styles of learning and ways of knowing, and that one of the best ways to teach is to repeat and repeat and repeat and repeat. We learn and forget, learn and forget, and we sometimes need other people to remind us what we've been learning.

Someday, maybe, one of the truths of modeling—that all bodies have the capacity for beauty, that there is no eternal capital-I Ideal—will stick with me. In the meantime, I've decided that I have to keep trying, just as I have to keep putting the same words and concepts on the dry erase board for my students, as it keeps on drying, keeps on getting erased.

In fairness, I have now, more than I did six years ago, a much clearer sense of who I am as a young adult in America in the first decade of the twenty-first century, who I am as a person, really. And I wish I could tell you that this transformation has occurred because I have grown up. That

I have gone from the caterpillar of the girl I once was to the butterfly of a woman. That it is because I have come of age.

But this is not a coming-of-age memoir. It is not, because I have not. Come of age. Nobody comes of age. Nobody's life has the traditional narrative arc of Freytag's Pyramid. Nobody's existence makes inherent, harmonious sense. That is fiction.

Fiction is a lie, of course, artfully told, but the biggest lie in it is that anyone's life goes from point A to point B with a rising action, climax, falling action, and *denouement*. Maybe I am being uncharitable. Maybe some people's lives do do that. But not mine. I am as confused in some ways about myself, my life, my gender, my sexuality, my body, my purpose, now as I was the first day I took off my clothes in a room full of strangers. I do not have as much of a grip as I would like. I do not feel especially in control.

Art is a lie that helps us feel in control. It helps us create an order and a harmony we can only rarely create in our own existence. Art helps us establish a sense that we, and the events of our lives, matter, that they have meaning and weight and beauty. And art gives us the idea of an audience, of a group of onlookers who care about what happens to us just as much as, if not more than, we do, who are invested and who will laugh when we laugh, cry when we cry, blush when we are embarrassed and cheer when we win.

This book is a lie about being in control. The control I get from being a part of art. From sectioning my life off in three-hour increments during which I am nude and drawn, threadless mistress of my tiny, cold domain. I am Type A to a fault. I am a planner, an anticipator, a worst-case-scenario impresario, and to me, the dependable structure of a drawing session delights my micromanagerial heart.

But so too is such a session inevitably full of surprises, or at least fraught with the potential for surprise. People are wild cards, and I love them for that. I am an extrovert. An exhibitionist even. And I like the way the students and teachers and even the other models can surprise me in some regard, no matter how long I've been doing this. The biggest surprise, still, the biggest thrill, is when somebody likes me, truly likes me, wants to see more of me and spend more time with me, either to work together or just to hang out.

My friend Jeffrey, the webmaster at my current office job, says that his goal is for people to be happy when he is there, and equally happy when

he is not. Not me. I want to be missed. Like Radiohead sings, I want you to notice when I'm not around. I wish I was special.

When I was still at my academic job—the job teaching the creative writing class where I ended up helping Audrey make her own way into art modeling—I was wary of the potential for narcissism in the subjects I had been assigned to teach: memoir and the personal essay. Beware, I warned my students (and inwardly, myself) that you do not make the mistake of presuming your audience's sympathy, of believing they will find an incident intriguing and worth their attention, simply because it really happened, and more specifically because it really happened *to you*. I was constantly on the lookout for opportunities to remind them not to commit this mis-step. When my Yahoo browser opened up with a fluff story about the growing self-absorption of America's young people, for instance, I brought it in and shared it with them. One of the examples the piece gave of why this latest generation—these Facebookers, these MySpacers—is growing up to be so self-involved is because every kid now is raised to believe he or she is incredibly special. The lyrics to the traditional song "*Frère Jacques,*" said the article, which used to be "*Dormez-vous, dormez-vous?*" are being taught to many pre-schoolers as "I am special, I am special, look at me, look at me."

When I showed this article to my creative nonfiction classes—writers, all exhibitionists, too—I asked for their reactions. They were appalled. I pretended to be appalled, as well. And I was not totally pretending; I was slightly disgusted. But so too could I understand. Inside, I could relate. Look at me, look at me.

Oscar Wilde says that to love oneself is the beginning of a lifelong romance. I do not love myself unconditionally, and neither did he. But it is an affair that I am working on having, a dance, a condition to approach.

Anyway, if I am honest, I cannot say with certainty that I am wiser now than I was when I began. I worry about the same kinds of things that I always have—my mortality, my intelligence, my likeability, my appearance, my talent, my usefulness—but in different ways. But I suppose that I have new tools for more advanced, more productive, more self-analytic worry. And that's something. That's a step. That's going forward; that's progress.

The process of art modeling, for me at least, is at its best one of understanding and of being understood, just as art—literature especially—is both a process of self-discovery and a discovery of others: self-exploration

and empathy. And even though maybe these attempts at understanding are always already an enterprise that is doomed to fail—we are all alone!—it is worth doing anyway. Even if it weren't, I'm not sure I could help myself.

Like a former professor of mine, the poet Bill Knott, I keep wishing for connections, even incorrect ones, like the kind he writes about in his tiny poem, "Wrong":

I wish to be misunderstood;
that is,
to be understood from your perspective.

Notes

Introduction: Look at Me

p. 5 "we have a degree of delight . . ." Burke, *A Philosophical Inquiry*, 92.

p. 6 "a girl learns that stories happen . . ." Wolf, *The Beauty Myth*, 61.

p. 12 "two major factors behind . . ." Barcan, *Nudity*, 181–87.

p. 14 "For the woman . . ." Bordo, "Beauty (Re)discovers the Male Body."

p. 15 Hickey, "Beyond Dark Glasses."

Chapter One: Naked If I Want To

p. 18 Barthes, "The Pleasure of the Text (1973)."

p. 18 Yates, *The Art of Memory*, 37.

p. 19 Clark, *The Nude: a Study in Ideal Form*, 3.

p. 19 "the bathroom of the French King François I . . ." Priest, "Mona Lisa—no wonder she's smiling."

p. 19 "Although she was begun in 1503 . . ." Wikipedia, "Mona Lisa."

p. 19 "Napoleon, too . . ." Priest.

p. 20 "*Naked Venus* . . ." Clark, 109.

p. 20 "What is striking about . . ." Berger, *Ways of Seeing*, 48.

p. 21 "ever since her sensational . . ." Segal, *Painted Ladies*, 12.

p. 22 "because of the speed . . ." Segal, 12.

p. 22 "one drachma" Lahanas . . . *Hellenica*.

p. 22 "up in the official vantage point . . ." Segal, 13.

p. 22 "the greatest . . ." Segal, 13

p. 22 "I gave myself to Phryne . . ." Segal, 14.

p. 22 "bargain for a piece . . ." Segal, 14.

p. 23 Pliny Lahanas.

p. 23 "tearing off her undervests" *The Deipnosophists of Athenaeus of Naucratis, Book XIII Concerning Women.*

p. 24 Polybius Lahanas.

p. 24 "knocked it down . . ." Valhouli, "Courtesan Power."

p. 24 "to Phryne" Segal, 18.

p. 24 "I remember reading . . ." Carter, reprinted in *Inside Out*, 29.

p. 25 "The nude, dressed up to the eyeballs . . ." Carter, 29.

p. 25–26 "Of course . . ." Carter, 32–33.

p. 28 "To be naked is to be oneself . . ." Berger, 54.

p. 28 "Gloria won out . . ." O'Hara, *Appointment in Samarra*, 256.

p. 28 "Ludovici, the artist . . ." O'Hara, 290.

p. 28–29 "If you were a real decent woman . . ." Smithsonian Institution, *Artists and Models.*

p. 29 "From Greek antiquity . . ." Steinhart, *The Undressed Art*, 113.

p. 30 "There was an exhibitionist model . . ." Elder discussion.

p. 31 Hughes, *American Visions*, 357.

p. 31 "the dialectic between clothing . . ." Barcan, 18.

p. 32 "regular and repeated public . . ." Barcan, 21.

p. 34 "The nude had flourished . . ." Clark, 26.

p. 35 "even in the 1960s . . ." Steinhart, 120.

p. 35 "despite the profession's . . ." Danna, *Rollover, Mona Lisa!*, 34.

p. 35 "There have always been noble . . ." Steinhart, 124.

p. 36 "Julie was played by Julie McCullough . . . Playboy . . . Azalea Queen . . ." Internet Movie Database. "Julie McCullough."

p. 36 "The episode entitled . . ." Tv.com. "Growing Pains: Nude Photos."

p. 36 "Mike's photography course . . ." Wodell, Russell. "Growing Pains: an Episode Guide."

p. 37 "Mike has won a prize for . . ." FortuneCity.com, "Episodelists & Guides: Growing Pains, Season 4."

p. 37 "CTS has decided . . ." Tv.com.

p. 37 "In the part where CJ . . ." Tv.com.

p. 38 "don't embarrass me, nor . . ." Goldberg, "Lee Friedlander's Nudes."

p. 38 "double issues of the photographer's . . ." Goldberg, 202.

p. 39 "Some of my relatives in Portugal . . ." Faria discussion.

p. 39 "Historically, modeling for artists . . ." Danna, 23.

p. 39 "at the very time . . ." Postle and Vaughn, *The Artist's Model*, 15.

p. 39 "'My parents don't mind at all . . ." Faria.

p. 41 "Now you know it's . . ." Elder discussion.

p. 42 "a form of representation . . ." Langmuir and Lynton, *The Yale Dictionary of Art and Artists*, 501.
p. 42 "Pigalle, Jean Baptiste . . ." Langmuir and Lynton, 538
p. 42 "Female nudity . . ." Barcan, 197.
p. 42 "Live female models may . . ." Steinhart, 85.
p. 42 "Renaissance artists often . . ." Barcan, 39.
p. 42 "Artists have seldom . . ." Steinhart, 113.
p. 44 "Bareness and nudity . . ." Barcan, 19.

Chapter Two: Do You Want Me to Seduce You?

p. 47 "Pliny the Elder . . ." Schama, "Unnatural Beauty."
p. 47 "sometimes known as Dibutades . . ." Muecke, "'Taught by love.'"
p. 49 "Many travelers pass . . ." Leader. *Stealing the Mona Lisa*, 31–32.
p. 49 "when we desire . . ." Leader, 32.
p. 50 "According to the mythology . . ." Nead, *The Female Nude*, 43.
p. 51 "In severing Eros . . ." Prose, *Lives of the Muses*, 4.
p. 51 "There *were* no deities . . ." Prose, 5.
p. 51 Karlstrom discussion.
p. 51 "Why did I start?" Hoffeld discussion.
p. 51 "assiduous frequenter of bordellos . . ." Borel, *The Seduction of Venus*, 24, 69.
p. 51–52 "As his friend Jean Genet recollected . . ." Borel, 69.
p. 52 "I go to work as the others rush to see their mistresses . . ." Borel, 75
p. 52 "goes something like this . . ." Leader, 53.
p. 55 "unrivaled topographer of male . . ." Hughes, *American Visions*, 254
p. 56–57 "moved to a rambling eighteenth-century . . ." Postle and Vaughn, *The Artist's Model*, 58.
p. 57 "openly set up house with . . ." Postle, 58.
p. 57 "over the history of Western art . . ." Steinhart, *The Undressed Art*, 106.
p. 57 "was that models . . ." Steinhart, 117.
p. 67 "the professionals of strip . . ." Barthes, 87.
p. 67 "dignified insistence on her privacy . . ." Prose, 108.
p. 68 "There is a subtle perversion . . ." Borel, 98.
p. 69–70 "The value the mind sets . . ." Barthelme, *Snow White*, 76.

p. 70 "turned to the question of sublimation . . ." Leader, 58.
p. 71 "I think the relationship aspect . . ." Hoffeld discussion.
p. 72 "Starting in the 1700s . . ." Muecke.
p. 72 "The French expression . . ." Spurling, 74
p. 74 "Americans put a premium . . ." Gregory, "The Fleeting Relationship."
p. 74 "In *Together Alone: Personal Relationships in Public Places* . . ." Gregory.
p. 74 "the value of 'anchored relationships . . ." Gregory.
p. 74 "It's good to have an intelligent life . . ." Andrus discussion.
p. 75 "You definitely were . . ." Hoffeld discussion.

Chapter Three: You Only Live Twice

p. 77 "Apparently, the Chinese government . . ." RoadsideAmerica.com. "Katy, Texas—Forbidden Gardens."
p. 78 "the third largest . . ." RoadsideAmerica.com.
p. 78 "Journey back to a time . . ." "Forbidden Gardens."
p. 78 "When he ascended . . ." Harcourt School Newsbreak.com. "More Soldiers in the Terra Cotta Army."
p. 78 "built by seven hundred thousand workers . . ." Harcourt School Newsbreak.com.
p. 78 "jewels, miniature cities and rivers of mercury" TexasTwisted.com. "Forbidden Gardens."
p. 78 "the bones of the 'interior designers'" Wikipedia, "Terra Cotta Soldiers."
p. 79 "No molds were used" Harcourt School Newsbreak.com.
p. 79 "Archaeologists estimate that just fifty years" Wikipedia, "Terra Cotta Soldiers."
p. 79 "Early visitors gradually destroyed . . ." Conneely, "Deadwood's lore has become its lure."
p. 80 "who died of a massive . . ." "Making Mount Rushmore."
p. 80 "Begun in 1948 at the urging of several Lakota chiefs . . ." Wikipedia, "Crazy Horse Memorial."
p. 80 "Whereas said presidential heads are 60 feet . . ." Wikipedia, "Crazy Horse Memorial."
p. 81 "When he showed up again . . . on September 5th, 1877 . . ." Wikipedia, "Crazy Horse Memorial."
p. 81 "a dramatized medieval . . ." Hutcheon, *Opera*.
p. 82 Hoag discussion.

p. 82 "expertise in anatomical . . ." Postle and Vaughn, *The Artist's Model*, 38

p. 83 "an affirmation of the visible . . ." Berger, *The Shape of a Pocket*, 14.

p. 83 "I like the hard lesson . . ." Kotker discussion.

p. 84 "According to the mission statement . . ." Boston University, "Mission Statement."

p. 86 "The living model is never . . ." Henri, *The Art Spirit*, 80–81.

p. 93 "Sforza Bettini, who . . ." Jiminez and Banham, *Dictionary of Artists' Models*, 547.

p. 93 "the only artist's model . . ." Segal, *Painted Ladies*, 30.

p. 94 "in Beatrice we see . . ." Segal, 35.

p. 94–95 "One face looks out from all his canvasses . . ." http://www.web-books.com/Classics/Poetry/anthology/Rossetti_C/InAnArtist.htm.

p. 96–97 "In Christian art, the naked body . . ." Walters, *The Nude Male*, 66.

p. 99 "eight months pregnant with their second . . ." Kluver and Martin, *Kiki's Paris*, 91.

p. 101 "I describe the relationship . . ." Solomon. "The Way We Live Now."

p. 101 "was among those who emphasized . . ." Borel, *The Seduction of Venus*, 24

p. 101–2 "I was still trying to work . . ." Paulsen, *The Monument*, 110–111.

p. 103–4 "There we shall rest . . ." Saint Augustine, *The City of God*, 408.

Chapter Four: Take a Picture—It'll Last Longer

p. 118 "A beautiful woman looking at her image . . ." Weil, *Gravity and Grace*.

p. 121 "Apollonie Sabatier . . ." Waller, *The Invention of the Model*.

Chapter Five: What It Feels Like for a Girl

p. 135 Elkins, *The Object Stares Back*, 87–89.

p. 142 "Seeraphin Soudbinine, the Swiss 'man-woman' Ottilie

Roederstein . . ." Jiminez and Banham, *Dictionary of Artists'
Models,* 286–87.

p. 142 "*Quand je pose pour* . . ." Jiminez, 287.
p. 143 "Amanda used my friends and family . . ." Tétrault discussion.
p. 144 "'suffered for the model . . ." Borel, *The Seduction of Venus,* 75.
p. 147 "That so many of the muses . . ." Prose, *Lives of the Muses,* 12.
p. 147 "the key here may be that more women . . ." Karlstrom, "Eros
 in the Studio," 155.
p. 152 "bringing peanuts for Ida to eat . . ." Jiminez, 457.
p. 153 "the act of portraying Rogers . . ." Jiminez, 458.
p. 153 "There is no excellent beauty . . ." Clark, *The Nude,* 19.

Chapter Six: The Lie That Tells the Truth

p. 159 "Who models?" Danna, *Rollover, Mona Lisa,* 19.
p. 159 "*Poser,* to pose, had . . ." Waller, *The Invention of the Model,*
 51.
p. 160 "The distinction between . . ." Nagel, *Concealment and
 Exposure,* 28.
p. 160 "Each of our inner lives . . ." Nagel, 28.
p. 160–61 "Dorian, from the moment . . ." Wilde, *The Picture of Dorian
 Gray,* 93.
p. 161 "every portrait that is . . ." Wilde, 4.
p. 162 "Withdraw into yourself . . ." Plotinus, "Ennead I: Sixth
 Tractate: Beauty," 150.
p. 165 "I wish to be misunderstood . . ." Knott. "Wrong." *The
 Unsubscriber,* 51.

Bibliography

Andrus, David. Discussion with the author. January 16, 2006.

Barcan, Ruth. *Nudity: a Cultural Anatomy (Dress, Body, Culture)*. Oxford, England: Berg Publishers, 2004.

Barthelme, Donald. *Snow White*. New York: Atheneum, 1972.

Barthes, Roland. *The Pleasure of the Text* (1973). From *A Critical and Cultural Theory Reader,* edited by Anthony Easthope and Kate McGowan. Toronto: University of Toronto Press, 2002.

Berger, John. *Ways of Seeing*. New York: Penguin Books, 1984.

———. *The Shape of a Pocket*. New York: Vintage International, 2001.

Bordo, Susan. "Beauty (Re) discovers the Male Body" in *Beauty Matters,* edited by Peggy Zeglin Brand. Bloomington: University of Indiana Press, 2000.

Borel, France. *The Seduction of Venus: Artists and Models*. New York: Rizzoli International Publications, Inc., 1990.

Boston University. College of Fine Arts. "Mission Statement." http://www.bu.edu/cfa/visual/programs/bfa/sculpture.htm.

Burke, Edmund. *A Philosophical Inquiry into the Origin of Our Ideas on the Sublime and Beautiful*. New York: Penguin Classics, 1998.

Carter, Angela, reprinted in *Inside Out: underwear and style in the UK* by Stephen Bayley, Alice Cicolini, et. al. London: Black Dog Publishing 2000: 29.

Clark, Kenneth. *The Nude: a Study in Ideal Form*. New York: MJF Books, 1956.

Conneely, Sean. "Deadwood's lore has become its lure," *St. Petersburg Times,* December 25, 2005. http://www.sptimes.com/2005/12/25/Travel/Deadwood_s_lore_has_b.shtml.

Danna, Theresa M. *Rollover, Mona Lisa! How Anyone Can Model for Artists*. Beverly Hills: Big Guy Publishing, 1992.

Elder, Doug. Discussion with the author. November 11, 2005.

Elkins, James. *The Object Stares Back: on the Nature of Seeing*. New York: Harcourt, 1997.

Faria, Bruno. Discussion with the author. December 8, 2005.

"Forbidden Gardens." http://www.forbidden-gardens.com/.

FortuneCity.com. "Episodelists & Guides: Growing Pains, Season 4."
 http://www.fortunecity.com/lavendar/pulpfiction/99/pains_s4.html#07.

Goldberg, Vicki. "Lee Friedlander's Nudes." *Light Matters: Writings on
 Photography.* New York: Aperture, 2005.

Gregory, Vanessa. "The Fleeting Relationship." *New York Times Magazine.*
 December 11, 2005.

Harcourt School Newsbreak.com. "More Soldiers in the Terra Cotta Army."
 http://www.harcourtschool.com/newsbreak/terra.html.

Henri, Robert. *The Art Spirit: Notes, Articles, Fragments of Letters and
 Talks to Students, Bearing on the Concept and Technique of Picture
 Making, the Study of Art Generally, and on Appreciation.* New York:
 J. B. Lippincott, 1923. Reprinted New York: Westview Press, 1984.

Hickey, Dave. "Beyond Dark Glasses," *New York Times,* November 12
 2000. http://www.nytimes.com/books/00/11/12/reviews/
 001112.12hickeyt.html?_r=1&oref=slogin

Hoag, Gerry. Discussion with the author. November 14, 2005

Hoffeld, Jeremy. Discussion with the author. January 23, 2006.

Hughes, Robert. *American Visions: The Epic History of Art in America.*
 New York: Knopf, 1997.

Hutcheon, Linda and Michael. *Opera: the Art of Dying.* Cambridge:
 Harvard University Press, 2004.

Internet Movie Database. "Julie McCullough." http://imdb.com/name/
 nm0567204/bio.

Jiminez, Jill Burke and Joanna Banham, eds. *Dictionary of Artists' Models.*
 London: Fitzroy Dearborn Publishers, 2001.

Karlstrom, Paul. "Eros in the Studio." In *Art and the Performance of
 Memory: Sounds and Gestures of Recollection,* edited by Richard
 Candida Smith. New York: Routledge, 2002.

———. Discussion with the author. October 2, 2005.

Kluver, Billy and Julie Martin, eds. *Kiki's Paris: Artists and Lovers
 1900–1930.* New York: Harry N. Abrams, 2002.

Knott, Bill. "Wrong." In *The Unsubscriber: Poems.* New York: Farrar,
 Straus, and Giroux, 2004.

Kotker, Ariel. Discussion with the author. November 14, 2005.

Lahanas, Michael. *Hellenica.* "Eros and Aphrodite." http://
 www.mlahanas.de/Greeks/Arts/Erotic.htm.

Langmuir, Erika and Norbert Lynton. *The Yale Dictionary of Art and
 Artists.* Hartford: Yale University Press, 2001.

Leader, Darian. *Stealing the Mona Lisa: What Art Stops Us From Seeing.*
 Washington, DC: Shoemaker and Hoard, 2002.

"Making Mount Rushmore." http://www.ohranger.com/mount-rushmore/
making-mount-rushmore.

Muecke, Frances. "'Taught by love': the origin of painting again." In *Art
Bulletin,* June 1999. http://www.findarticles.com/p/articles/mi_m0422/
is_2_81/ai_55174797

Nagel, Thomas. *Concealment and Exposure: And Other Essays.* Oxford,
England: Oxford University Press, 2002.

Nead, Lynda. *The Female Nude: Art, Obscenity, and Sexuality.* London:
Routledge, 1992.

O'Hara, John. *Appointment in Samarra, BUtterfield 8, Hope of Heaven.*
New York: Random House, 1938.

Paulsen, Gary. *The Monument.* New York: Delacorte Press, 1991.

Plotinus, "Ennead I: Sixth Tractate: Beauty." In *Philosophies of Art and
Beauty: selected Readings in Aesthetics from Plato to Heidegger,* edited
by Albert Hofstadter and Richard Kuhns. Chicago: University of
Chicago Press, 1976.

James Priest. "Mona Lisa—no wonder she's smiling," *Victoria Brooks'
Greatest Escapes.com Travel Webzine.* http://www.greatestescapes.com/
index.php?articleid=192&page=1&issue=2000–06–01.

Postle, Martin and William Vaughn. *The Artist's Model: from Etty to
Spencer.* London: Merrell Holberton, 1999.

Prose, Francine. *Lives of the Muses: Nine Women and the Artists They
Inspired.* New York: HarperCollins, 2002.

RoadsideAmerica.com. "Katy, Texas—Forbidden Gardens." http://www.
roadsideamerica.com/tips/getAttraction.php?tip_AttractionNo==1279.

Schama, Simon. "Unnatural Beauty," an edited extract from his collection of
essays, *Hang-Ups,* published by BBC Books. *The Guardian.* November
6, 2004. http://arts.guardian.co.uk/features/story/0,11710,
1344669,00.html.

Segal, Muriel. *Painted Ladies: Models of the Great Artists.* New York: Stein
and Day, 1972.

Smithsonian Institution. *Artists and Models, An Exhibition of Photographs
and Letters.* Washington, DC: U. S. Government Printing Office, 1975.

Solomon, Deborah. "The Way We Live Now: Questions for Elfriede Jelinek;
A Gloom of Her Own." *New York Times* Magazine. November 21,
2004.

Spurling, Hilary. "Matisse and His Models." *Smithsonian.* October 2005.
http://www.smithsonianmag.com/arts-culture/Matisse_and_His_
Models.html.

Steinhart, Peter. *The Undressed Art: Why We Draw.* New York: Knopf,
2004.

Tétrault, Amanda. Discussion with the author. January 23, 2006.

TexasTwisted.com. "Forbidden Gardens." http://www.texastwisted.com/attr/forbiddengardens/.

Tv.com. "Growing Pains: Nude Photos." http://www.tv.com/episode/16204/summary.html.

Valhouli, Christina. "Courtesan Power." Salon.com. November 15, 2000.

Waller, Susan. *The Invention of the Model: Artists and Models in Paris, 1830–1870.* London: Ashgate Publishing, 2006.

Walters, Margaret. *The Nude Male: a New Perspective.* London: Paddington Press: 1978.

Weil, Simone. *Gravity and Grace.* London: Routledge, 1972.

Wikipedia. "Crazy Horse Memorial." http://en.wikipedia.org/wiki/Crazy_Horse_Memorial.

———."Mona Lisa." *http://en.wikipedia.org/wiki/Mona_lisa#History*

———. "Terra Cotta Army." *http://en.wikipedia.org/wiki/Terra_cotta_soldiers*

Wilde, Oscar. *The Picture of Dorian Gray.* Oxford, England: Oxford University Press, 1998.

Wodell, Russell. "Growing Pains: an Episode Guide." http://epguides.com/GrowingPains/guide.shtml.

Wolf, Naomi. *The Beauty Myth: how images of beauty are used against women.* New York: William Morrow & Company, Inc., 1991.

Yates, Frances A. *The Art of Memory.* Chicago: University of Chicago Press, 1967.

Index

Kathleen Rooney is the author of *Reading with Oprah: The Book Club That Changed America,* as well as the poetry collections *Oneiromance (An Epithalamion), Something Really Wonderful,* and *That Tiny Insane Voluptuousness,* the latter two written collaboratively with Elisa Gabbert. Rooney was a 2003 recipient of a Ruth Lilly Fellowship from *Poetry* magazine, and her essay "Live Nude Girl" was selected for *Twentysomething Essays by Twentysomething Writers.* Her poems and essays have appeared in the *Nation, Gettysburg Review, Harvard Review, Another Chicago Magazine, Contemporary Poetry Review,* and elsewhere.